LOUIS COMFORT TIFFANY

David A. Hanks

Essay by Richard H. Driehaus

Founded in 2003, the Richard H. Driehaus Museum is committed to the preservation and interpretation of Chicago's historic Samuel M. Nickerson Mansion, built between 1879 and 1883, and the collection of fine and decorative arts it houses.

The Driehaus Museum focuses on a period when reform and the "quest for beauty" in the decorative arts were developing in England and the United States, as seen in the Aesthetic interiors of the Nickerson Mansion. The origins of this reform were in the English Aesthetic Movement of the 1860s, which sought to create artistic domestic interiors. Momentum for this movement developed in the United States after visitors to the 1879 Centennial International Exposition in Philadelphia were exposed to this international trend.

A meticulous five-year restoration of the Nickerson Mansion was completed in 2008, recapturing the spirit of its Gilded Age interiors. These renovated interiors provide a dramatic setting to display pieces from the Driehaus Collection of Fine and Decorative Arts, which includes works by Louis Comfort Tiffany, arranged in settings evocative of the period along with the mansion's surviving furnishings on the first floor. The galleries on the second floor, formerly the family's private living quarters, provide space for special exhibitions; and the third-floor ballroom and its adjoining galleries, formerly luxurious bedrooms for the Nickersons' guests, are utilized for a variety of public lectures, concerts, performances, and other Museum programs.

The Nickerson residence was one of two Chicago interiors to be included in the seminal publication *Artistic Houses* in 1883–84, along with eight interiors by Louis C. Tiffany's firm. Today, the Nickerson interiors provide the perfect setting in which to present these beautiful and intricate pieces of Tiffany's work, so that visitors may appreciate his supreme achievements in a period-appropriate milieu.

Many talented individuals were responsible for the creation of this exhibition and its accompanying publication. I would like to express my deep appreciation to our founder, Richard H. Driehaus, whose passion for the work of Tiffany has made this, our inaugural special exhibition at the Driehaus Museum, possible. We are also grateful to the exhibition's presenting sponsor, BMO Harris Bank. Their generous support has helped to make it possible to share this beautiful collection with the public.

In the breathtaking historic galleries of the Driehaus Museum, we are pleased to present this exhibition of the work of Louis Comfort Tiffany, truly an "artist for the ages."

LISE DUBÉ-SCHERR

PRESERVING TIFFANY: A COLLECTOR'S VISION

Art interprets the beauty of ideas and of visible things, making them concrete and lasting.

LOUIS COMFORT TIFFANY

The roots of my Tiffany collection—my interpretation of what the artist and designer called the "quest of beauty"—can be traced back to the early 1970s. As a new collector, I focused on nineteenth-century posters for my apartment and for future use in a new home. Gradually my interests expanded to include works by Tiffany. I became a collector of lamps, windows, and vases, enjoying their beauty as well as the simple pleasure of owning, preserving, and eventually sharing them with others.

At the same time my good friend Tom McCarthy and I decided to open a restaurant/bar on the Southwest Side of Chicago, the neighborhood where I had grown up. We wanted Gilhooley's Grande Saloon (FIG. 1) to be an upscale and comfortable environment that encouraged the art of conversation and conviviality, a place where patrons could enjoy and be inspired by original works of art and architectural elements reminiscent of a turn-of-the-century Victorian pub. Gilhooley's logo (FIG. 2) was inspired by *Le Grillon*, a classic poster by Jacques Villon portraying an idealized scene of the poet J-M Levet seated in a famous French cabaret in the Latin Quarter (FIG. 3). To this we added other Art Nouveau and Belle Epoque posters from my collection—works by Jules Chéret, Théophile Steinlen, Edward Penfield, William Bradley, Henri de Toulouse-Lautrec, and Alphonse Mucha (FIG. 4). We further enhanced the mood with turn-of-the-century architectural elements—chandeliers, mantels, ironwork, fretwork, and terracotta fragments—to give the space authenticity, depth, and vibrancy.

Gilhooley's ultimately became the setting for my first Tiffany acquisition in 1980: an exquisite window entitled *Woman on the Crescent Moon* (FIG. 5). Thought to have been made for the home of Mark Twain in Hartford, Connecticut, the window depicts a woman cradled in a sliver of a moon on an abstracted background of brilliant orange covered by shades of vivid blue striated glass in the foreground.

The morning of the auction, Tom and I arrived just as bidding started for *Woman on the Crescent Moon*. It was a "Dutch auction" that began with a high asking price that was lowered until someone accepted the auctioneer's price, or the seller's minimum was reached. There was little interest in the window, which was poorly displayed on the stage. The combination of its multilayered glass, a common Tiffany practice, and insufficient lighting made it difficult to see the window's true beauty. Fortunately, I had previewed it in different lighting the night before and knew how magnificent it really was. I ended up with the winning bid. Among the auction-goers that day was Dr. Egon Neustadt, the famous collector of Tiffany glass, who subsequently told me he regretted not bidding on this window.

And so began my collection of Tiffany. In the thirty-five years since that first window, it has grown to comprise approximately 1,500 lamps, vases, decorative objects, and accessories. I am not just in search of masterpieces or rare works. Instead, I pursue an object that strikes me as arresting, with powerful imagery, a sense of drama, and rich, vibrant colors.

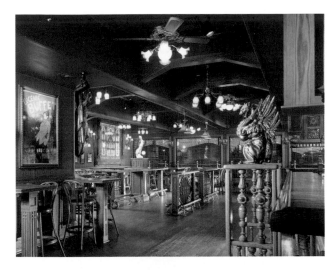

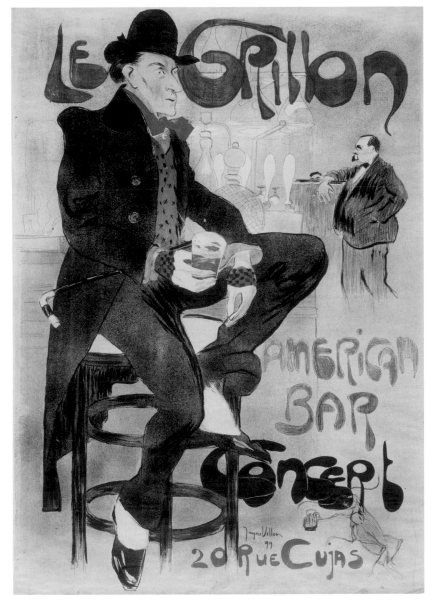

FIG. 1 Gilhooley's Grande Saloon.

FIG. 2 Gilhooley's Grande Saloon logo. Richard H. Driehaus Archive.

FIG. 3 Jacques Villon, *Le Grillon*, 1899. Lithograph, 57 3/$_4$ x 44 1/$_8$ in. (146.7 x 112.1 cm).

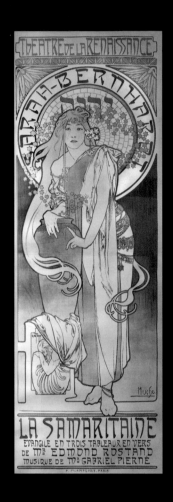

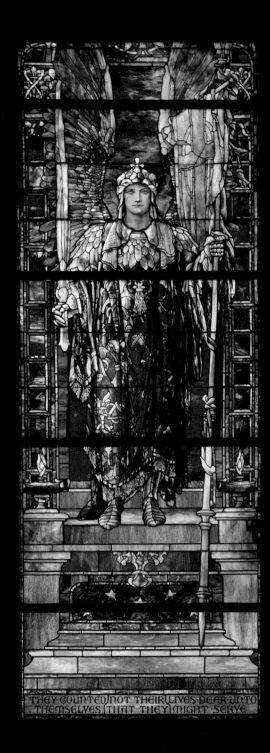

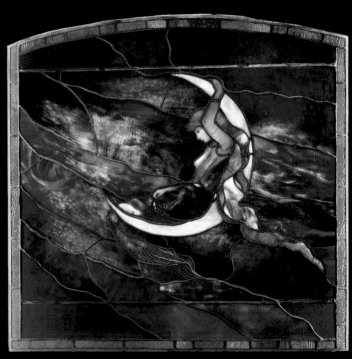

Masterpieces

I am always on the lookout for great works of art by Tiffany. When lit well, a stained-glass window can be incredibly powerful. Because light is transmitted through glass and not reflected off it, the window glows in a way a canvas never can. The light shifting within the various layers of glass has a soulful quality unmatched in other media. It creates a greater intimacy between the object and the observer.

I found one of the most powerful windows in my collection while vacationing in Colorado. It was so captivating I purchased it on the spot without even negotiating the price.

Today *Saint Michael*, an eighteen-foot window (FIG. 6), is on permanent display at my corporate office in the historic Ransom Cable House. It can be seen from the street and is one of the most significant pieces I own.

The Archangel, with his ruby-red garment, golden sword, and jewel-toned wings, commands every passerby's attention. This was most likely a memorial window for World War I as the epitaph below the image reads, "They counted not their lives dear unto themselves, that they might serve." It is one of the many devotional windows I have acquired.

After All Angels Episcopal Church in New York was demolished in 1979, I had the opportunity to acquire all ten panels of a marvelous series of ecclesiastical windows by Tiffany Glass & Decorating Company. Today, four of these are installed in the reception room at my office, bathing the space in warm gold tones (FIG. 8). The scene depicts the Christian soul ascending to Heaven. The angels have delicately painted faces and vestments of multicolored drapery glass against a mottled beige background. The tracery window is a brilliant cobalt blue.

Built in 1890 in the neo-Gothic style, All Angels united the work of some of the greatest designers and architects of the late nineteenth century. The *New York Times* described its interior as spectacular. All Angels served its community and congregation for nearly a century, and its demolition shocked the community and left a hole in history that cannot be replaced. I am privileged to be a custodian of some of its outstanding elements.

Another rare object in my collection, acquired at auction in 1998, is a candelabrum from the Tiffany Glass & Decorating Company chapel at the World's Columbian Exposition of 1892–93 (FIG. 7). I was interested because of its connection to Chicago and Tiffany's exquisite exhibition in the Manufacturers and Liberal Arts Building. It is thought to be one of just two medieval-style benediction candelabra. The chapel Tiffany created was said to be so powerful that men removed their hats as if entering a real church.

Preservation and Display

Thanks to the wide exposure and critical acclaim Tiffany received at the Exposition, the firm won a number of important commissions in Chicago. As David Hanks describes in his essay, these include the mosaic frieze in the superbly restored

FIG. 4 Alphonse Mucha, *Sarah Bernhardt in "La Samaritaine" at the Theatre de la Renaissance*, 1897. Lithograph, 68 x 23 in. (172.7 x 58.4 cm).

FIG. 5 Attributed to Louis Comfort Tiffany, *Woman on the Crescent Moon* window. Stained glass, 39 5/8 x 40 1/4 in. (100.6 x 102.2 cm).

FIG. 6 Louis Comfort Tiffany, Tiffany Studios, *St. Michael* window. Favrile glass, 216 x 57 in. (548.6 x 144.8 cm).

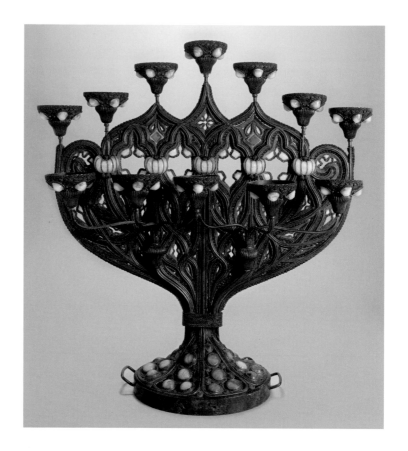

FIG. 7 Louis Comfort Tiffany,
Tiffany Glass & Decorating
Company, Candelabrum, 1893.
Bronze, molded glass, 47 x 44 in.
(119.4 x 111.8 cm).

FIG. 8 Louis Comfort Tiffany,
Tiffany Studios, *The Christian Soul
Ascending to Heaven* windows,
1900. Stained glass, 125 x 31 in.
(317.5 x 78.7 cm).

Marquette Building atrium, the so-called Tiffany Dome, actually vaulting, at
Marshall Field's (now Macy's) at State Street, the magnificent glass dome at the
Chicago Cultural Center (originally the Chicago Public Library), and the stained
glass dome in the Art Institute of Chicago's Fullerton Hall.

I collect with a passion for preservation, purchasing works that inspire, are
significant historically, or represent an important piece of Chicago. Rarely is an
object in the art market in perfect condition. Fragments or objects in need of
restoration might be imperfect, yet they are significant and worth saving. I see my
role as that of custodian. By placing these pieces into the skilled hands of conservators
for restoration, I am helping ensure their legacy for generations to come.

From the first year I began collecting, I have always preferred to simultaneously
use, live, and work with the art. Whether at Gilhooley's or in my home or office,
the turn-of-the-century windows, furniture, posters, and architectural objects
are the harmonizing finishing touch in a historic space. My neo-Romanesque
office in the Ransom Cable House was completed in 1886, and my Queen Anne–style
home in 1877 (FIGS. 9, 10).

But my interests are not just about historical accuracy. Artworks introduce and
encourage artistic expression. They deepen one's sense of place and identity within

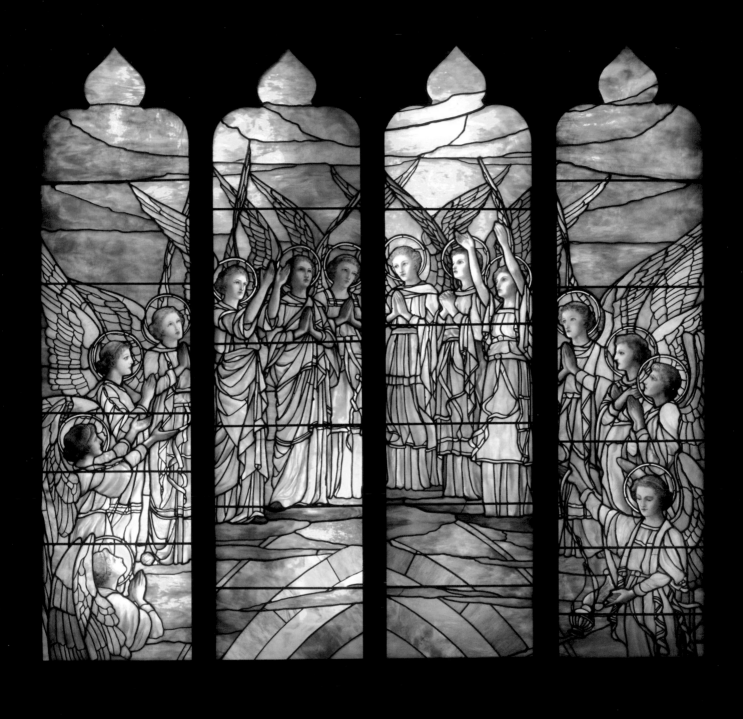

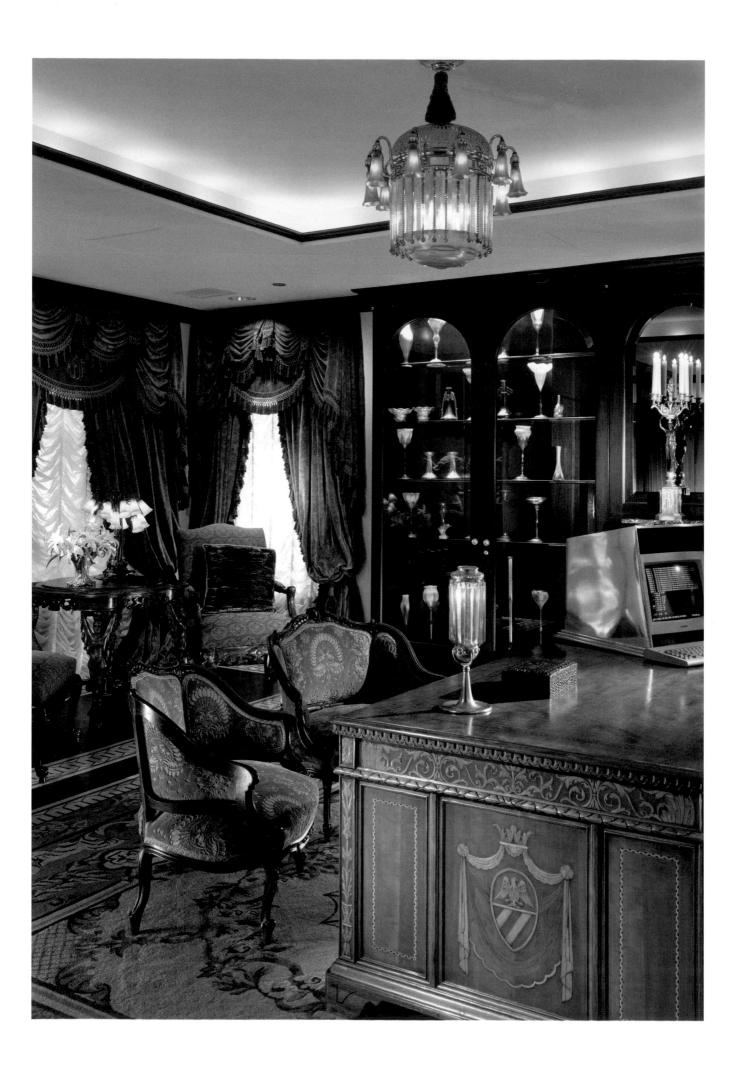

a wider context of time and culture. The Arts and Crafts, Victorian, and Belle Epoque styles of the late nineteenth and early twentieth centuries lend a charming warmth and comfort to breakfast at home, luncheons and teas, or dinner with family and friends. Rather than stowing away these objects in the name of perfection, never to be enjoyed, I believe the patina and nicks they acquire with age and use are part of what gives them their character.

My first opportunity to display a group of windows publicly came in the late 1990s. E. B. Smith approached me about his plan to display museum-quality stained-glass windows on Chicago's Navy Pier. I was inspired to join him in his endeavor, creating an adjacent gallery with eleven Tiffany windows and an impressive glass-and-wood fire screen (FIGS. 12, 13). Opened in 2002, the Richard H. Driehaus Gallery of Stained Glass has delighted countless visitors to Navy Pier, the top tourist and leisure destination in the Midwest.

In the process of designing the stained-glass gallery, it was crucial to select every detail in tandem with the artwork. I wanted an immersive environment—one that would draw in visitors and encourage them to stay. We dimmed the lights to allow

FIG. 9 Richard H. Driehaus office, Driehaus Capital Management LLC.

FIG. 10 Dining room of the Richard H. Driehaus residence.

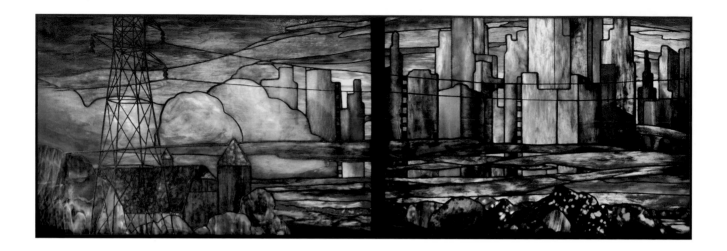

the glow of the stained glass to suffuse the room. Brief explanatory panels were backlit and a classical mood created that was enhanced by the choice of flooring and wall colors. As a special touch, we added Tiffany's signature in gold lettering on the floor. The sum of the architectural space, lighting, colors, and artworks mattered more than any individual element.

The first image greeting visitors to the gallery is a vibrant futuristic Chicago skyline, featured in a window commissioned from Tiffany Studios in the late 1920s by utilities magnate Sam Insull (FIG. 11). The work was an early acquisition of mine, purchased at the same auction as *Woman on the Crescent Moon*.

This window was originally displayed in his utility company in Joliet, Illinois, to commemorate the electrification of America. The foreground features the towers of the industrial plant and electrical transmission wires. Rural fields are in the middle ground, and a futuristic view of Chicago's developing skyline in the background. With its mottled and striated opalescent glass in mauve, blue, gold, and green, the window depicts the contrast between the rural past and future urban growth of America. It's a beautiful work. While it is based on a view of the city more than eighty years ago, the shape of modern Chicago is easily recognizable in it today.

A Collection Finds a Home

The Richard H. Driehaus Museum was founded in 2003 in the historic Samuel M. Nickerson House. It was a wonderful opportunity to take the immersion concept a quantum leap further. My association with the Nickerson mansion began in August 1994. I had just moved my office to the Ransom Cable House across the street and was celebrating that milestone.

At the time, the R. H. Love Galleries occupied the Nickerson House. The firm was offering a large bust of Abraham Lincoln for sale, and I asked my friend Reuben "Buzz" Harper, an interior designer from New Orleans, to come take a look

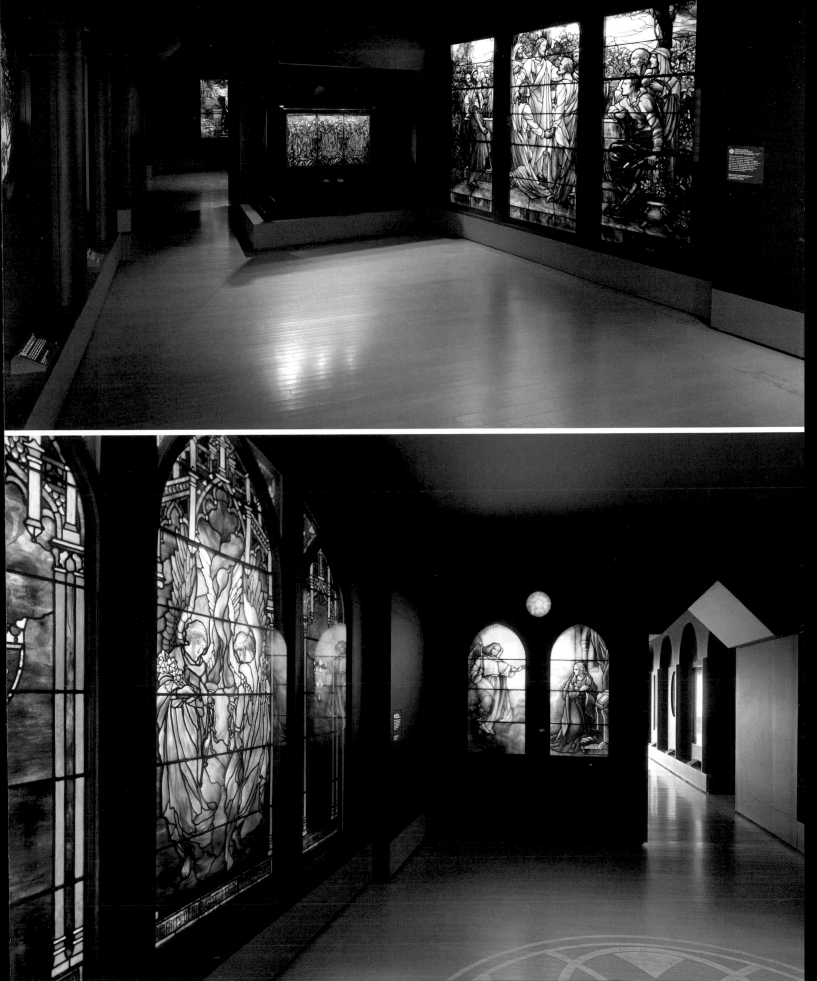

at the marble sculpture. Instead, he took one look at the Nickerson's grand lobby and emphatically said, "Richard, don't buy the bust. Buy the building!"

Eight years later, with my friend's suggestion still implanted in my mind, I approached the American College of Surgeons. They had owned the mansion for decades along with the adjacent Murphy Auditorium. The college kindly reviewed my request and even went as far as running it past then Mayor Daley for his blessing. Thankfully, both agreed I would be a worthy custodian. So began my role as a steward for preserving this magnificent building and the museum it would house.

By then my collection, with Tiffany as an essential core, had expanded to include decorative objects, furniture, and sculpture from late nineteenth- and early twentieth-century Europe and America. Featured are works by Louis Majorelle, Herter Brothers, Edward Colonna, Augustus Saint-Gaudens, Koloman Moser, Émile Gallé, and Josef Hoffmann. I agreed with Buzz. This palatial residence, which between 1883 and 1916 served as home to first a wealthy banker and then to a paper baron, would be the perfect context to display these artworks from the same period.

Restoration of the Nickerson House was masterminded by my good friend, Dr. M. Kirby Talley. Kirby's impeccable eye for detail and restrained hand

FIG. 14 Interior of the Richard H. Driehaus Museum.

created a feast for the senses that is about the overall environment and the space. He sensitively united the materials, objects, and finishes from the house and my collection and created a masterpiece. It was a monumental five-year journey that was life changing for both of us.

Opened in 2008, the Museum perfectly unifies my twin passions for architectural preservation and the decorative arts. It fulfills my goal to create an immersive experience (FIG. 14). The galleries, formerly the grand rooms in which the families entertained, illustrate the type of environment one might have experienced firsthand during the Gilded Age, with a Chickering & Sons piano, Tiffany fireplace screens, lamps, and Pre-Raphaelite Victorian paintings.

My first experience of visiting the restored building with the collections so carefully arranged was unforgettable and yet indescribable. It is this very ineffability that makes it truly special. The space is somewhat like a book one reads slowly while cherishing every moment spent inside the story. Guests do not walk briskly through the Driehaus Museum. They linger on every extravagant detail—whether a Tiffany chandelier, a suite of Herter Brothers furniture, intricate marquetry, stunning tile work, or richly designed fabrics.

As William Morris said, "These old buildings do not belong to us only; they have belonged to our forefathers and they will belong to our descendants. They are not in any sense our property to do as we like with. We are only trustees for those that come after us."

This exhibition, *Louis Comfort Tiffany: Treasures from the Driehaus Collection*, is the culmination of my thirty-five years spent collecting and admiring the artist's work. For the Driehaus Museum, the creation and subsequent opening of this first exhibition is a milestone, one that will deepen the visitor experience and further the Museum's mission to interpret and contextualize the decorative arts and prevailing design philosophies of America's Gilded Age.

This unique exhibition in an equally unique space showcases period works against elegant, immaculately restored historic interiors. Visitors will appreciate the work of Tiffany's firms in a context for which many of these objects were originally created.

I am delighted to exhibit a selection of Tiffany's works from my collection for the first time in Chicago, where private and ecclesiastical commissions of his firms' work were second only to those of his flagship city, New York. It has been a great pleasure to be involved in the creation of this exhibition and publication, selecting which treasures to share.

One should always strive to exceed expectations. I hope this exhibition, the first devoted solely to my collection, achieves this goal.

RICHARD H. DRIEHAUS

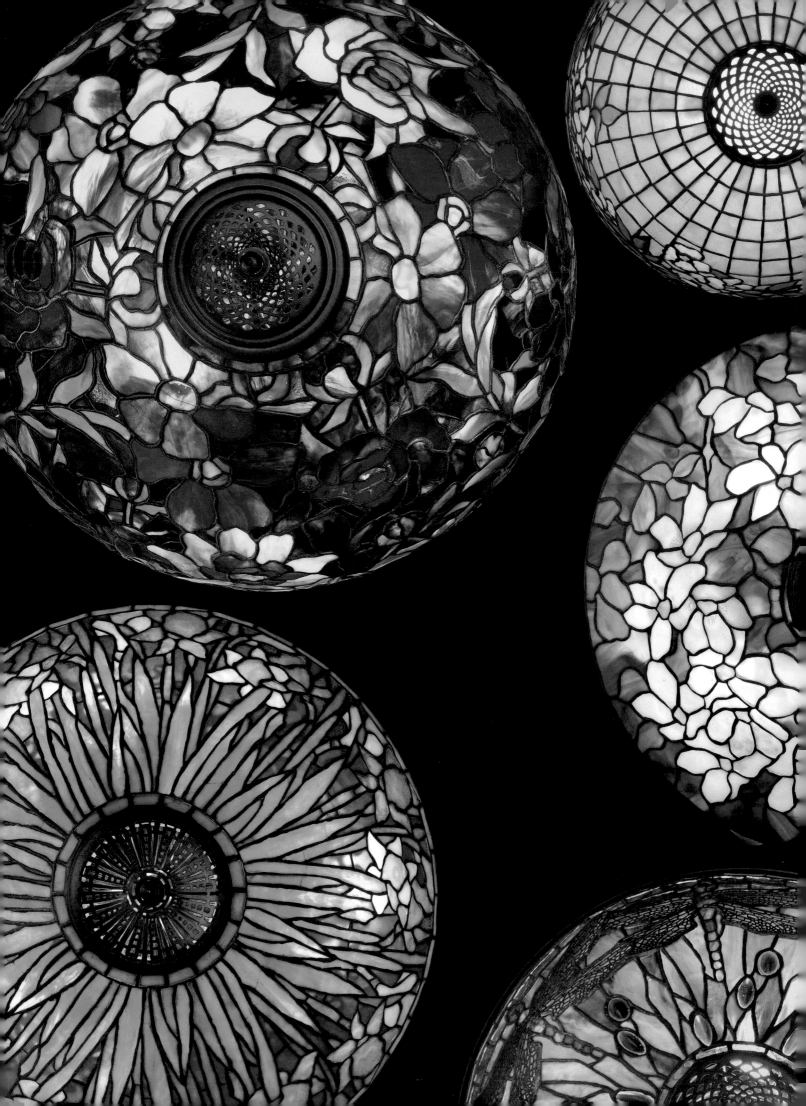

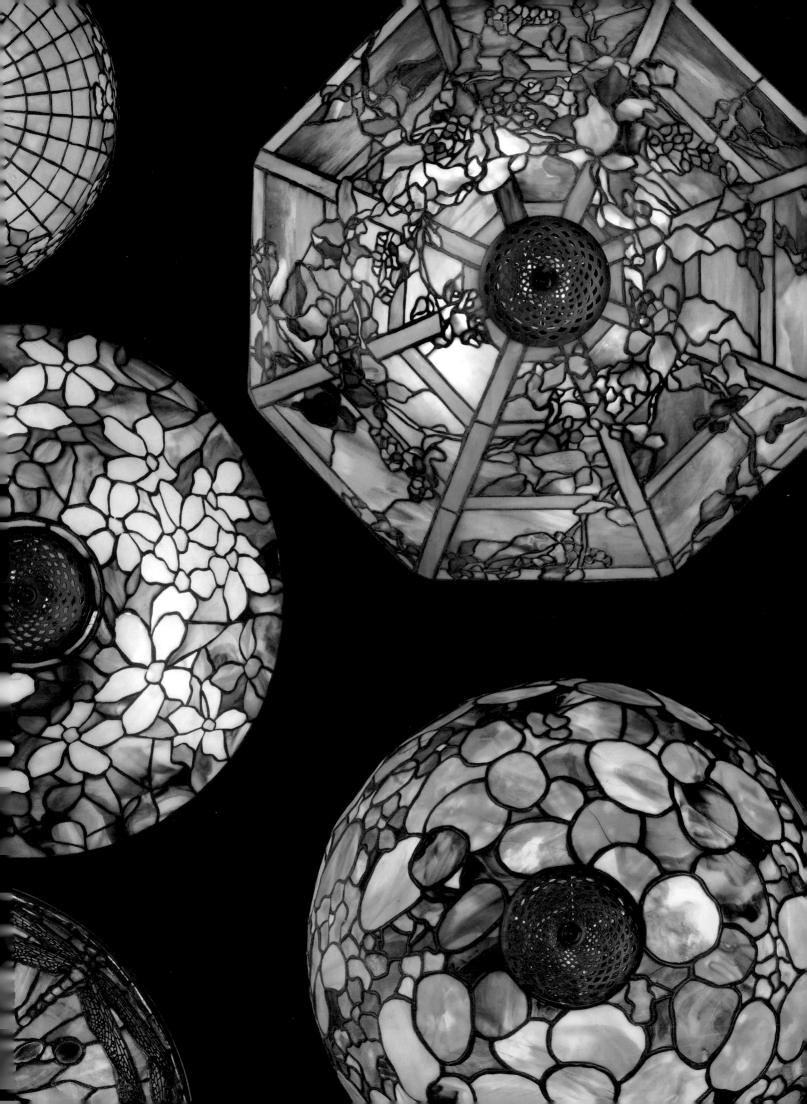

LOUIS COMFORT TIFFANY IN CHICAGO

Louis Comfort Tiffany (1848–1933) was an artist, interior designer, and decorative arts entrepreneur who had established an international reputation by the 1890s. A portrait of Tiffany by Joaquín Sorolla y Bastida in 1911 shows him at the age of sixty-three, with palette in hand, in his garden at Laurelton Hall, his estate in Oyster Bay, Long Island (FIG. 1). The brilliantly colored garden setting evokes his lifelong fascination with nature as an inspiration for his work. The interiors at Laurelton Hall, begun in 1902 and richly decorated with his creations and his collections of art and decorative objects spanning Eastern and Western cultures, sum up his design philosophy: "Nature is always right—that is a saying we often hear from the past; and here is another: 'Nature is always beautiful.'"[1]

The son of Charles Lewis Tiffany, founder of the luxury goods firm Tiffany & Co., Louis Tiffany developed his artistic sensibility at an early age through travel and study.[2] Initially uninterested in working for the family company, he decided to become an artist and, in early November 1866, began his career as a painter studying at the National Academy of Design in New York. Although he turned to designing interiors and various forms of decorative arts in the 1870s, his interest in painting continued throughout his life. He first toured Europe in 1865–66, and in 1868 he went to Paris to study under the painter Léon Bailly and was influenced by Bailly's orientalist canvases. From July 1870 through February 1871, Tiffany travelled extensively with the artist Robert Swain Gifford through North Africa and western Europe, and saw many things that influenced his work. In 1878, Louis C. Tiffany and Company was formed, with an address at the Bella Apartments at 48 East 26th Street, where Tiffany lived from 1878 to 1885. This was the first of a series of business ventures focused on interior decoration.[3] About 1880, Tiffany's artistic and business interests shifted to the design and production of decorative glass, and in 1885 he formed the Tiffany Glass Company.

A series of related firms that Tiffany founded in the 1890s reflected the expansion of his identity as an entrepreneur. In 1892, he formed Tiffany Glass & Decorating Company, and in late 1892 or 1893 established a glass furnace in Corona, Queens, where he made his own glass. The following year, he separated the glass-manufacturing in Corona from Tiffany Glass & Decorating Company and named it the Stourbridge Glass Company. Siegfried Bing, the tastemaker who would introduce Tiffany's glass and other work to Paris when he opened his shop in December 1895, described the success of the Tiffany enterprise in terms of its scale. Tiffany could be credited for the "establishment of a large factory, a vast central workshop that would consolidate under one roof an army of craftsmen representing every relevant technique: glassmakers and stone setters, silversmiths, embroiderers and weavers, casemakers and carvers, gilders, jewelers, cabinetmakers . . . united by a common current of ideas."[4] In 1898, Tiffany added lighting to his business, and in the following year he introduced enamelwork. In 1902 he changed the name Tiffany Glass & Decorating Company to Tiffany Studios. After his father's death in the same year, Tiffany became the art director for Tiffany & Co., but he continued to pour his energies into Tiffany Studios.

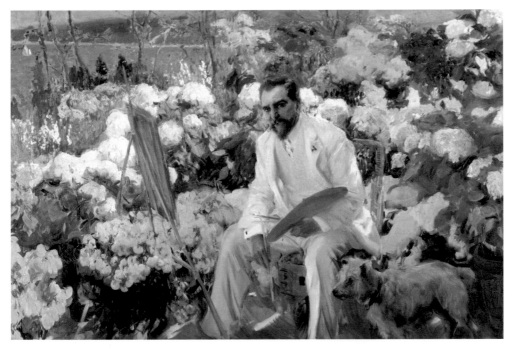

FIG. 1 Joaquín Sorolla y Bastida (1863–1923), *Louis Comfort Tiffany*, 1911. Oil on canvas, 59 1/2 x 88 3/4 in. (151.1 x 225.4 cm). The Hispanic Society of America.

FIG. 2 Louis Comfort Tiffany, Tiffany Glass & Decorating Company, Chapel at the World's Columbian Exposition, 1893. From *Architectural Record*, Jan–Mar 1896.

FIG. 3 Louis Comfort Tiffany, Tiffany Glass & Decorating Company, Chapel at the World's Columbian Exposition, 1893, as reassembled in the Charles Hosmer Morse Museum of American Art, Winter Park, Florida.

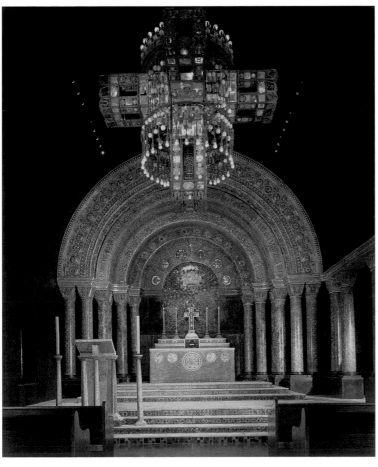

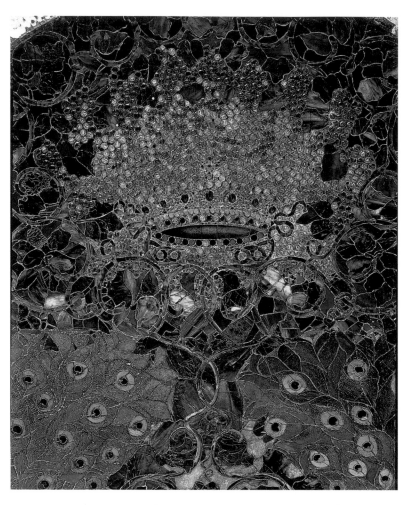

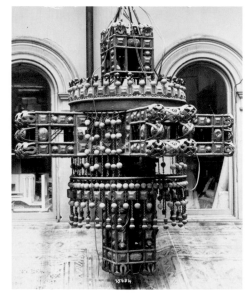

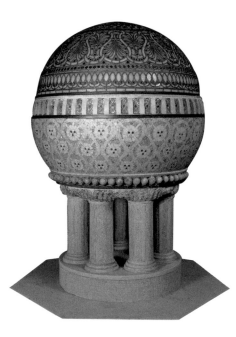

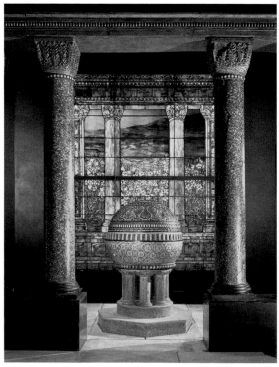

lthough the work of Tiffany Glass & Decorating Company has long been associated with New York, the firm opened an office in Chicago in the 1880s, possibly to take advantage of the business growth attending the decades-long rebuilding of the city after the Great Fire of 1871. Tiffany's work in Chicago is particularly distinguished for its extraordinary mosaics, though his output there reflected the overall range of objects intended for a wealthy clientele. The Lakeside City Directory of Chicago for 1884 lists "Louis C. Tiffany & Co." under "decorators," at the Central Music Hall. In the 1885 directory Louis C. Tiffany & Co. is again listed along with John C. Platt, the firm's treasurer.[5] In 1886, "The Tiffany Glass Co." is listed under "decorators" at a new address, 250 and 252 Wabash Avenue, again listing Platt as well. Tiffany's commissions during this period in Chicago have not been documented, but they no doubt included church interiors, a specialty of the firm, as well as residential work.[6]

In 1893, the Tiffany firm was poised to establish a major presence both in Chicago and internationally by creating a spectacular display at the World's Columbian Exposition. It may have been Siegfried Bing who persuaded Tiffany to exhibit at the exposition and to take over a portion of the space that his father had reserved for Tiffany & Co. in the Manufacturers and Liberal Arts Building.[7] Organized to commemorate the four-hundredth anniversary of the discovery of the New World, the Chicago Exposition became celebrated as the "White City" because of its Beaux-Arts-style buildings covered in chalky white plaster by Richard Morris Hunt, McKim, Mead & White, and other firms. But the centerpiece of the Tiffany Glass & Decorating Company exhibition was, in contrast to the Beaux-Arts classicism of the Court of Honor, a "Romanesque Revival" chapel with "Byzantine-style" mosaics designed by Tiffany himself and executed under his supervision (FIG. 2).[8] A June 1894 article in the *Chicago Daily Tribune* states that the chapel was purchased in 1894 for $50,000 by an anonymous widow.[9] She was later identified as Mrs. Celia Whipple Wallace, and, after some consideration, she donated the chapel to the Cathedral Church of St. John the Divine in New York. In 1916, Tiffany rescued his chapel, in poor condition after years of neglect, and brought it to Laurelton Hall. Today the chapel is installed at the Morse Museum of American Art in Winter Park, Florida (FIG. 3). An enormous electrified chandelier—a ten-by-eight-foot cylindrical and cruciform construction weighing about one thousand pounds—dominated the space (FIG. 5). The chandelier won an award for its imaginative adaptation of electricity. The altar was a simple rectangular form of white marble, covered in pale iridescent mosaics of Favrile glass, jewels, and mother-of-pearl. Behind the altar stood a mosaic-covered reredos (screen) in blues and greens depicting peacocks among vines, a favorite Tiffany motif as well as a Christian symbol of immortality (FIG. 4). Against the walls

FIG. 4 Louis Comfort Tiffany, Tiffany Glass & Decorating Company, Reredos for chapel. Favrile glass mosaic, 90 x 72 in. (228.6 x 182.9 cm). Charles Hosmer Morse Museum of American Art, Winter Park, Florida.

FIG. 5 Louis Comfort Tiffany, Tiffany Glass & Decorating Company, Electrolier in the form of a hanging cross for the Tiffany chapel. Cast Favrile glass and metal, 120 x 96 in. (304.8 x 243.8 cm), photographed in the firm's Fourth Avenue Studio before being sent to Chicago in 1892.

FIG. 6 Louis Comfort Tiffany, Tiffany Glass & Decorating Company, Baptistery as reinstalled at the Morse Museum. Charles Hosmer Morse Museum of American Art, Winter Park, Florida.

FIG. 7 Louis Comfort Tiffany, Tiffany Glass & Decorating Company, Baptismal font for the chapel, c. 1892. Marble, Favrile glass, and marble mosaic, 63 x 42 x 42 in. (160 x 106.7 x 106.7 cm). Charles Hosmer Morse Museum of American Art, Winter Park, Florida.

large-scale columns and round-headed arches were combined with colorful glass mosaic surfaces and stained-glass windows. Adjacent to the main space of the chapel was a baptistery (FIG. 6), composed of the same rich materials and including an imposing, spherical baptismal font, covered in mosaic and supported by eight columnar legs on an octagonal plinth (FIG. 7). Among the many works of art created for the chapel were candlesticks and a group of candelabra, one of which is now in the Driehaus Collection (CAT. 49). Tiffany also displayed two secular stained-glass windows in the so-called Dark Room, including *Parakeets and Gold Fish Bowl* (FIG. 8). Tiffany's daring techniques in stained glass, which he had developed simultaneously with John La Farge, are illustrated in this exposition window. In particular, the three-dimensional effect achieved through the use of opalescent drapery glass plated with layers of Favrile glass, as seen in the fishbowl, illustrate the extraordinary level of artistry in stained glass. According to the 1893 publication of the Tiffany Glass & Decorating Company: "We have placed in this room two windows which illustrate most perfectly the possibilities of American glass. In one window there is portrayed a number of paroquets resting upon a branch of a fruit-tree in blossom, from which is hanging a globe of gold fish; the effect produced is most realistic, and has been obtained without the assistance of paints or enamels, solely by using opalescent glass in accordance with the principles that govern mosaic work."[10]

The Romanesque Revival had been imported to Chicago in the 1880s, as seen in the chapel and in two major works by Henry Hobson Richardson: the Marshall Field Warehouse (1885–87) and the Glessner House (1886). This style was also adopted for Chicago's Protestant churches, with which Tiffany would already have been familiar from his earlier work. Decorating work for churches and the design and production of appropriate accoutrements remained Tiffany's main business throughout much of his career. It was therefore understandable that he would emphasize this aspect of his business in Chicago.

The importance of mosaics to Tiffany's chapel design and for the future of his company was outlined in the booklet *Tiffany Glass Mosaics*, which the firm published in 1896.[11] Tiffany had used mosaics in his early interiors, beginning in 1881 or 1882 with the main hall and stairways of the Union League Club, and he lavished them on the H. O. Havemeyer House in 1891–92.[12] The historic designs of Ravenna and San Marco were among the many inspirations for his modern creations. Bing wrote that, during his travels, Tiffany was deeply impressed by "the sight of the Byzantine basilicas, with their dazzling mosaics, wherein were synthesized all the essential laws and all the imaginable possibilities of the great art of decoration."[13]

Tiffany's mosaics were made using a combination of squares and pieces cut into special shapes. He "increased the color range and created illusionistic effects through his developments in colored and textured stained glass . . . to produce a wide range of colors within the glass itself . . . Semitransparent glass backed with metallic foil added the depth and brilliance of reflected light."[14] According to *Tiffany Glass Mosaics*, during production of a Favrile glass mosaic, the face of the mosaic was

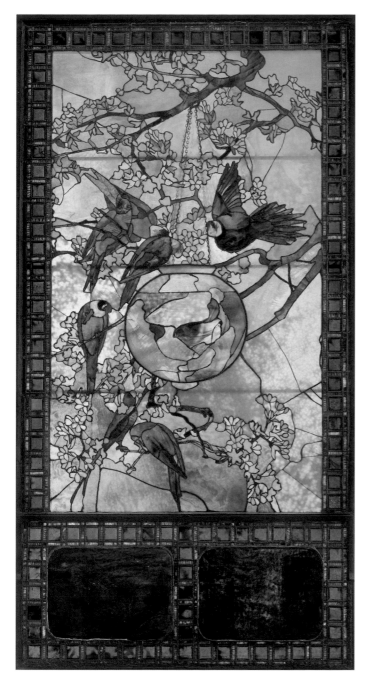

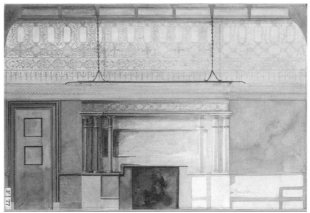

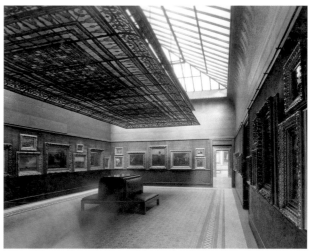

FIG. 8 Louis Comfort Tiffany,
Tiffany Glass & Decorating Company,
Parakeets and Gold Fish Bowl window,
c. 1892. Stained glass, 77 x 38 ¹/₂ in.
(195.6 x 97.8 cm). Museum of Fine
Arts, Boston, 2008.1415.

FIG. 9 Louis Comfort Tiffany,
Tiffany Glass & Decorating Company,
Design for Henry Field Memorial
Gallery at the Art Institute of Chicago,
c. 1893–94. Watercolor, pen,
and silver, metallic inks and graphite
on paper, 20 ¹/₄ x 13 ³/₄ in. (51.4 x
34.9 cm), The Metropolitan Museum
of Art. Purchase, Walter Hoving
and Julia T. Weld gifts and Dodge
Fund, 1967.

FIG. 10 Louis Comfort Tiffany,
Tiffany Glass & Decorating Company,
Henry Field Gallery ceiling, 1893–94.
Ryerson and Burnham Archives, The
Art Institute of Chicago.

always turned toward the artist so that every detail could be seen during the whole operation, correcting mistakes and making alterations "as the right setting of the tesserae [mosaic pieces] is the key which unlocks their full color values in their relation to one another and to the light."[15]

According to a reviewer in 1893, the Tiffany Glass & Decorating Company presentation at the Chicago exposition demonstrated the firm's virtuosity and range, which included "frescoes, mural paintings, colored glass windows, marble and glass mosaics, wood carving and inlaying metal work, embroideries, upholsteries and hangings."[16] The exhibition showcased its line of ecclesiastical wares, from mosaics, stained-glass windows, and furniture to clerical vestments. The popularity and success of the Tiffany exhibit could be measured by attendance (1.4 million visitors) and awards (forty-four medals). It was a critically acclaimed triumph for the recently formed Tiffany Glass & Decorating Company. The investment paid off handsomely: Tiffany won a series of important Chicago commissions immediately following the exposition.

The first of these came in 1893–94 from the Art Institute of Chicago to create a gallery in its recently completed museum building, designed by the Boston architectural firm Shepley, Rutan & Coolidge for the Columbian Exposition. Mrs. Thomas Nelson Page gave funds for the new space as a memorial to her first husband, Henry Field, who had died in 1890. The space, described in 1898 as "the finest public gallery in America,"[17] was planned to accommodate Field's much admired collection of French nineteenth-century paintings.[18]

Today the Field Memorial Gallery, which was dismantled in a 1950s modernization of the space, is known from a watercolor of an elevation of the gallery in the Metropolitan Museum of Art and a single period photograph (FIGS. 9, 10). The latter shows a handsomely decorated interior that was designed, at the donor's request, to reflect the original setting for the collection in the Field house at 293 Ontario, designed by Burnham & Root in 1881–82.[19] A contemporary observer described the gallery in the *Chicago Tribune* before the installation of the paintings. In its colors and materials the room must have been as opulent as Tiffany's chapel at the exposition: the woodwork was polished ebony with mother-of-pearl insets in the door and panels. The walls were covered with apple-green velour as a background for the paintings, which were to be hung from an ebony rail. A broad coved frieze, in tones "of yellow bronze shading to green," extended to the skylight. The dado was inlaid with glass mosaic above a polished ebony baseboard. The mosaic floor resembled a Persian carpet, with harmonious hues of green and yellow amid pale pink, red, and black stone.[20]

A large panel of ornamental Tiffany glass, thirty-four by fourteen feet, suspended above the room, allowed natural light from the building's peaked skylight to filter in, providing diffused lighting for the paintings. Electric lights were concealed above the panel so that the room could be illuminated artificially, as needed. The pattern of the panel was a carpet-like series of bands in multiple colors in keeping

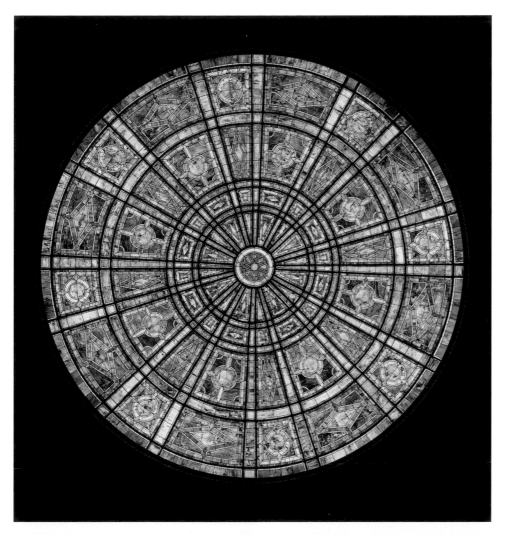

FIG. 11 Tiffany Glass & Decorating Company, stained-glass dome, Fullerton Hall Auditorium, 1898. Museum Archives, 00142738-01, The Art Institute of Chicago.

FIG. 12 Shepley, Rutan & Coolidge with Healy & Millet and Tiffany Glass & Decorating Company, Fullerton Hall Auditorium, 1898. Museum Archives, 00142738-01, The Art Institute of Chicago.

FIG. 13 Interior of Fullerton Hall, Art Institute of Chicago, after restoration by Weese Langley Weese, 2001.

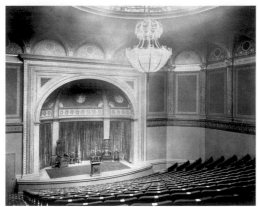

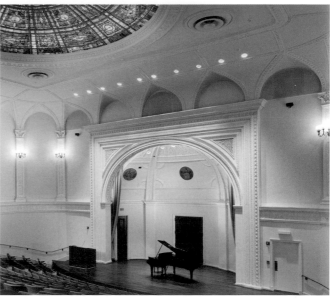

FIG. 14 Holabird & Roche, lobby,
Marquette Building, 1894–95.
Ryerson and Burnham Archive,
The Art Institute of Chicago.

FIG. 15 James A. Holzer, Tiffany Glass
& Decorating Company, *Offer of Peace*
mosaic, Marquette Building, 1895.
Inscription: "They answered that they
were Illinois and in token of peace
presented the pipe to smoke."

FIG. 16 James A. Holzer, Tiffany Glass
& Decorating Company, *Death of
Marquette* mosaic, Marquette Building,
1895. Inscription: "To die as he had
always asked in a wretched cabin amid
the forest destitute of all human aid."

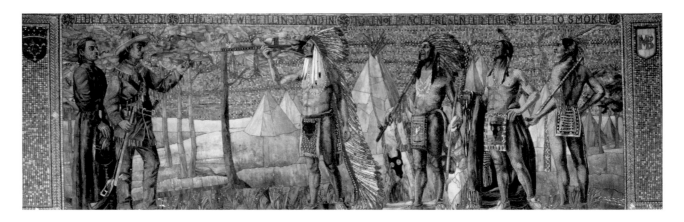

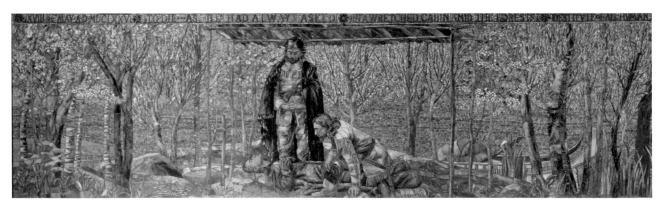

with those of the room. A fireplace was flanked with polished ebony chimney corner seats and surrounded by a mosaic of bronze-colored glass. Four ebony pillars on either side, with capitals of bronze set with semiprecious stones, supported an ebony canopy edged with jewel-like pieces of pale glass.

The three horizontal divisions of the walls—with frieze above and dado below—limited the installation of the paintings to the midsection where they were viewed at eye level, a modern concept, rather than stacked to the ceiling in the manner prevalent in the nineteenth century. In this regard, the Field Memorial Gallery resembled another Tiffany interior: the Veterans Room at the Seventh Regiment Armory, New York, of 1879–80 (see p. 131). Both have the same tripartite division of walls, each decorated in sympathetic low-relief patterns and muted colors, and each room is dominated by a large fireplace with lush mosaics. The room reflected the innovations of the Aesthetic Movement; it is not known how much of the Field design should be credited to the original interior on Ontario because the appearance of that room is unknown. According to contemporary accounts, the Field Gallery was arranged to Mrs. Page's specifications. It may also have been through her interest that, following the opening of the gallery in 1894, the Art Institute displayed Tiffany's glass: "A large case of Favrile glass which has recently been placed in the upper corridor of the Art Institute is attracting much attention. It was made under the personal supervision of Louis C. Tiffany and some of it is exquisite in color and form."[21]

In 1898, Tiffany Glass & Decorating Company received a second commission from the Art Institute for the dome of Fullerton Hall, an auditorium designed by Shepley, Rutan & Coolidge (FIGS. 12, 13) and built in what had been an open courtyard off the museum's main entrance. A gift from Charles W. Fullerton in memory of his father, the auditorium was a neo-Renaissance design, loosely adapting the wall treatment of the Piccolomini Library in Siena, Italy. The interior decoration represented a collaboration of three firms: while the architects were responsible for the blind-arched walls, Healy & Millet of Chicago was responsible for the interior color scheme of red panels against olive-green walls,[22] and Tiffany furnished the green and gold opalescent glass skylight, which survives today (FIG. 11), as well as the brass and crystal electrified chandelier, the fate of which is unknown. The total was a harmonious interior created by the two design firms working closely with the architects of the hall, probably represented by Charles Coolidge.

The success of the much-admired mosaics in the chapel at the Columbian Exposition led to three magnificent installations of Tiffany glass mosaics in Chicago that survive to the present day. These were secular and unapologetically gorgeous. Two were designed by Jacob A. Holzer (1858–1938), a Swiss artist who immigrated to the United States in 1875, and worked for the sculptor Augustus Saint-Gaudens in 1881 and 1882 and with John La Farge from 1882 to 1886. At the end of the decade and in the 1890s Holzer worked both independently and on staff for Tiffany, and he became Tiffany's chief designer in 1890, heading the

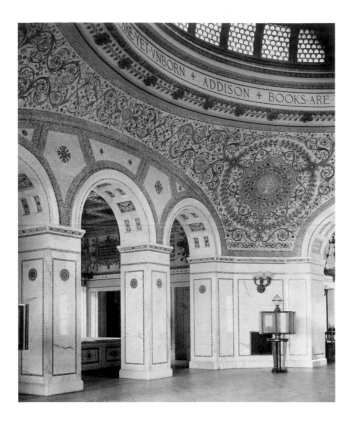

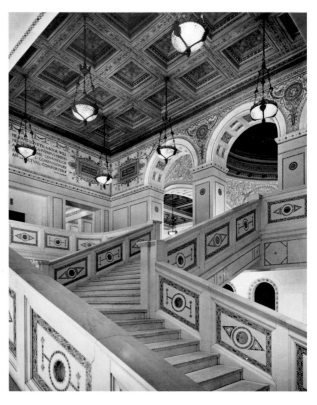

mosaic workshop.[23] Holzer's skillful service to the Tiffany Glass & Decorating
Company can be seen in the mosaic frieze in the lobby of the four-story atrium of
the Marquette Building, a prestigious business address at 140 South Dearborn
Street, designed by Holabird & Roche in 1894 (FIG. 14). In contrast to the office
building's straightforward facade of Chicago-style steel-and-brick grid, the
four-foot-high Tiffany frieze surrounding the central hall is part of an elaborate
decorative scheme based on the explorations of Jacques Marquette, a scheme
suggested by Owen Aldis, one of the building's developers, who had translated
Marquette's travel journals in 1891. The decoration included bronze sculpture
and reliefs, all relating to the historic theme of the explorations of Marquette,
a Jesuit priest, and Louis Joliet, who recorded their travels through Illinois County
in 1674–75. Set off by hexagonal mosaic panels, the frieze depicts scenes of
the expedition in brilliant colors, all executed in Tiffany's workshop. The explorers'
meeting with Native Americans, for example, is illustrated in iridescent Favrile
glass and mother-of-pearl (FIG. 15). The figures and surrounding landscape are
detailed and realistic, while the teepees and the body of water in the far background
are more abstract. The third in the series illustrates the death of Marquette in a
glorious landscape of blooming trees by a river (FIG. 16). According to a contemporary
newspaper article, Tiffany exhibited the mosaic panels in New York before they
were shipped to Chicago: "A handsome historical frieze in glass mosaic was viewed
by a large number of people yesterday at the storerooms of the Tiffany Glass and

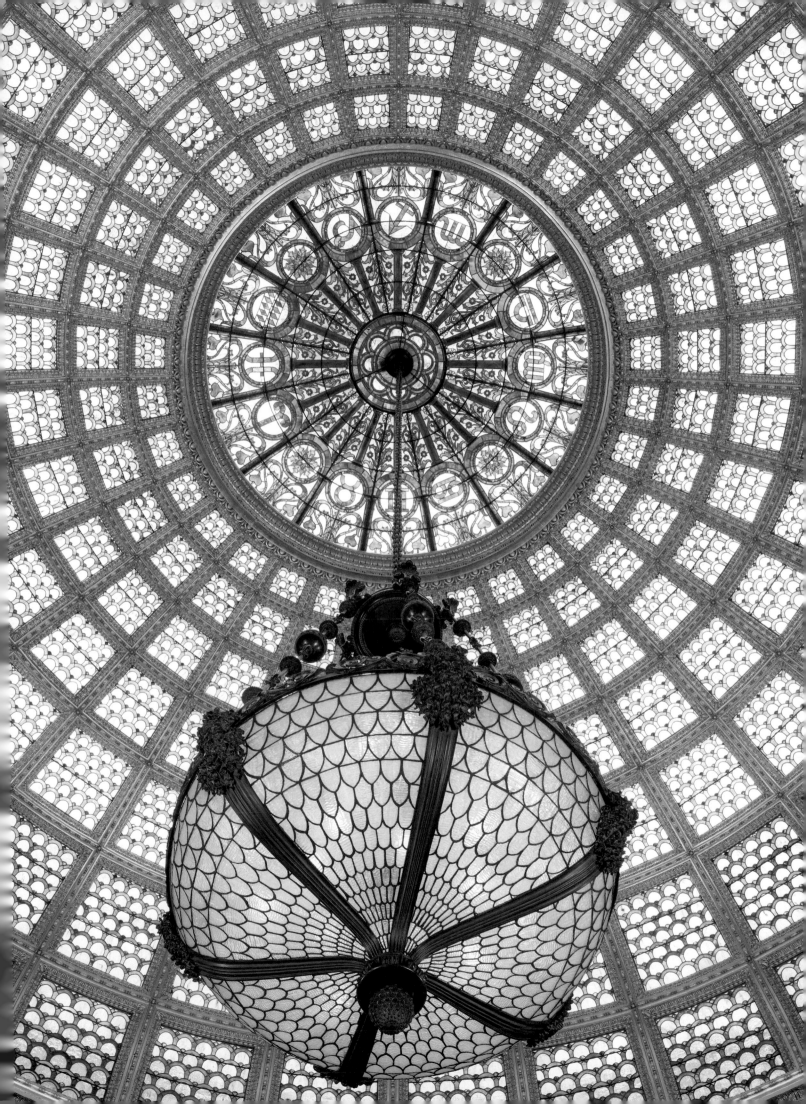

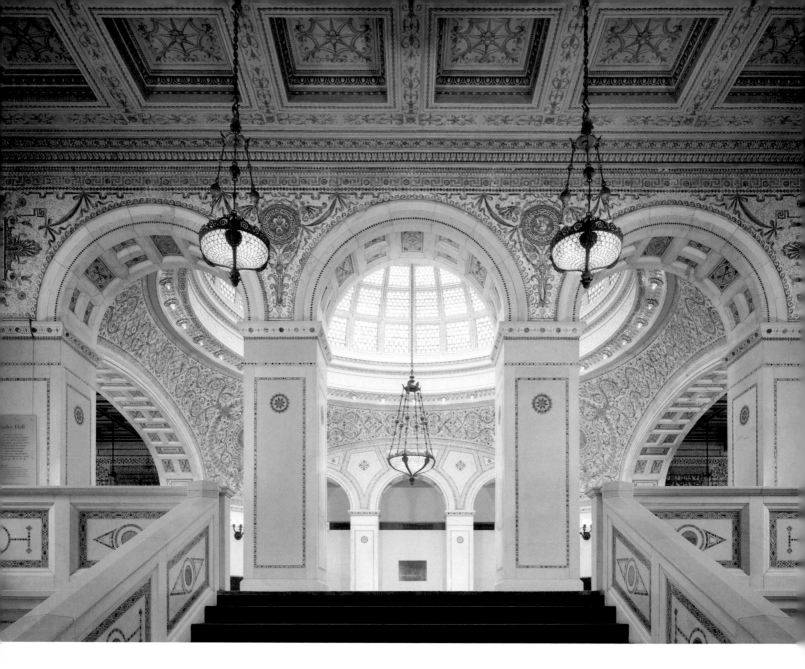

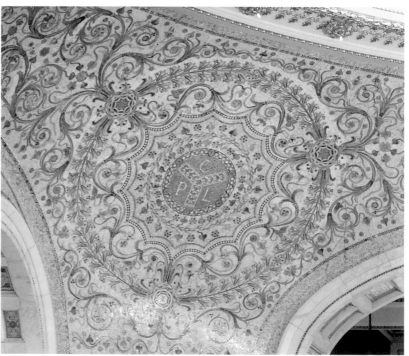

FIG. 20 Jacob A. Holzer, Tiffany Glass & Decorating Company, View of book delivery room from grand stairway, Chicago Public Library, 1897.

FIG. 21 Jacob A. Holzer, Tiffany Glass & Decorating Company, Mosaic detail, book delivery room, Chicago Public Library, 1897.

Decorating Company, 333 Fourth Avenue . . . It contains 200,000 pieces of glass and 10,000 pieces of pearl . . . J. A. Holzer designed the frieze, and a year was required in which to complete the work."[24]

Tiffany Glass & Decorating Company's best-known mosaic commission—also the work of Jacob Holzer—was for the Chicago Public Library (FIGS. 17–21). The impressive Beaux-Arts building at Michigan Avenue and Washington Street, designed by Shepley, Rutan & Coolidge in 1897, is the home of the Chicago Cultural Center today. Charles Coolidge was credited "for the design and construction of the building and for its decorations."[25] According to a contemporary article, the architect provided the plan for the interior and the Library Board put the project to bid. Tiffany Glass & Decorating Company made the most elaborate display and was awarded the contract for all the important interior decoration.[26] For the magnificent glass mosaics, which were very different in character from the Marquette mosaic work, Holzer worked in collaboration with Coolidge. The Marquette and Public Library mosaics reveal the different aesthetics that Holzer could apply in response to the collaborative nature of each Tiffany commission and to the different purposes of the buildings. The Marquette mosaics are illustrative and romantic in theme; the library's are neo-Renaissance and academic in the Beaux-Arts spirit. According to a contemporary magazine article, the reading room decoration was "a copy of the fine hall in the Ducal Palace of Venice."[27] The third-floor book delivery room of the library contains a spectacular Tiffany glass dome, also designed by Holzer. Elaborate mosaic decoration surrounds the dome, the delivery room, and the grand stairway, which was described in *Tiffany Glass Mosaics*: "White Italian veined marble is inlaid with a combination of glass mosaic, Royal Irish green marble and pearl. The color scheme is of J. A. Holzer. This is by far the most extensive piece of wall-mosaic work undertaken since the decoration of the Cathedral of Monreale, Sicily, in the 13th century."[28] Because the library faces the rail yards across Michigan Avenue, its mosaics served a functional as well as aesthetic purpose. According to a Tiffany Glass & Decorating Company advertisement of 1896, "In cities where a smoky atmosphere prevails the year round, and where the collection of soot and dirt soon dims all exposed surface, it becomes an absolute necessity to use some manner of decoration which may be of such character that occasional cleaning will renew all its original color and beauty. Glass Mosaic fills this exact condition, and furthermore, gives the most exquisite decorative effects."[29] The decorative themes in Holzer's mosaic designs include short texts in multiple languages, authors of an eclectic range of literature, and books of numerous cultures, reflecting the diverse ethnicities of the city's population. The Tiffany firm's magnificent dome was covered in the 1930s, when Tiffany's work had fallen into disrepair and was out of fashion, but it was restored in 2008.

The Grand Army of the Republic (G.A.R.), a fraternal order of Civil War Union veterans, had a series of rooms within the library building. The G.A.R. Memorial Hall was fifty-three by ninety-six feet with a thirty-three-foot-high ceiling—an enormous space opulently decorated in the neo-Renaissance style by Tiffany's firm (FIG. 23).

In contrast with the gold and white airiness of the library's welcoming stairway and delivery room, this room's dark, heavily ornamented sobriety suggests the solemnity of its purpose: it was intended to contain a collection of Civil War mementos.[30]

The choice of the same Boston architectural firm for the Public Library and the Art Institute buildings suggests the conservatism of Chicago's cultural leaders in the 1890s. Tiffany Glass & Decorating Company was identified with East Coast architects and and could successfully collaborate with them in Chicago. Tiffany kept up the firm's reputation for working there, as demonstrated by the inclusion of his designs in the Chicago Architectural Club's exhibitions at the Art Institute of Chicago. The eighth exhibition, in 1895, included four drawings by Jacob Holzer, one of them a "Young Indian, Mosaic Design," possibly a study for the Marquette lobby mosaic. For the ninth exhibition, in 1896, Tiffany exhibited designs for the G. A. R. Memorial Hall at the Chicago Public Library, along with a scale model of the room.[31] Three designs by Holzer for Tiffany Glass & Decorating Company were included in the tenth exhibition, and four by Frederick Wilson in the eleventh.

Tiffany's firm also received a commission from one of Chicago's leading department stores, where luxurious decorative schemes were designed to entice customers. Rivaling the Carson Pirie Scott Department Store of 1899 by Louis Sullivan was Marshall Field & Company. Marshall Field occupied buildings in the State Street area for decades, and, in 1907, opened two newly erected buildings, the first on Wabash and Washington Street and a separate Store for Men in a second building across Washington Street on State Street, both designed by D. H. Burnham & Company. Tiffany Studios was selected to decorate the arched and domed mosaic ceiling of the five-story atrium in the main retail store (FIGS. 22, 25). The elaborate vaulted design with interlocking ovals filled the entire surface, with brilliant blue sections in the three oval spaces at the very top. Massive semi-spherical glass light fixtures were suspended from the ovals.

Tiffany's second commission for Marshall Field was for the Men's Grille on the sixth floor of the Store for Men, including a fountain, stained-glass ceiling, and mosaic zodiac designs atop pillars (FIG. 24). A Tiffany Studios watercolor of this fountain, now in the Driehaus Collection, shows the design in plan and elevation (CAT. 42). The store's 1933 visitor brochure described the Tiffany fountain as "symbolizing the Court of the universe. The fountain itself suggests the earth as a great luminous ball rolling through space above the water, the multicolored glass dome overhead typifies the sun's rays broken into prismatic colors; and the ornamental forms of the signs of the zodiac, done in Tiffany mosaic, at the top of the pillars throughout the room, suggest the constellations of the universe."[32]

Maintained until the 1950s, the Men's Grille was a collaboration between Tiffany and the D. H. Burnham & Company architect, Edward Bennett, and is fully

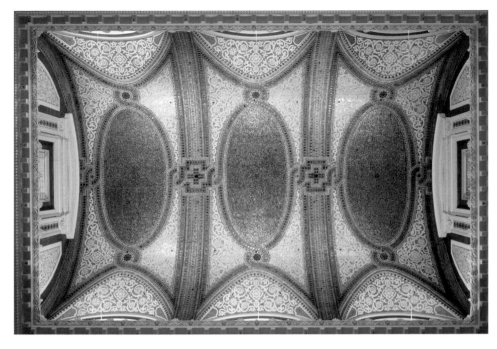

FIG. 22 Tiffany Studios, Mosaic ceiling, courtyard Marshall Field & Company, Chicago, 1907, depicted on a postcard. The Richard H. Driehaus Museum Archives.

FIG. 23 Tiffany Glass & Decorating Company, G.A.R. Memorial Hall, Chicago Public Library, 1898. From *The Inland Architect*, January 1898.

FIG. 24 Tiffany Studios, Men's Grille Room, Marshall Field & Company, Chicago, 1914. Photograph from Target Corporation.

FIG. 25 Tiffany Studios, Mosaic ceiling, Marshall Field & Company, Chicago, 1907.

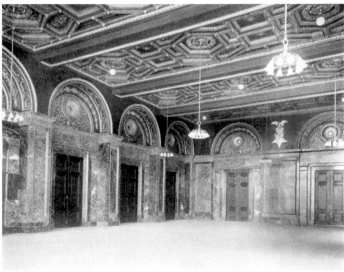

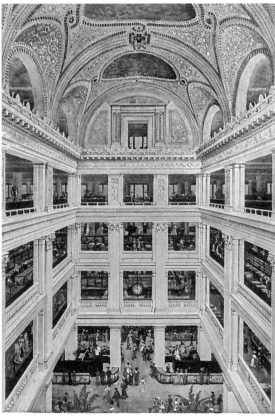

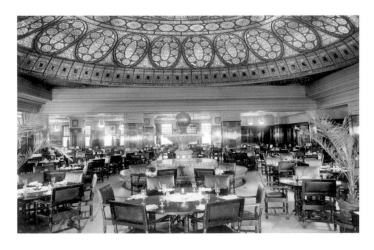

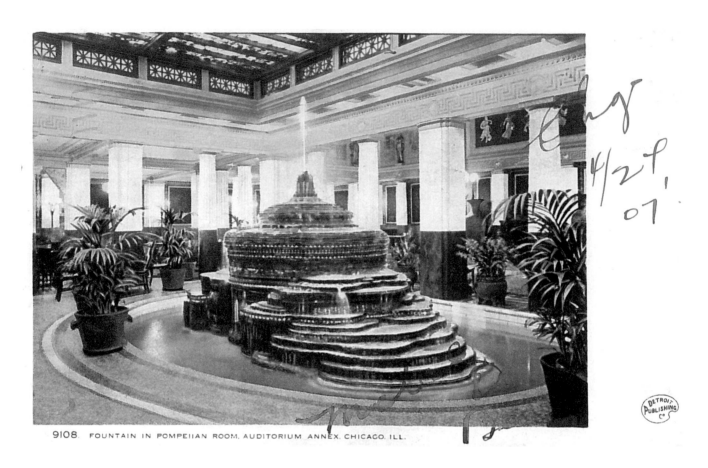

9108. FOUNTAIN IN POMPEIIAN ROOM, AUDITORIUM ANNEX, CHICAGO, ILL.

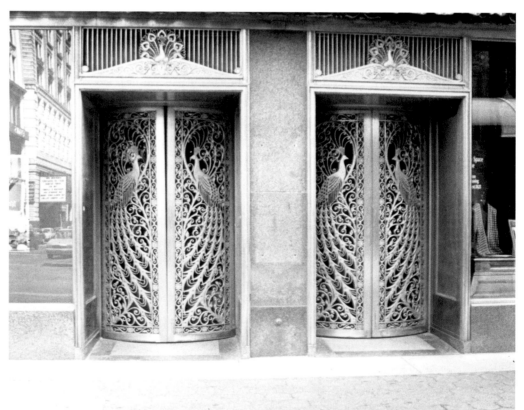

recorded in Bennett's diaries, rare documentation of the way Tiffany's firm worked with architects.[33] Bennett oversaw Tiffany's work on both the mosaic ceiling in the atrium and the fountain for the new Marshall Field State Street store. Bennett's diary entries between April 17, 1906, and September 30, 1907, reveal that such architectural commissions were collaborative and complex, and Bennett himself was as involved in the minute details of the design as the Tiffany Studios staff. On August 8, 1906, Bennett wrote that he worked with Tiffany on the design for the dome: "Several important changes were agreed especially regarding the width of rib-design of spandrels, etc." According to the diary entry of September 4, 1906, the lighting of the dome was discussed, and experiments were made with the mosaic. Bennett was convinced that a subdued lighting would be most successful. He was dissatisfied with the samples Tiffany completed for the mosaic dome because they did not meet his aesthetic standards. In a final entry on September 30, 1907, as the dome was unveiled, Bennett wrote of "Tiffany's disregard of architectural conditions and ignorance of proportion in form." His collaboration with the self-taught Tiffany may have frustrated the Beaux-Arts trained Bennett, but the mosaic dome has survived to the present, an impressive vision that still delights patrons in the main shopping court. In Tiffany's day, Marshall Field & Company was also an important retail outlet for his firm's products. Although O'Brien's Art Galleries, at 208 Wabash Avenue, displayed and sold Tiffany Favrile glass in 1896 and 1897,[34] by 1901, Marshall Field & Co. had become the Chicago agent for Tiffany.[35] In 1906, the department store announced a two-week exhibit of "Tiffany Glass, Metal, Lamps, Candle Sticks, et cetera."[36]

One of Chicago's leading hotels also commissioned the Tiffany firm to enhance its grand and luxurious interiors. The popularity of the Tiffany Glass & Decorating Company's exhibit at the 1901 Pan-American Exposition in Buffalo may have led to the installation of an astonishing Tiffany fountain from that exhibition in the new Pompeiian Room of the Congress Hotel at 520 South Michigan Avenue. This interior was the best known of a series of lavishly decorated rooms that graced the hotel's Auditorium Annex, designed by Holabird & Roche and completed in 1902. The Pan-American Exposition was notable for its brilliant electrical lighting, with energy provided from nearby Niagara Falls, reflecting the progress of science and technology. Tiffany's large Favrile-glass-tiered fountain was originally created for the Manufactures and Liberal Arts Building at the exposition, and its goal was evidently pure spectacle.[37] Electrically lighted from inside and from below, it resembled a futuristic sculpture in its undulating layers. In its new setting in Chicago, the fountain dominated the center of the room (FIG. 26), as it had in the exposition. It was described by a Chicago critic as a "weird and beautiful creation in myriad points of color, set by a most cunning craft in some kind of cement . . . the artist has endeavored to interpret in his material the beauty of the geyser pools of the Yellowstone."[38] Tiffany also provided a row of windows for the Pompeiian Room and an art-glass skylight, which, according to a contemporary account, was a marvel of beauty,

FIG. 26 Postcard of the Pompeiian Room Fountain. Congress Hotel, Chicago. The Richard H. Driehaus Museum Archives.

FIG. 27 Tiffany Studios, Peacock Doors, C.D. Peacock, Palmer House, Chicago, 1926–27. Chicago History Museum.

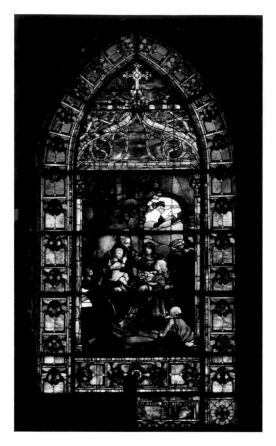

FIG. 28 Tiffany Glass & Decorating
Company, *Christ Blessing the
Little Children* window, 1893. Second
Presbyterian Church. Stained
glass, 16 ft., 5 in. x 8 ft. (4.9 m x 2.4 m).

FIG. 29 Tiffany Glass & Decorating
Company, *Jeweled Window*. 1895.
Second Presbyterian Church, Chicago.
Stained glass, 16 ft., 5 in. x 8 ft.
(4.9 m x 2.4 m).

"a glimpse of its purple, amber and green spanning the pool below is a recall to the vine-covered arbors and courts of the Campania."[39] The American critic Evelyn Marie Stuart wrote that the Pompeiian Room had been called the most beautiful room in America by Edward Burne-Jones, one of England's most important artists in the early twentieth century.[40] It is not known what became of the Pompeiian Room fountain. In 1942, the Congress Hotel was taken over by the U.S. Army and architectural features were sold off, which may have included the fountain.[41]

The last of Tiffany Studios' important designs in Chicago was in the Palmer House hotel at State and Monroe, also designed by Holabird & Roche and completed in 1927. In the street-level lobby was the shop of C. D. Peacock, a venerable and prestigious retailer of silver and jewelry. Here Tiffany used a literal trademark in the shop's stunning peacock entry doors, designed in 1926–27 (FIG. 27). Tiffany had employed the peacock, a favorite motif for its opalescent plumes and princely associations, in the mosaic designs for his own house, in the Havemeyer House, and in the chapel at the Columbian Exposition. Even without color, the peacock design is dramatic; the swooping paired peacocks are surrounded by a more classical pediment and frame. Of the three bronze peacock doors, two are in their original location today. The third door, originally the Monroe Street entrance of the store, is now within the Monroe Street entrance of the Palmer House.

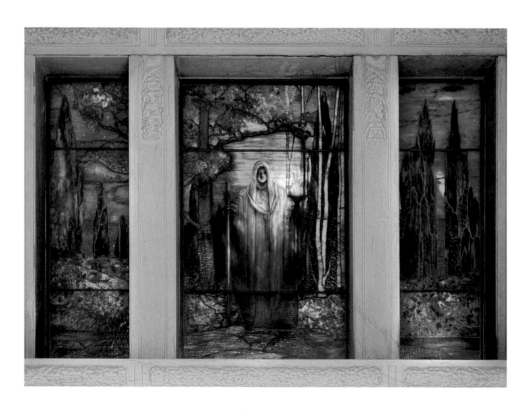

In the late nineteenth and early twentieth centuries, churches and mausoleums throughout the United States were adorned with stained-glass memorial windows. At the turn of the century, Chicago had a number of designers of stained-glass windows and a flourishing industry led by Healy & Millet. Other Chicago firms included Linden Glass Co. and Giannini & Hilgart. Tiffany competed with these firms for prized commissions, and some of his most important work was ecclesiastical. Particularly noteworthy in Chicago are Tiffany's windows for the Second Presbyterian Church at 1936 South Michigan Avenue, designed by James Renwick and completed in 1874. *Christ Blessing the Little Children*, 1893, is the earliest of ten windows by Tiffany in this building (FIG. 28). A more abstract design (FIG. 29) presents an elaborate jeweled cross above a cartouche with "IHS," representing the Greek words for "Jesus, God, Savior," against a ground of meandering vines and flowers, surrounded by multiple bands of geometric and floral designs. The combination of pinks, blues, and yellows in this 1895 window harkens back to stained-glass designs of the thirteenth century. This and the *Christ Blessing* window both survived a fire in 1900, which destroyed the church roof and much of the nave. The rich decorative scheme in the reconstructed church included twenty stained-glass windows, including two by Burne-Jones and eight by Tiffany.[42]

Of Tiffany windows for Chicago mausoleums, the *Angel of Truth* triptych for John G. Shedd is the most glorious, notable for its vibrant coloration and striking image (FIG. 32). A somber-faced angel stands in the center of a nighttime landscape, surrounded by silhouetted trees. Before its installation in Chicago, the Shedd window was exhibited at Tiffany Studios in New York, where it was described in the press: "The figure of Truth, emerging from a grove of cypress, dominates the composition. This figure has been carried out, without the use of lead support, by means of glass overlays which give it the requisite strength. There is a great depth of rich blues in the color scheme."[43] John Shedd was president of Marshall Field & Co. in 1907 (he served from 1906 to 1926), the year Tiffany's work was installed. The magnate's frequent meetings with Edward Bennett of D. H. Burnham & Company, as recorded in the Bennett diaries, attest to his close supervision of the Tiffany commission.

A Tiffany Studios watercolor in the Metropolitan Museum of Art is a design for a medallion window for the John B. Murphy Memorial Auditorium of the American College of Surgeons in Chicago (FIG. 30). It was rejected and the commission was given to Willets Studios, a competing Philadelphia firm.[44] The Tiffany submission with its Early Christian motifs may have been too ecclesiastical for the surgeons; the design that was selected and installed was neo-Renaissance and had no religious motifs. The subdued color scheme and geometric patterns reflect Tiffany's late conservative aesthetic.

Tiffany won his first fame in the United States in the post–Civil War period. He was a nineteenth-century artist who was inspired by nature and adhered to realism.

FIG. 30 Louis Comfort Tiffany, Tiffany Studios. "Design for medallion window for the American College of Surgeons, Chicago," c. 1923–26. Watercolor, graphite, ink, and gouache on paper, mounted on board, 27 ½ x 12 ¼ in. (69.8 x 31.1 cm). The Metropolitan Museum of Art, The Elisha Whittelsey Collection, The Elisha Whittelsey Fund, 1953 (53.679.1816).

FIG. 31 Frank Lloyd Wright, Window designed for the J. J. Walser House, Chicago, 1903. Leaded glass, 64 ¾ x 29 in. (164.5 x 73.7 cm). Richard H. Driehaus Collection.

FIG. 32 Tiffany Studios, John G. Shedd Memorial Triptych Window, *The Angel of Truth*, Shedd Mausoleum, Chicago, 1914. Stained glass.

He rejected the modernism that developed in the later period of his life, such as the art exhibited in the 1913 New York Armory show in New York. His realistically rendered and elaborately detailed windows were very different from the simple, abstract, geometric designs in the Midwest in the early twentieth century by such Chicago architects as Frank Lloyd Wright. A window from the J. J. Walser House of 1903 (FIG. 31) reveals Wright's geometric sense of design. Wright wrote, as if with Tiffany's windows in mind, "Nothing is more annoying to me than any tendency toward realism of form in window glass, to get mixed up with the view outside."[45] Wright's windows were to be integral to the architecture, while Tiffany created stand-alone works of art, more like easel paintings, often to be placed in existing buildings. Beginning around 1900, Wright introduced stylized floral designs, which became standard for "Chicago School" art glass.[46] These windows appeared to be appropriate for machine manufacture, but both Wright's and Tiffany's windows always required the work of skilled craftspeople. Wright also employed the casement window, allowing for more air and light to enter the room. Tiffany's fixed windows were translucent but never transparent.

Tiffany's fame and popularity had already waned before he died in 1933, and many of his creations are now lost to history. Three years after his death, the contents of his studio were auctioned outside the Tiffany Studios building on West 23rd Street in New York. Salvage dealers destroyed exquisite lamp shades, knocking them against the curb to separate the materials and retrieve the bronze for scrap.[47] The fate of Tiffany's glass ceiling panel in the Field Memorial Gallery at the Art Institute is unknown. Was it assigned to the dump or dismantled and sold to antique dealers? After being covered up for many years, Tiffany's glass dome for the Art Institute's Fullerton Hall was restored in 1999–2001, but the surrounding interior, to which the glass related, does not replicate the original scheme. The key to understanding such an interior is the overall harmony sought in the design: the wall colors should provide a setting for the glass and complement its colors, but today the glass dome floats without aesthetic connection to the room for which it was created.

Yet this infelicity is, fortunately, unusual in today's reverent treatment of Tiffany. After a period of obscurity and scorn for his work in the 1930s and 1940s, interest was rekindled in the 1950s and the admiration continues today, in particular for his extraordinary contributions in glass. Writing in 1955, Edgar Kaufmann Jr., the organizer of the Museum of Modern Art's *Good Design* exhibitions at midcentury, declared that Tiffany was "coming back into view after the double-eclipse he suffered from both ultra-conservative and ultra-modern tastes in the 1910s." He saw Tiffany's work as "challenging . . . his work stands against the current of modern design: for utility and the machine he gave not a fig."[48] As a curator for design at MoMA, Kaufmann collected Tiffany glass for the museum, as well as for his personal collection where he integrated it with modern interiors and furniture. It is hard to believe that there was a period when Tiffany was out of fashion, as popular as his work is with collectors and the public today.

NOTES

1. Louis C. Tiffany, "Color and Its Kinship to Sound," *The Art World* 2 (May 1917): 142.

2. For a thorough and insightful summary of Louis Comfort Tiffany's life and work in historic context, see Marilynn A. Johnson, *Louis Comfort Tiffany: Artist for the Ages* (London: Scala, 2005), 18–59.

3. For dating of events in Tiffany's life we have relied throughout on Barbara Veith, "Chronology," in Alice Cooney Frelinghuysen, *Louis Comfort Tiffany and Laurelton Hall*, The Metropolitan Museum of Art (New Haven: Yale University Press, 2006), 225-33.

4. Samuel [Siegfried] Bing, "Artistic America (La culture artistique en Amérique, 1895)," reprinted in *Artistic America, Tiffany Glass, and Art Nouveau* (Cambridge, MA: MIT Press, 1970), 146.

5. John Cheney Platt, Treasurer of The Tiffany Glass Company. "Art Notes," *The New York Times* (January 25, 1886).

6. "Chicago," *The American Architect and Building News* 50, no. 1037 (November 9, 1895): 67, mentions that Tiffany was decorating Christ Reformed Episcopal Church in South Chicago.

7. Robert Koch, *Louis C. Tiffany: The Collected Works of Robert Koch* (Atglen, PA: Schiffer, 2001), 61.

8. In keeping with atelier practice among architects and designers, Tiffany took credit for all productions generated by his firms, but recent scholarship has identified his various employees and the distinctions between their contributions and the degree of his supervision of them. For example, see Martin Eidelberg, Nina Gray, Margaret K. Hofer, *A New Light on Tiffany: Clara Driscoll and the Tiffany Girls* (New York: New-York Historical Society, 2007).

9. "Tiffany Chapel Comes to Chicago: It Has Been Purchased by a Widow for a Large Price," *Chicago Daily Tribune* (June 3, 1894).

10. A Synopsis of the Exhibit of the Tiffany Glass & Decorating Company in the American Section of the Manufacturers and Liberal Arts Building at the World's Fair, Jackson Park, Chicago, Illinois, 1893, with an appendix on Memorial Windows (New York: Tiffany Glass & Decorating Company, 1893), 8.

11. *Tiffany Mosaic Glass for Walls, Ceilings, Inlays and Other Ornamental Work* (New York: Tiffany Glass & Decorating Company, 1896), 21.

12. See Alice Cooney Frelinghuysen, "Louis C. Tiffany and the Dawning of a New Era in Mosaics," in Nancy Long, ed., *The Tiffany Chapel at the Morse Museum* (Winter Park, FL: Charles Hosmer Morse Museum of American Art, 2002), 41–70.

13. Bing, reprinted in *Artistic America, Tiffany Glass, and Art Nouveau*, 195.

14. Alice Cooney Frelinghuysen, *Louis Comfort Tiffany at The Metropolitan Museum of Art* (New York: The Metropolitan Museum of Art, 1998, reprinted 2006), 45.

15. *Tiffany Mosaic Glass for Walls, Ceilings, Inlays and Other Ornamental Work*, 19–20.

16. "Tiffany Glass and Decorating Company's Exhibit at the Columbian Exposition," *The Decorator and Furnisher* 23 (October 1893): 9.

17. *Brush and Pencil* 2, no 1 (April 1898): 2.

18. "Art Gems in Chicago," *Chicago Daily Tribune* (March 4, 1894).

19. The permit to build this house at this address was issued April 27, 1881, to Jonathan W. Brooks. According to the Chicago directory, in the following year Henry Field, who had been living in France, was living in this house (email from Lesley Martin, Chicago History Museum, to David A. Hanks, July 31, 2012). Tim Samuelson has pointed out that the Brooks house is listed in the Burnham & Root projects with a building date of 1883, and the house was demolished in 1979 (email from Tim Samuelson to David A. Hanks, August 20, 2012).

20. *Chicago Tribune* (August 12, 1894). I thank Tim Samuelson, Cultural Historian, City of Chicago, for alerting me to this article. Alice Cooney Frelinghuysen also gives a description of the room, based on the article, in "Louis Comfort Tiffany at the Metropolitan Museum," *The Metropolitan Museum of Art Bulletin* (Summer 1998): 22.

21. "Pictures by English Painters," *Chicago Tribune* (November 13, 1894): 3.

22. "Art," *The Chicago Tribune* (June 26, 1898).

23. On Holzer and Tiffany's use of mosaics, see Davida Tenenbaum Deutsch, "The Osborne, New York City," *The Magazine Antiques* (July 1986): 152–58. Also see Alice Cooney Frelinghuysen, "Louis C. Tiffany and the Dawning of a New Era for Mosaics," in Nancy Long, ed., *The Tiffany Chapel at the Morse Museum*, 41–69.

24. "A Handsome Frieze in Glass Scenes from the Travels of Marquette and Joliet Designed by J. A. Holzer," *The New York Times* (April 13, 1895).

25. N. Clifford Ricker, "Technical Review of the Chicago Public Library," *The Inland Architect* 30, no. 6 (January 1898): 3.

26. "Chicago," *The American Architect and Building News* 50, no. 1037 (November 9, 1895): 66.

27. "Chicago," *The American Architect and Building News* 50, no. 1037 (November 9, 1895): 66–67.

28. *Tiffany Glass & Decorating Company, Tiffany Glass Mosaics for Walls, Ceilings, Inlays, and Other Ornamental Work; Unrestricted in Color, Impervious to Moisture, and Absolutely Permanent* (New York: Tiffany Glass & Decorating Company, 1896), 22.

29. Tiffany company advertisement in *Chicago Architectural Club: Catalogue, Ninth Annual Exhibition* (Chicago: Art Institute of Chicago, 1896), unpaginated.

30. Ricker, "Technical Review of the Chicago Public Library," 14.

31. *Chicago Architectural Club: Catalogue, Ninth Annual Exhibition* (Chicago: Art Institute of Chicago, 1896), unpaginated.

32. Marshall Field & Co. visitor brochure, no date, Chicago History Museum Library.

33. Edward H. Bennett Collection, Ryerson and Burnham Archives, The Art Institute of Chicago. Entries dated August 8 and September 4, 1906, and February 20 and September 30, 1907.

34. The gallery advertised in *House Beautiful* 7, no. 1 (December 1899): 375.

35. Advertisement, *Chicago Tribune* (December 13, 1901).

36. The advertisement appeared in the *Chicago Tribune* (March 19, 1906): 9.

37. "Art Court at Pan-American," *The New York Times* (March 31, 1901).

38. "New Auditorium Annex," *The Inland Architect and News Record* 40, no. 6 (January 1903): 51.

39. "New Auditorium Annex," 51.

40. *Fine Arts Journal* (October 1917): 34, quoted in Robert Bruegmann, *The Architects and the City: Holabird & Roche of Chicago, 1880–1918* (Chicago: University of Chicago Press, 1997), 229.

41. Bruegmann, *The Architects and the City: Holabird & Roche of Chicago, 1880–1918*, 230.

42. Other Chicago churches with Tiffany windows include the Hyde Park Union Church at 5600 South Woodlawn Avenue. For a list of Tiffany windows in Chicago, see Alastair Duncan, *Tiffany Windows: The Indispensable Book on Louis C. Tiffany Masterworks* (New York: Simon & Schuster, 1980), 210–11.

43. "'Angel of Truth' by Louis C. Tiffany; John G. Shedd Mausoleum, Chicago Ill.," *New York Herald*, Section 3 (December 26, 1915): 12.

44. Alice Cooney Frelinghuysen, *Louis Comfort Tiffany at The Metropolitan Museum of Art*, 37.

45. "In the Cause of Architecture VI: The Meaning of Material—Glass," *The Architectural Record* (July 1928).

46. See Sharon S. Darling, *Chicago Ceramics & Glass: An Illustrated History from 1871 to 1933* (Chicago: Chicago Historical Society, 1979), 101–59.

47. See Martin Filler, "Iridescent Phoenix: The Tiffany Revival," in Marilynn A. Johnson, *Louis Comfort Tiffany: Artist for the Ages* (London: Scala, 2005), 98–107.

48. Edgar Kaufmann Jr., "Tiffany, Then and Now," *Interiors* 114 (February 1955): 84. Kaufmann added: "After forty years of stern modernity, we are again beguiled by one of art nouveau's most delightful talents," 83.

LAMPS

I n 1893, Tiffany established a glass works in Corona, Queens, and employed
Arthur J. Nash to manage it. Formerly manager and chief designer at Thomas
Webb and Sons at the Dennis glassworks near Stourbridge, England, Nash
immigrated to New York around 1890 and met Tiffany soon after. Nash was a
skilled manager and technician, expert in the chemistry of glass-making
and responsible for developing the formula for Tiffany's enormously successful
Favrile glass.[1] Like Clara Driscoll (who designed the famous Dragonfly lamp,
among many others), Nash shared Tiffany's artistic vision and reliance on the
forms and colors inspired by nature.

Tiffany's earliest lamp designs, in production soon after the World's
Columbian Exposition, were for fuel lamps with reservoirs for oil or kerosene,
which dictated the bulbous form of the base. Fuel lamps continued in production
along with electrified lamps as power gradually became available to American
households. Some later electric lamp designs retained the fuel lamp forms. New
lamp designs were introduced annually, and a numbering system was devised
to identify them.[2] Tiffany's production of table lamps began in earnest by 1899.[3]
The company published *Bronze Lamps* in 1904 and the Price List for lamps on
October 1, 1906, which provides a key to the numbering system for the lamp bases
and shades. According to the 1906 Price List, Tiffany Studios shades were
priced from $30 to $750, which today would be the equivalent of about $770
to about $19,200. In 1933, Tiffany Studios produced an illustrated catalogue of their
lamps with a price list.[4]

Tiffany's work in lighting began with his commissions for interior decoration in
the last quarter of the nineteenth century. While Tiffany's windows were most often
ecclesiastical, the lamps were primarily for residential use. Early examples of Tiffany's
lighting are seen in the hanging fixture in the drawing room of his own residence in
the Bella Apartments of 1879 (see p. 129) and in the Havemeyer House, completed in
early 1892, where each room had different lighting—chandeliers, table lamps,
and wall sconces. In the music room (see p. 131) there was a table lamp with a leaded-
glass shade and a magnificent hanging lamp with blossoms of Queen Anne's lace.
Tiffany also created enormous hanging fixtures, as seen in the chapel for the Columbian
Exposition (see p. 23), and stained-glass ceilings lit from above, as seen in the
Field Memorial Gallery (see p. 27), where Tiffany wanted to manipulate the light and
control its diffusion in an interior space, articulating the natural light in the room
with the new electric technology.

In 1885, Tiffany collaborated with Thomas A. Edison in creating the electric
footlights for the Lyceum Theater, New York, which was his first commission for
lighting and a project that bankrupted Louis C. Tiffany and Company within the
year.[5] The early industrial designers admired the exposed light bulb, a technological
wonder at that time, but in Tiffany's artistic approach, the lamps covered the bulb
and directed the light downward. The lamps took low-wattage bulbs for soft lighting
in the darkened interiors common at the turn of the century. The metal bases were
cast in bronze, to which patina was applied in varying shades of green and brown. Some
of these bases include insets of glass jewels or mosaic, adding to the complexity of the

View of Tiffany Furnaces in Corona,
(Queens), Long Island, New York.
From Tiffany Favrile Glass
brochure, 1905.

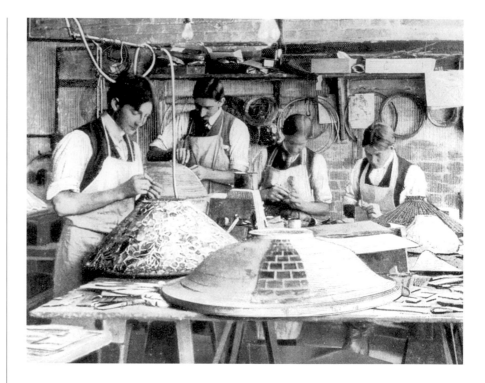

1. See Nash Papers in the Juliette K. and Leonard S. Rakow Research Library, the Corning Museum of Glass, New York.

2. See Martin Eidelberg, *Tiffany Favrile Glass and the Quest of Beauty* (New York: Lillian Nassau, 2007), 88–91.

3. See catalogue of lamps in *Lamps and Fixtures* (New York: Tiffany Glass & Decorating Company, 1899).

4. The photo catalogue of lamps is reproduced in Robert Koch, *Louis C. Tiffany: The Collected Works of Robert Koch* (Atglen, PA: Schiffer, 2001), 264–72.

5. Barbara Veith, "Chronology," in *Louis Comfort Tiffany and Laurelton Hall: An Artist's Country Estate* (New York: The Metropolitan Museum of Art; New Haven, CT: Yale University Press, 2006), 226.

6. See Martin Eidelberg, Nina Gray, and Margaret K. Hofer, *A New Light on Tiffany: Clara Driscoll and the Tiffany Girls* (New York: New-York Historical Society, 2007).

7. Eidelberg, Gray, and Hofer, 61.

design. Shades and bases were interchangeable, and most lamps were not unique since many models continued in production for several years.

Tiffany artisans assembled leaded-glass shades on wooden forms, based on patterns that indicated the arrangement of the glass. In the photograph above, the workman on the left is working on a floral shade. A domed shade in the foreground has geometric-patterned leading. The colors and kinds of glass selected varied depending on the sensibility of the artisan—Tiffany employed many women because he believed that their color sense was superior to men's. Craftspeople were usually not credited for their designs, and female workers received even less attention than their male counterparts.[6] Even Arthur Nash and Clara Driscoll were rarely acknowledged as designers.

Although some scholars have maintained that Tiffany's lamps were made from leftover pieces of stained window glass, recent research on Clara Driscoll proves otherwise. Among Driscoll's duties was supervising the selection and cutting of glass for lamps. "Typically, sheet glass was stored in the basement of the Manhattan building, and in one letter she referred to the problem of getting the glass from there . . . It is most likely that she normally went to the basement and selected the glass herself, even though the men carried it up to her studio."[7]

After 1910 the production of the lamps tapered off and the number of workers was reduced. Presumably production ceased prior to April 1932, when Tiffany Studios filed for bankruptcy, but the lamps were still being sold after Tiffany's death in January 1933.

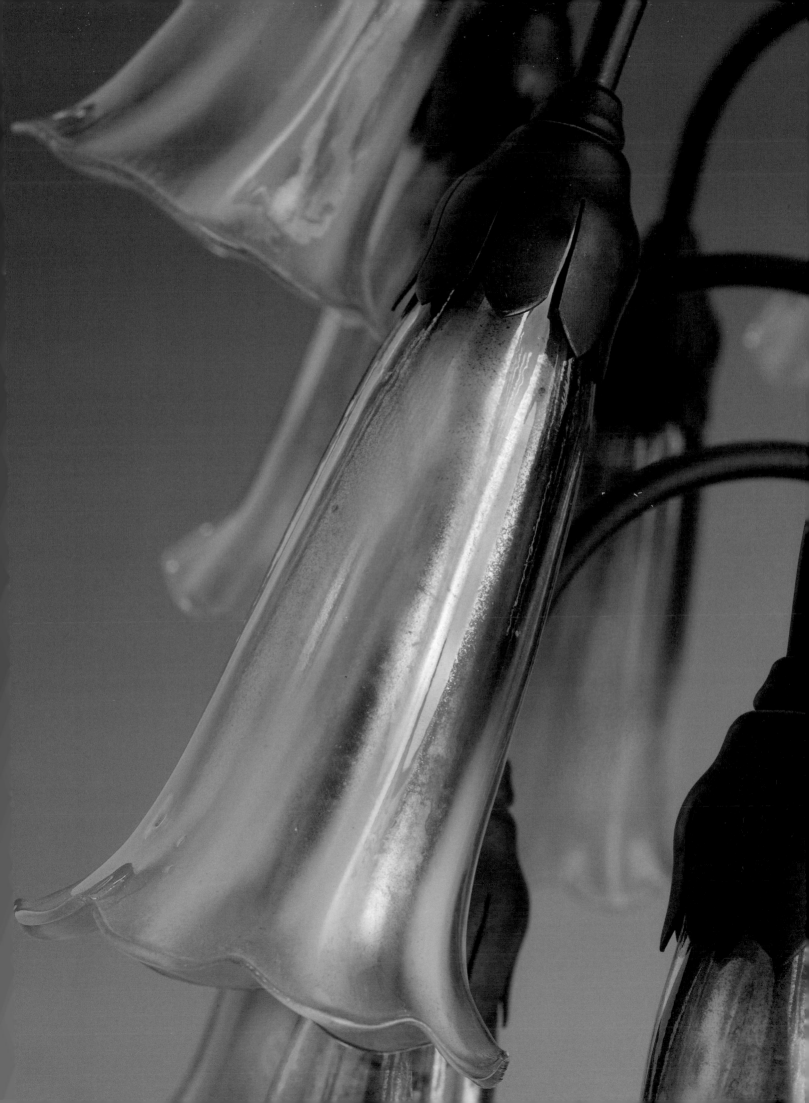

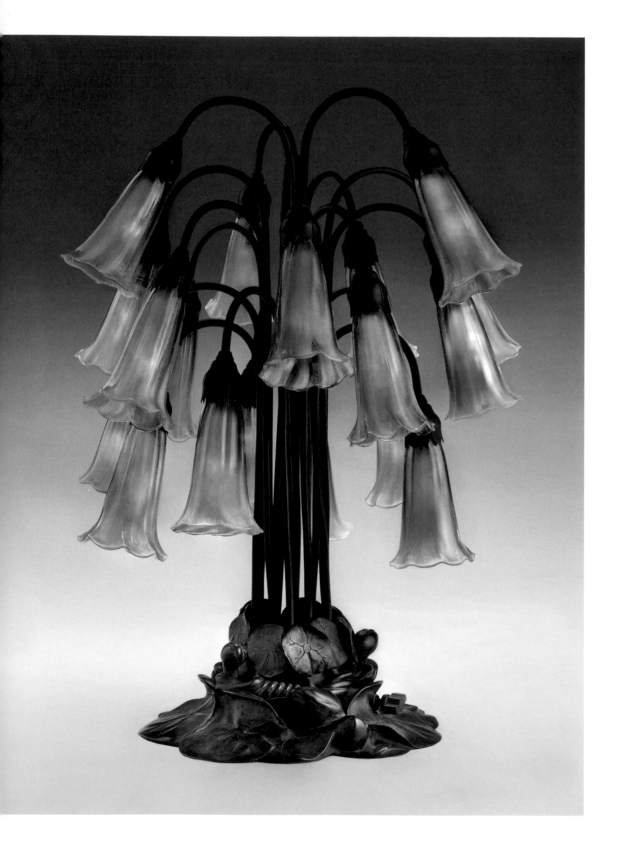

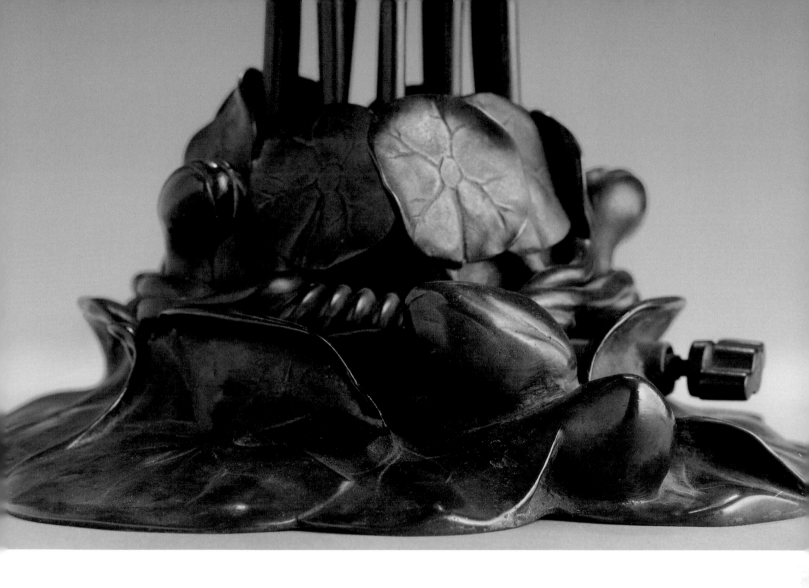

EIGHTEEN-LIGHT LILY TABLE LAMP

Prior to 1902
Bronze, blown glass
Height: 19 ¾ x 13 in. (50.2 x 33 cm)
Impressed on underside:
TIFFANY STUDIOS / NEW YORK / 1063 /
[conjoined monogram TGDCO]
Acc. no. 38103

The Lily lamp was one of the best known and successful of Tiffany's designs. The bronze Pond Lily base consists of a cluster of lily pad leaves from which stems of varying length grow upward, bending gracefully at the top to turn downward, terminating in delicate blossoms of glass. The lily shades are translucent amber trumpets accentuated with iridescent glass. This model was exhibited in Tiffany's display at the 1902 Turin Exposition of Industrial Arts, where it was noted that the electric lights, unlike fuel lamps, allowed the shades to point downward. The number of lilies on this type of lamp range from three to eighteen. A floor-lamp version was also produced.

Table lamps on view at the Turin Exposition of Industrial Arts, 1902. From *Arte italiana, decorativa e industriale,* 1902.

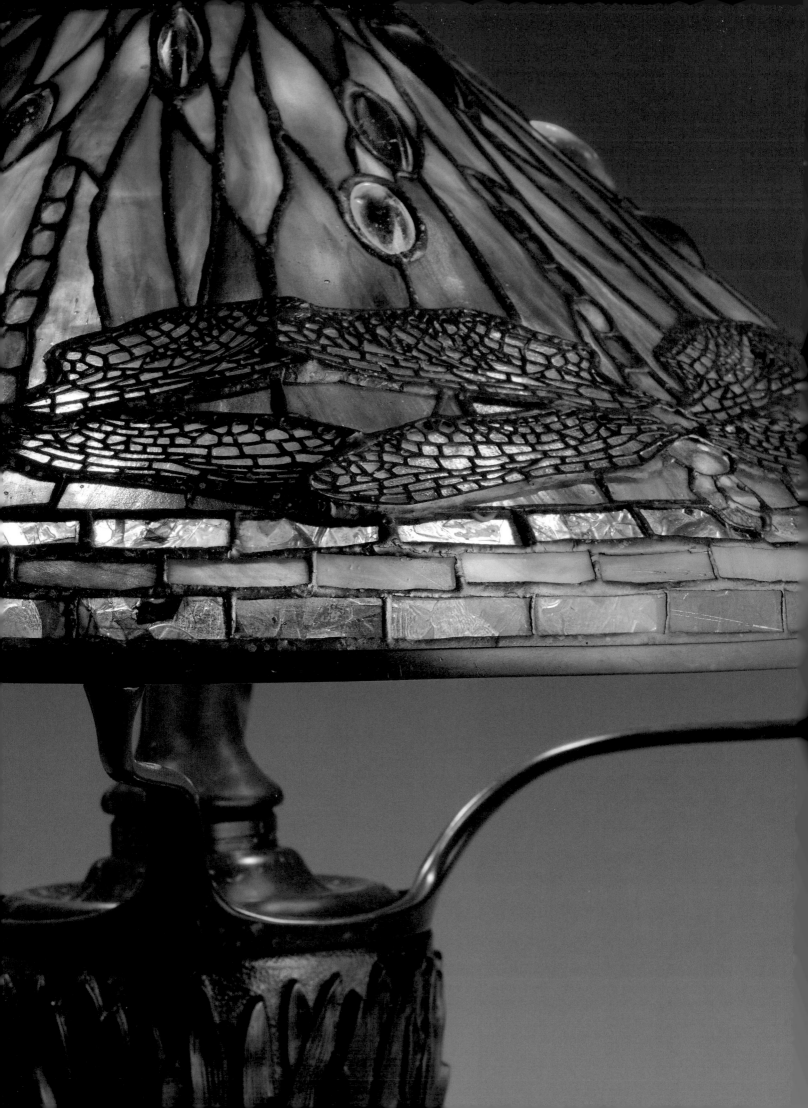

2

DRAGONFLY LAMP
c. 1902–6
Blown glass, patinated bronze
23 1/2 x 20 1/2 in. (59.7 x 52.1 cm)
Impressed on rim of shade:
TIFFANY STUDIOS / NEW YORK / 1495–41
Impressed on top side of base:
TIFFANY STUDIOS / NEW YORK / 225
Impressed on fuel canister:
TIFFANY STUDIOS / NEW YORK / 4739
Impressed on underside of base, at center: 2
Scratched on underside of base (possibly
later): LIV
Acc. no. 30017

Originally designed for oil or kerosene
with an oil–can insert, this lamp was later
electrified by Tiffany Studios. The cast–
bronze base is formed of sculpted cattail
plants rising from a bed of water–lily
leaves. The Dragonfly motif, one of Tiffany's
most popular designs, is credited to
Clara Driscoll. Here dragonflies with yellow,
green, and pink wings and bodies form
a band around the shade against a ground
of green leaves.

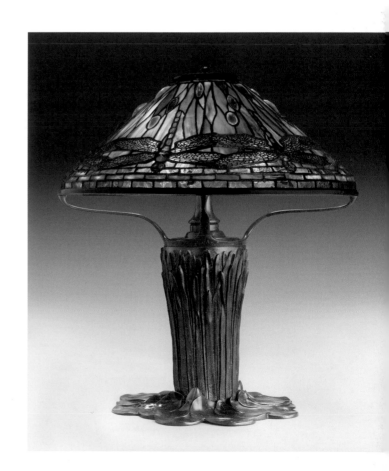

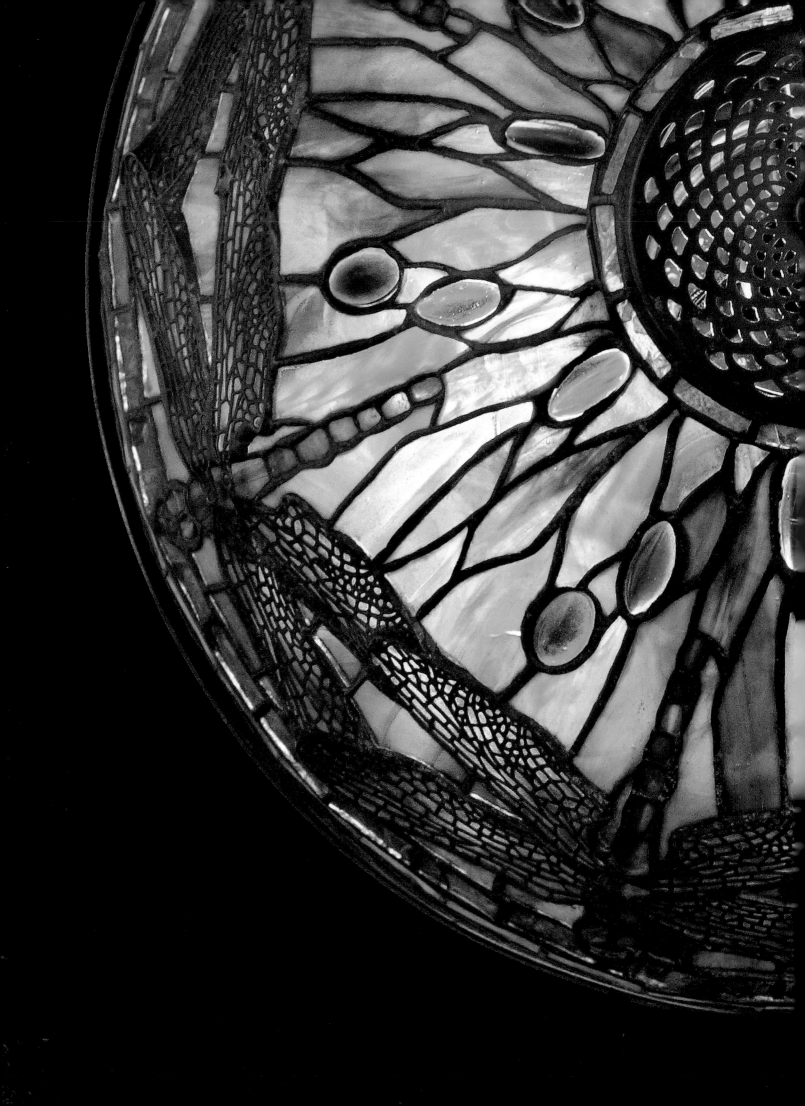

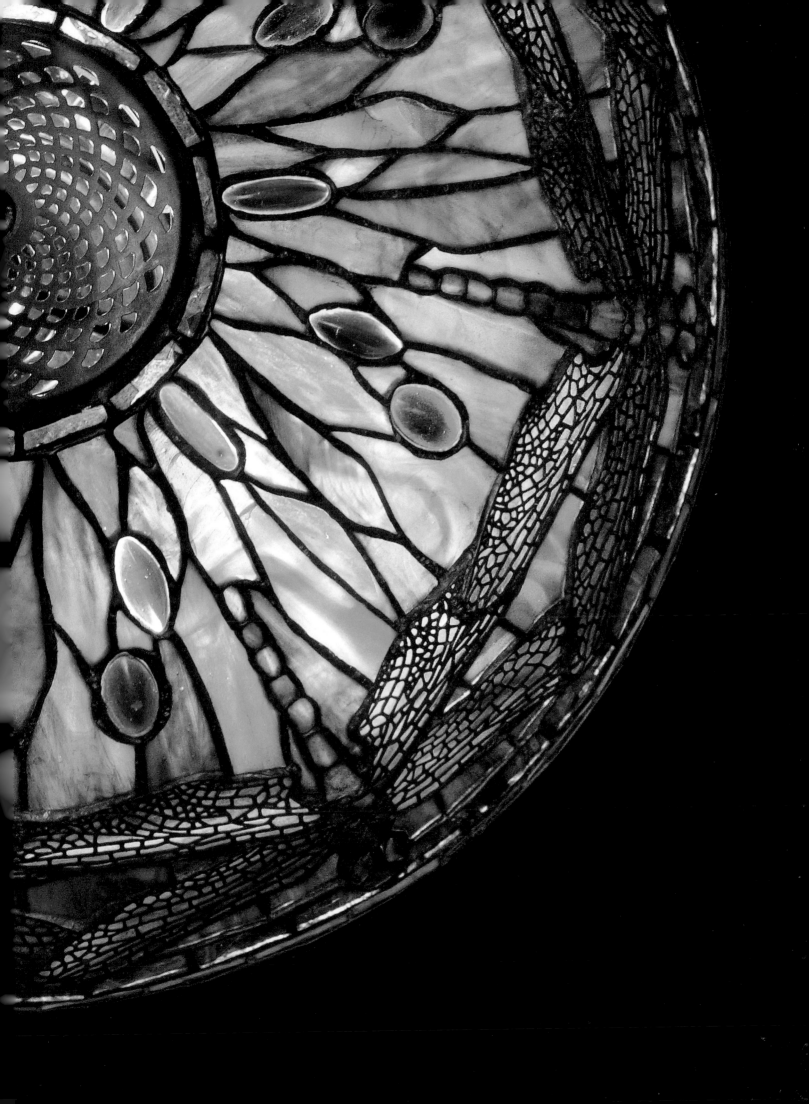

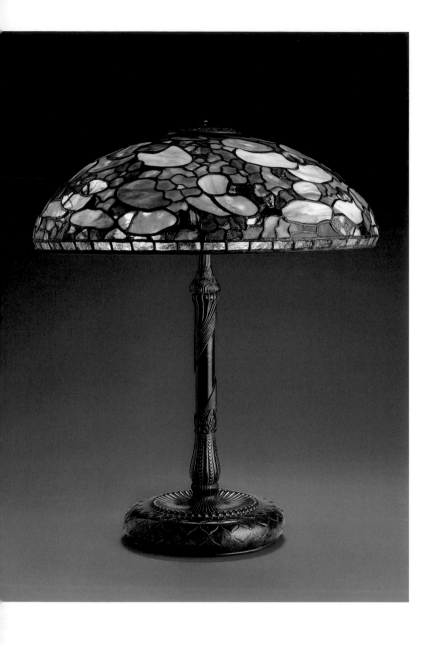

3

NASTURTIUM LAMP
c. 1910
Leaded glass, patinated bronze
25 1/4 x 20 1/2 in. (64.1 x 52.1 cm)
Impressed on shade (on added rim):
TIFFANY STUDIOS / NEW YORK /
Impressed on underside of base: 262
TIFFANY STUDIOS / NEW YORK /
Acc. no. 31122

A wonderful rich medley of confetti and
twig leaves are interspersed with five-
petal blossoms with mottled and striated
green leaves on a shallow domed shade.
In contrast to the organic floral design, a
geometric row of green and yellow glass
edges the shade.

4

OCTOBER NIGHT LAMP
c. 1910
Leaded glass, patinated bronze
27 3/4 x 25 in. (70.5 x 63.5 cm)
No marks
Acc. no. 30262

Branches of bittersweet with berries in a
variety of autumnal colors inspired the
name *October Night*. The foliage appears
to grow on both sides of the trellis that
determines the octagonal form of the
shade. A sample panel from this design
kept by Tiffany Studios is in the Morse
Museum in Winter Park, Florida.

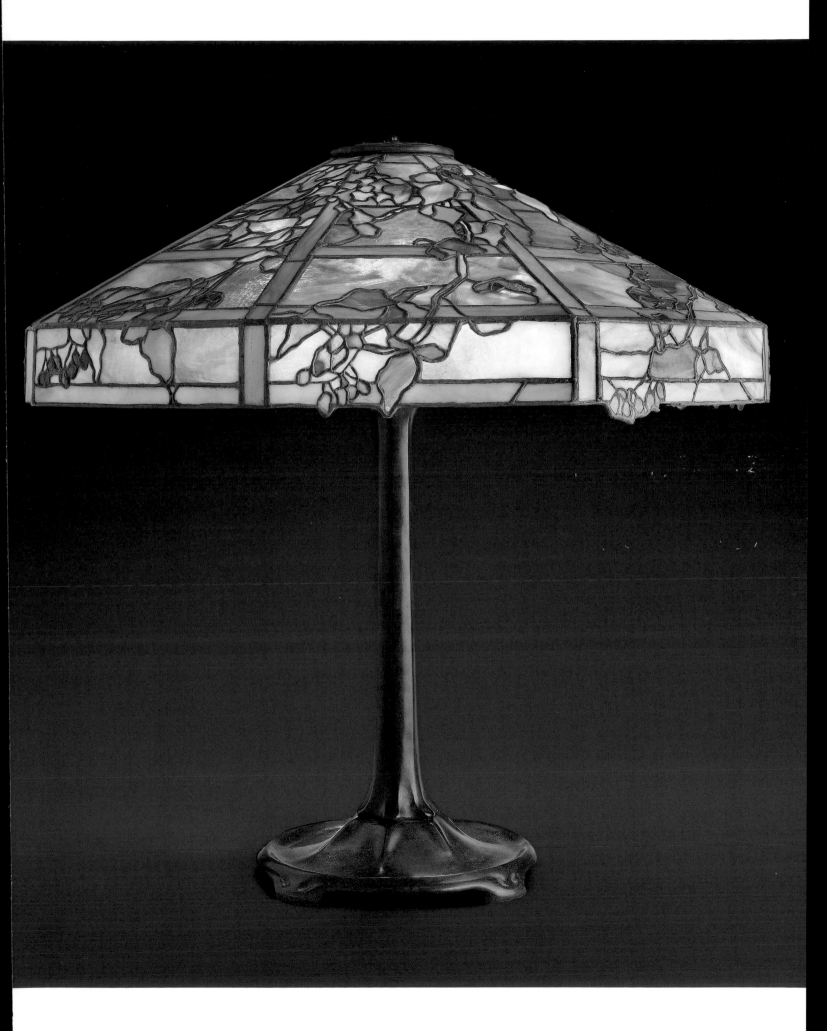

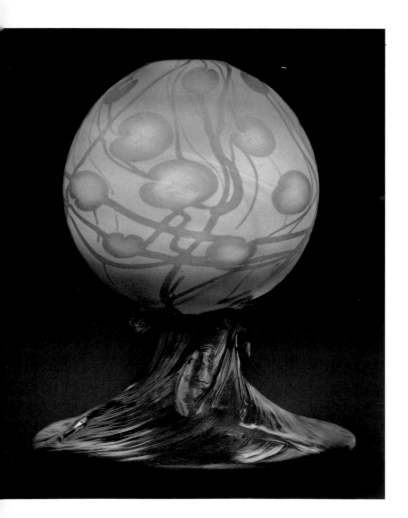

FISH AND WAVES LAMP
c. 1900
Blown glass, patinated bronze
17 1/2 x 16 in. (44.5 x 40.6 cm)
Impressed on underside of base:
TIFFANY STUDIOS GLASS NEW YORK
Acc. no. 31121

This lamp has an extremely rare and early
base with impressed fish swimming
against strong waves. An opening at the
top accommodates an electric bulb
socket. The waves crest at the top to
support the spherical yellow shade
with intertwined gold lily pads which
appear to float, complementing the
aquatic theme of the base. The base was
illustrated in periodicals as early as
1898 and appeared in the company's
1906 Price List.

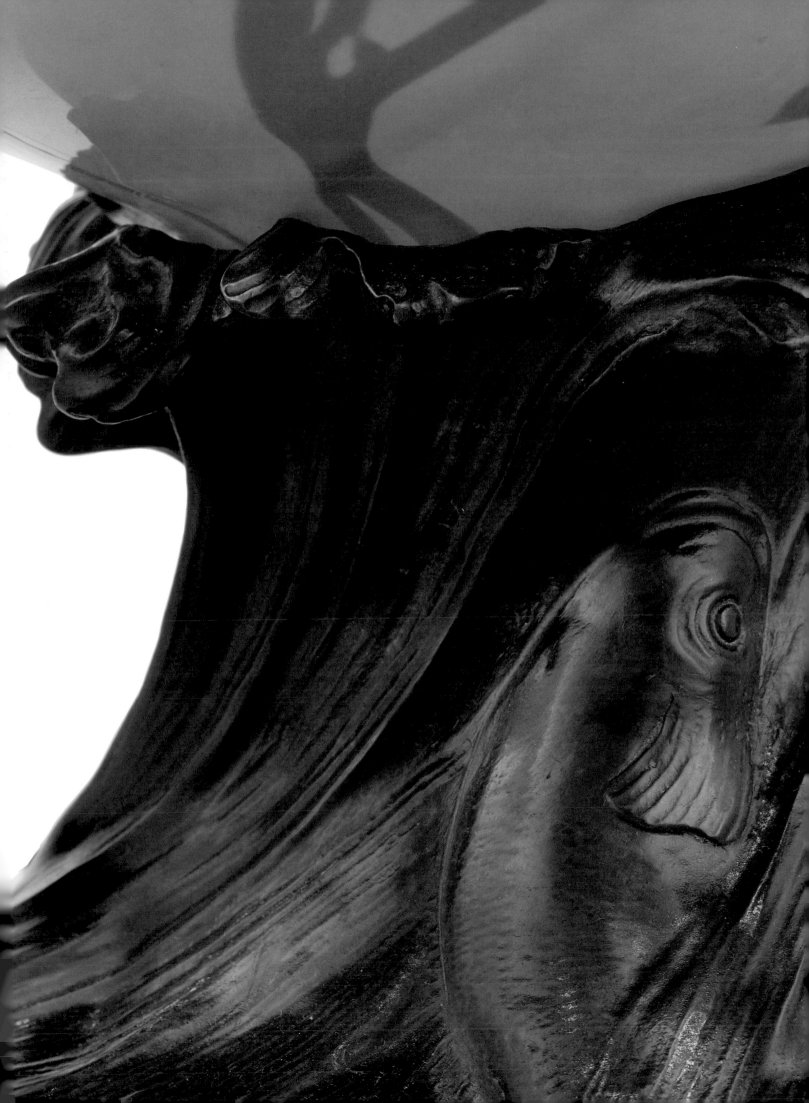

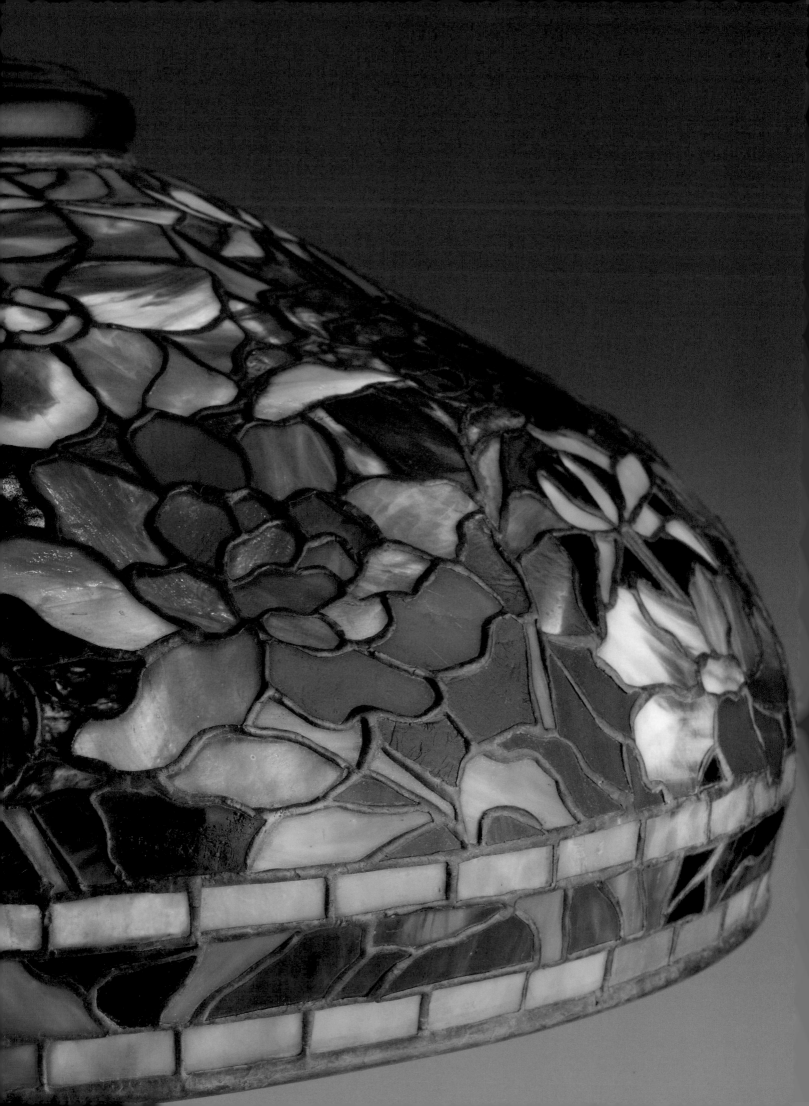

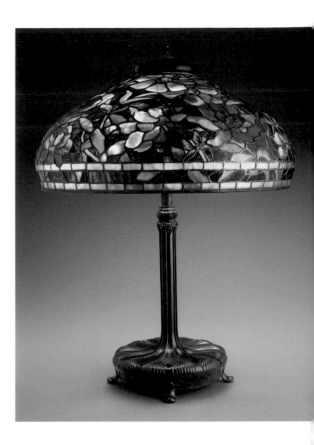

6 PEONY LAMP

c. 1903–5

Leaded glass and bronze

32 x 22 in. (81.3 x 55.9 cm)

Impressed on underside of base: TIFFANY
STUDIOS / NEW YORK / 367 / S180

Impressed on rim of shade: TIFFANY
STUDIOS / NEW YORK / 1505-37

Acc. nos. 30676 and 30018

Red and pink peonies are depicted on the
shade in a design intended to be viewed
from above. The form combines globular
and cone shapes. Mottled green leaves
overlap two geometric rows at the rim.

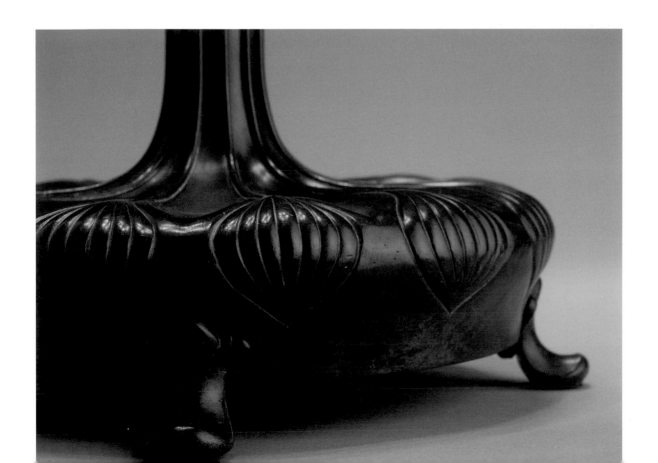

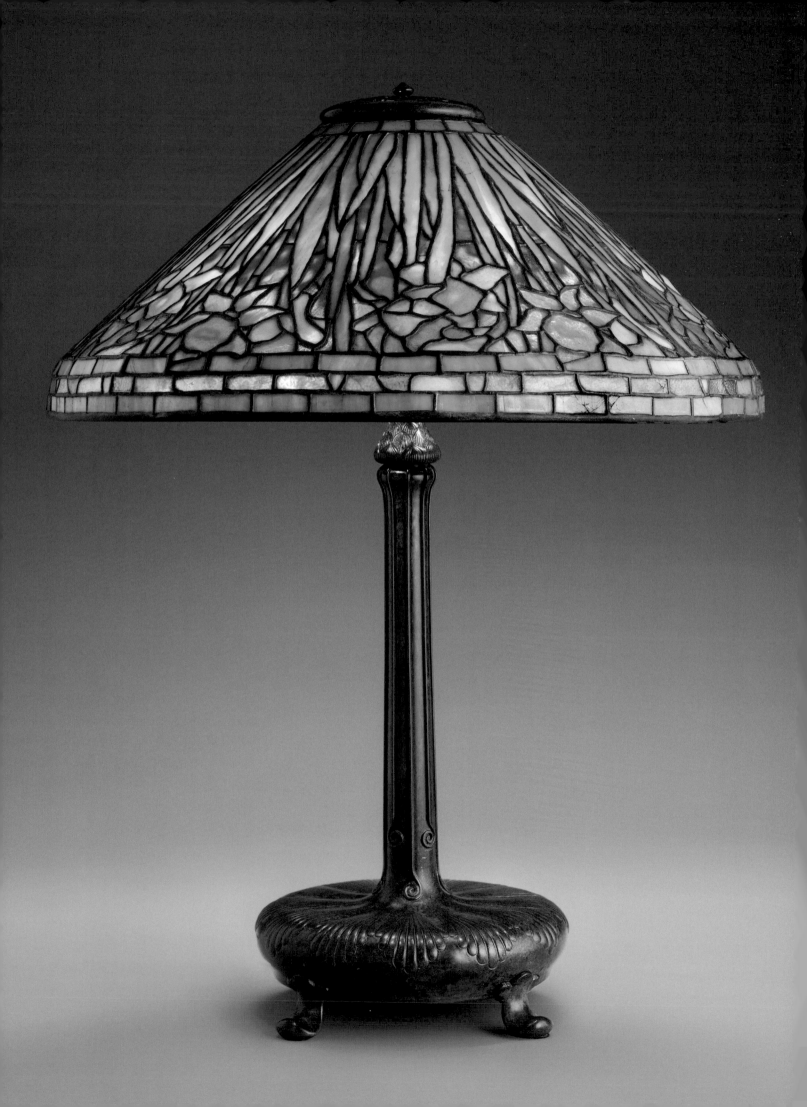

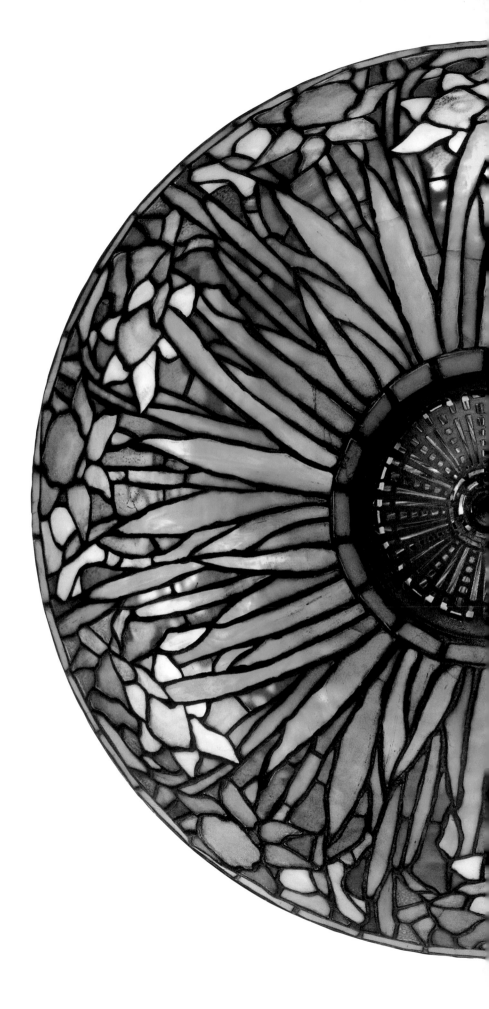

7 | DAFFODIL LAMP
1899–1910
Bronze, glass
26 $\frac{1}{2}$ x 20 in. (67.3 x 50.8 cm)
Stamped on shade:
TIFFANY STUDIOS N.Y. 1497
Stamped on base:
TIFFANY STUDIOS / 9922
Acc. no. 39972

Tiffany and his staff sometimes used
photographic studies in the design process,
as seen here. As in the photograph, the
daffodils and their leaves fall downward
toward the edge of the shade, some
overlapping the geometric border. The
flower petals are realistically rendered
by means of mottling and shading. Some
flowers are open, some closed. This
popular design remained in production
through 1924 and was listed in the Price
Lists for 1901, 1906, and 1913.

Tiffany Studios, photograph of daffodils
positioned on a conical sheet of paper.
Charles Hosmer Morse Museum
of American Art, Winter Park, Florida.

NAUTILUS SHELL CENTERPIECE LAMP
c. 1910
Mother-of-pearl, gilt bronze,
blown glass, nautilus shell
26 x 23 in. (66 x 58.4 cm)
Shade: Diam. 14 in. (35.6 cm)
Impressed on base:
TIFFANY STUDIOS / NEW YORK
Numbers impressed on 7 of the 8 bronze
decorative mounts of nautilus shells:
1, 3, 4, 6, 7, 9, T [?]
Acc. no. 30744

This fanciful design combines exotic
materials: Favrile glass, gilt bronze, mother-
of-pearl, and nautilus shell. The undulating
shaft is cast and inset with rows of pearl-like
jewels and large mother-of-pearl ovals
as well as an amber iridescent glass sphere at

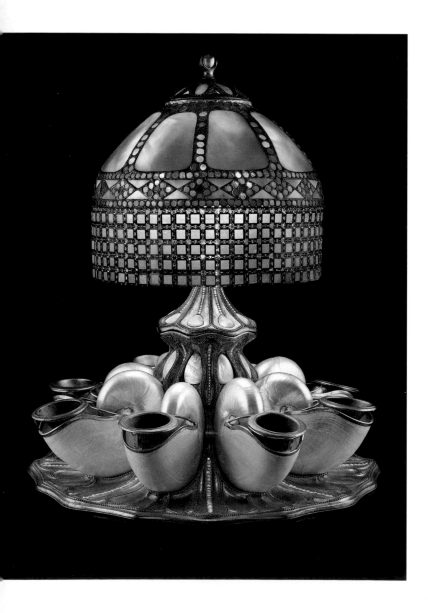

the top. The eight nautilus shell containers may have been used as flower vases. The shade is a traditional geometric glass design with a fringe border made of chainmail tiles in iridescent amber glass, similar to that used for the fire screen (CAT. 39). In contrast, the undulating base moves as an ocean below with floating nautilus shells like so many ships at dock. The organic form of the nautilus shell appealed to Tiffany. At the turn of the century, he utilized a single nautilus shell as a shade on a small table lamp and received a patent for the design and method of inserting a bulb inside the shell.[1] This centerpiece lamp is unique and well documented. It is accompanied by the original price tag, which reads "550.00," and original invoice on Tiffany Studios stationery. In addition, a note signed by Joseph A. Briggs, the last manager of the studio, states that this lamp was sold from his father's collection on December 5, 1978.[2] While most Tiffany lamp shades and bases were interchangeable, this lamp was designed as a unified whole. As a special order, the centerpiece lamp would not have been included in the 1906 Price List, which listed only one lamp with a higher price, the Lotus model at $750. Another Tiffany centerpiece lamp, also unique, has a magnificent peacock shade and in place of nautilus shells around the base has Favrile glass bowls.[3] Both designs perfectly evoke the opulence of the Gilded Age with its luxurious ornamentation and use of exotic materials.

1. Patent D30,665 applied for Feb. 1, 1899, granted May 2, 1899.

2. These documents are in the Driehaus Collection Archives.

3. See Koch, *Louis C. Tiffany: The Collected Works of Robert Koch*, p. 75 for an illustration of this lamp owned by Gladys and Robert Koch. It sold at Phillips, New York, Important Twentieth Century Decorative Arts, sale no. 803, December 7, 1998.

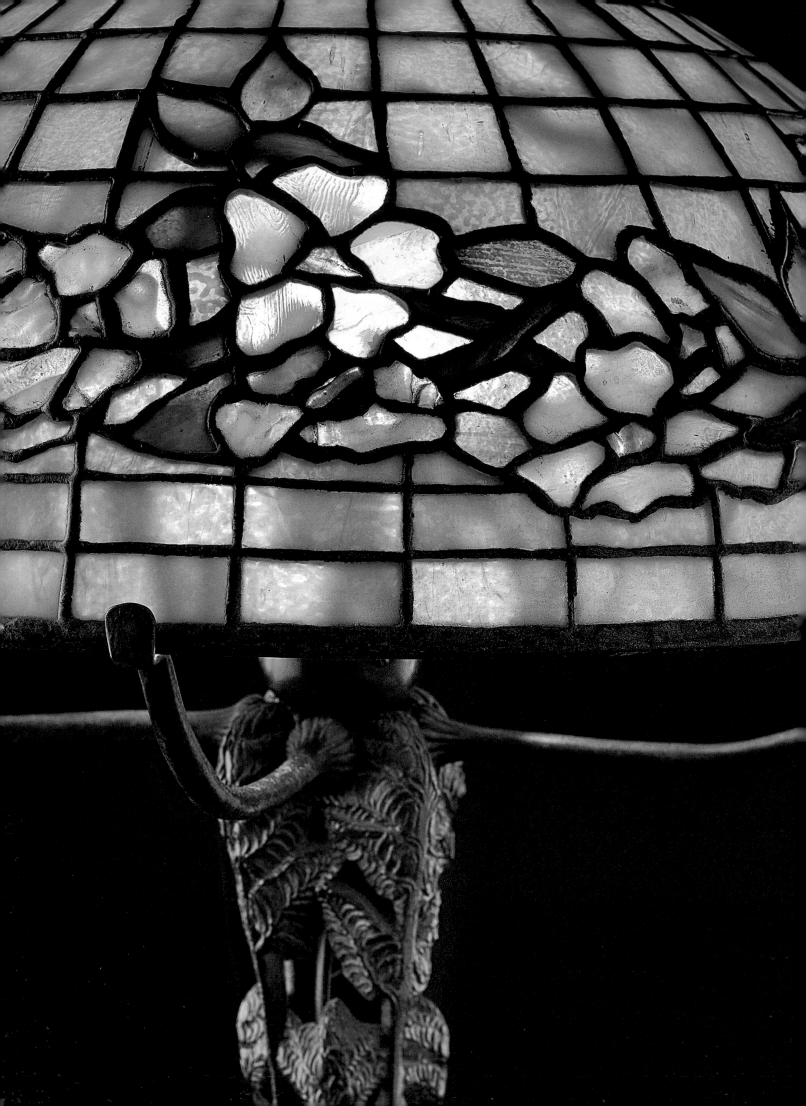

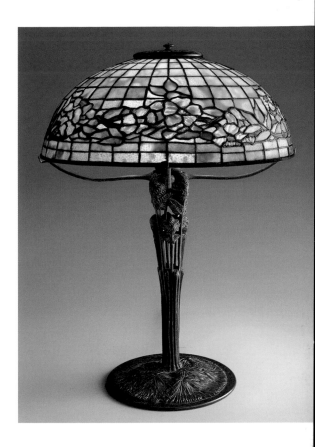

9 | BANDED DOGWOOD LAMP WITH FERN BASE
c. 1905
Leaded glass and patinated bronze
23 1/4 x 14 in. (59.1 x 35.6 cm)
Impressed on metal tag affixed to
rim of shade:
TIFFANY STUDIOS / NEW YORK / 1553
Impressed on underside of base:
262 TIFFANY STUDIOS / NEW YORK / 6856
Acc. no. 31151

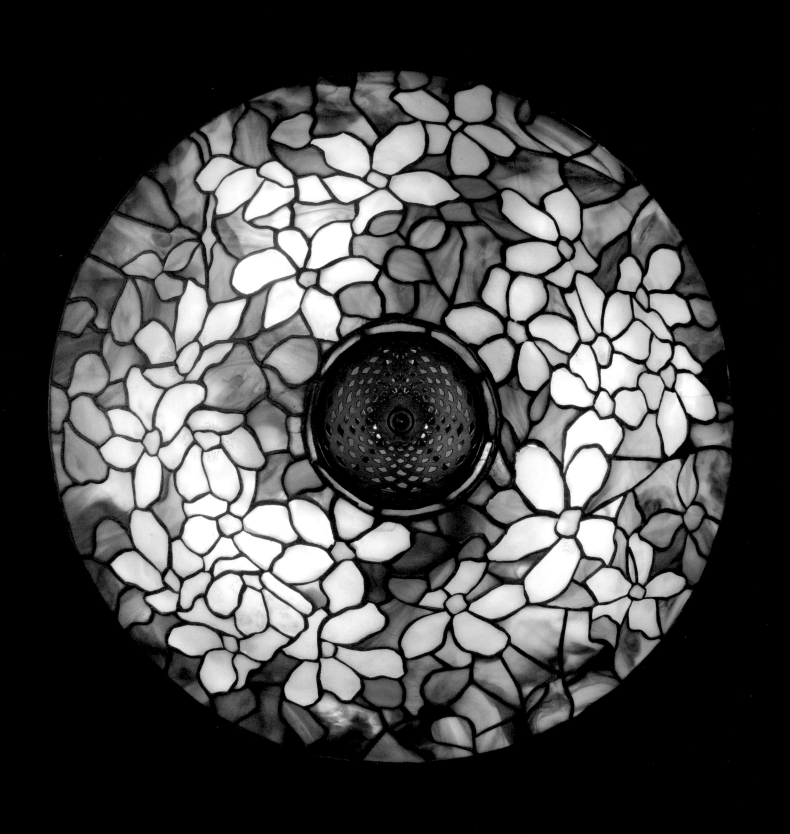

10 CLEMATIS LAMP

c. 1903–10

Bronze, glass

22 ½ x 18 ½ in. (57.2 x 47 cm)

Stamped on rim of shade:

TIFFANY STUDIOS NEW YORK

Stamped on one leg:

TIFFANY STUDIOS

Stamped on one leg: NEW YORK

Stamped on one ball foot: 440

Acc. no. 30721

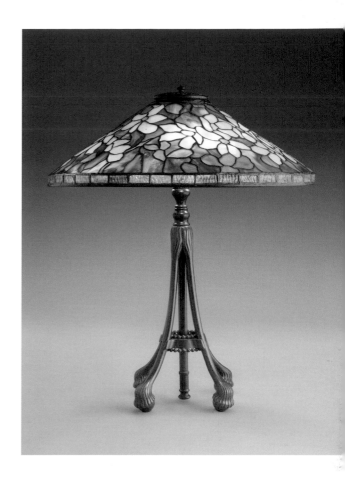

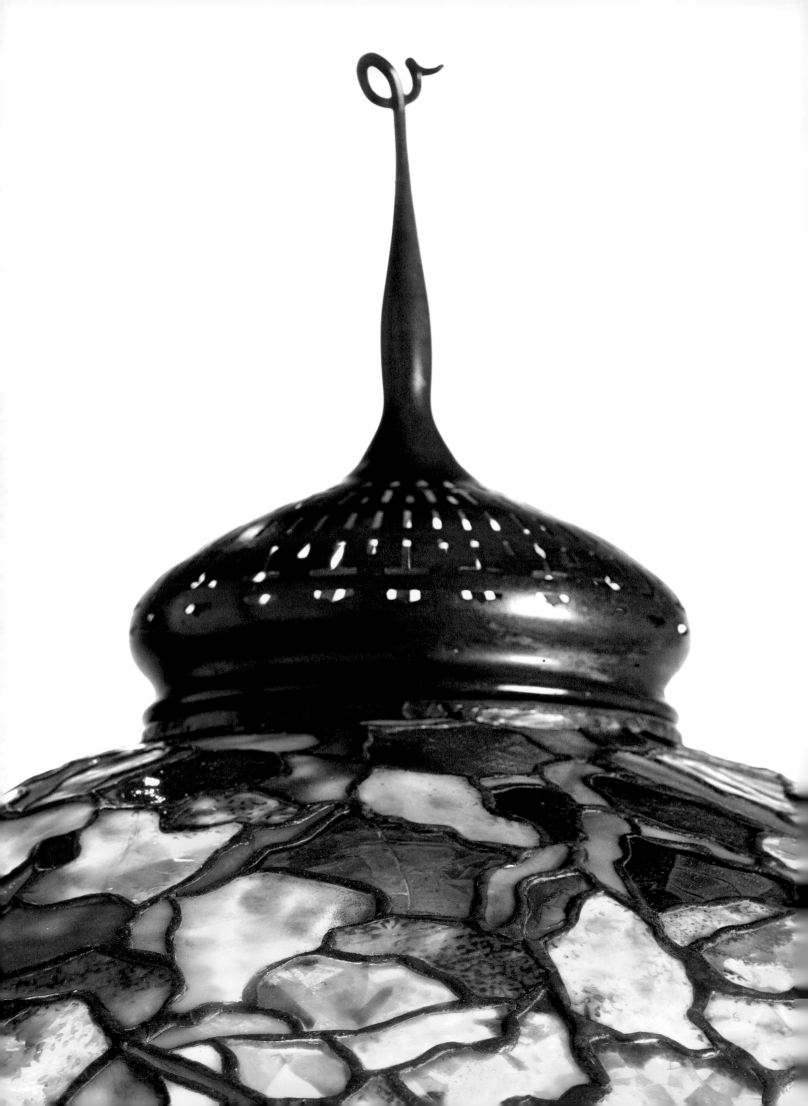

11

SNOWBALL FLOOR LAMP
c. 1903–10
Leaded glass, bronze
78 1/4 x 25 1/2 in. (198.8 x 64.8 cm)
Two plaques affixed to leading:
TIFFANY STUDIOS [and] NEW YORK
Impressed on base: TIFFANY STUDIOS
NEW YORK 337
Stamped in rim of shade: 3
Stamped on feet: 11, 12, 13, 14, 15
Acc. no. 31026

The rounded shape of the shade reflects
the globular form of the hydrangea flower.
The detail of the top shows the confetti
glass that was used to create the flower
clusters. The same shade could be used
on table lamps and ceiling fixtures.

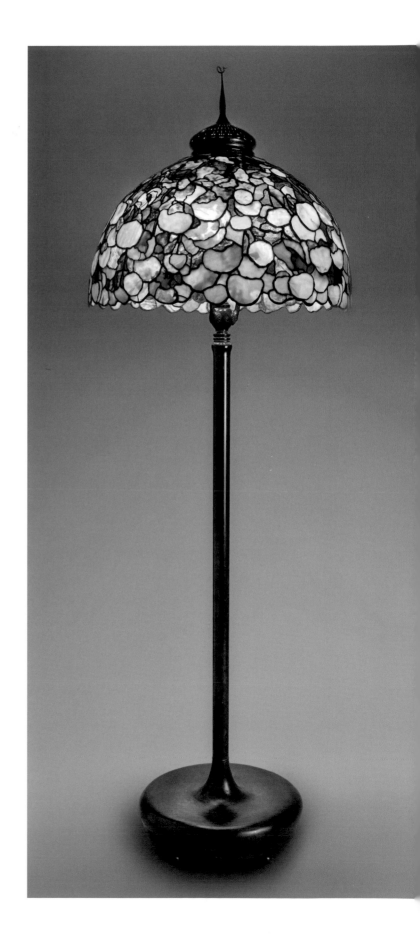

FLORAL VASES

iffany invented the poetic term "Favrile," from the Latin word *fabrilis* (handmade), to describe all the blown glass he produced. It was a guarantee to his customers of its high quality. According to a Tiffany Studios brochure, Favrile glass was "a composition of various colored glasses worked together while hot" and then blown into shapes.[1] Some pieces were iridescent, an effect achieved by exposing the hot glass to metallic vapors to imitate iridescence from the effects of moisture over time that is found in ancient glass.

Many of the dominant styles at the turn of the century appear in Tiffany's work over his entire career, as seen, for example, in the Romanesque style used in the chapel at the World's Columbian Exposition, or the neo-Renaissance style in his G. A. R. rooms at the Chicago Public Library. The ancient Middle East and the Orient were also sources for his designs, but nature was his primary inspiration. Tiffany glass, especially the flowerform vases, is often linked to the Art Nouveau style, but they were very different from the "abstract, dynamic, linear vocabulary" of European Art Nouveau.[2] However, Tiffany's design concept had parallels in Europe, seen, for example, in the Art Nouveau work of Émile Gallé, whose factory in Nancy Tiffany visited in 1889. The floral vases were modern forms inspired by a variety of flowers and plants, many of them cultivated in the gardens at Laurelton Hall. Tiffany liked both exotic species and common field flowers, sometimes photographing them as part of his artistic research. The long slender stems of glass or bronze that support the various flowerform bowls ranging from buds to open flowers are pure fantasy, without a functional use other than as a work of art; grouped, the vases create a garden. In the vases included here, we see variations in height, bowl shape, and coloration, though yellows and greens are favored.

Samuel Howe, a contemporary critic, wrote: "For years a Painter has given himself up to the peculiar study of transmitting beauties of nature to elements of decoration. Here has he lived for twenty years, working and resting and working again. The garden his school, the flower his companion, his friend and his inspirer."[3] Siegfried Bing put it eloquently: "Never, perhaps, has any man carried to greater perfection the art of faithfully rendering Nature in her most seductive aspects, while subjecting her with so much sagacity to the wholesome canons of decoration."[4]

In 1906 Tiffany published a Price List of his productions, which allows the dating of objects based on the list's numbering system as well as the marks of his previous firms.[5]

1. Tiffany Studios brochure, c. 1894, cited in Robert Koch, *Louis C. Tiffany: The Collected Works of Robert Koch* (Atglen, PA: Schiffer, 2001), 99.

2. Martin Eidelberg, "Tiffany and the Cult of Nature," in Alastair Duncan, Martin Eidelberg, and Neil Harris, *Masterworks of Louis Comfort Tiffany* (New York: Harry N. Abrams, 1989), 67.

3. Samuel Howe, "One Source of Color Values [Louis C. Tiffany Gardens]," *House and Garden* 10 (September 1906): 105–13.

4. Samuel [Siegfried] Bing, "Louis C. Tiffany's Coloured Glass Work," in *Artistic America, Tiffany Glass, and Art Nouveau* (Cambridge, MA: MIT, 1970), 211.

5. For information on the numbering of Tiffany glass, see Martin Eidelberg, *Tiffany Favrile Glass and the Quest of Beauty* (New York: Lillian Nassau, 2007), 88–91.

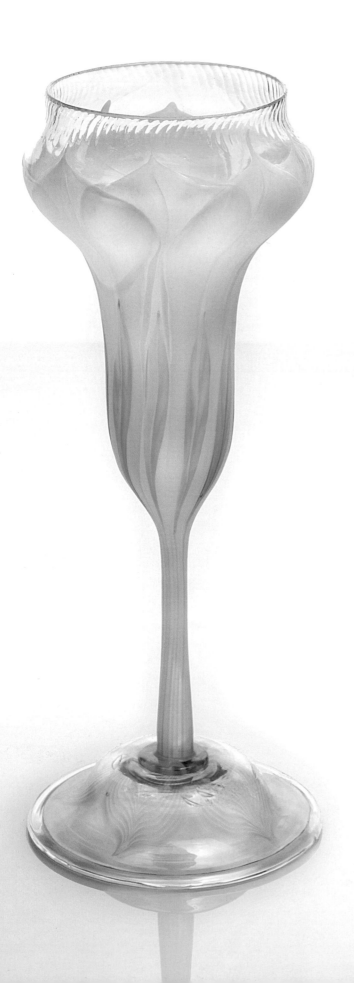

12 | FLOWERFORM VASE
c. 1900–1903
Blown glass, wheel engraved
Height: 13 ¼ in. (33.7 cm)
Engraved on underside near
outer edge: 720
Engraved on pontil: L.C.T. W6812
Acc. no. 80253

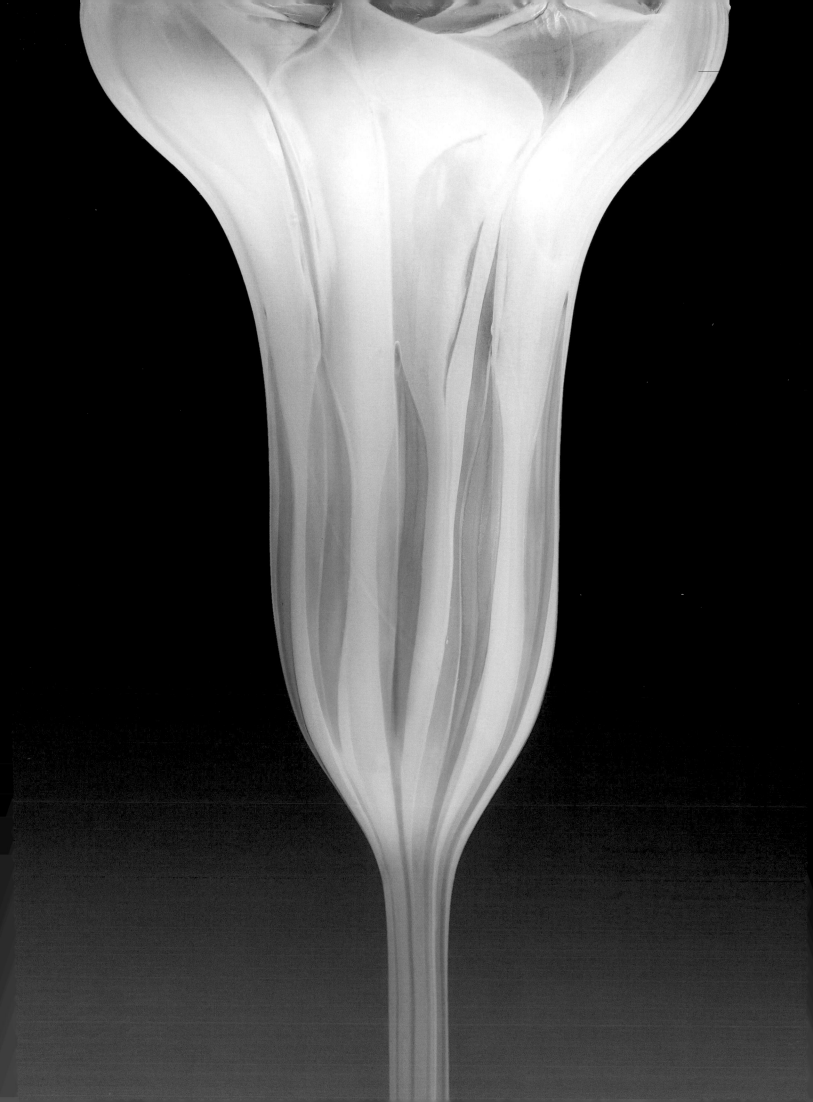

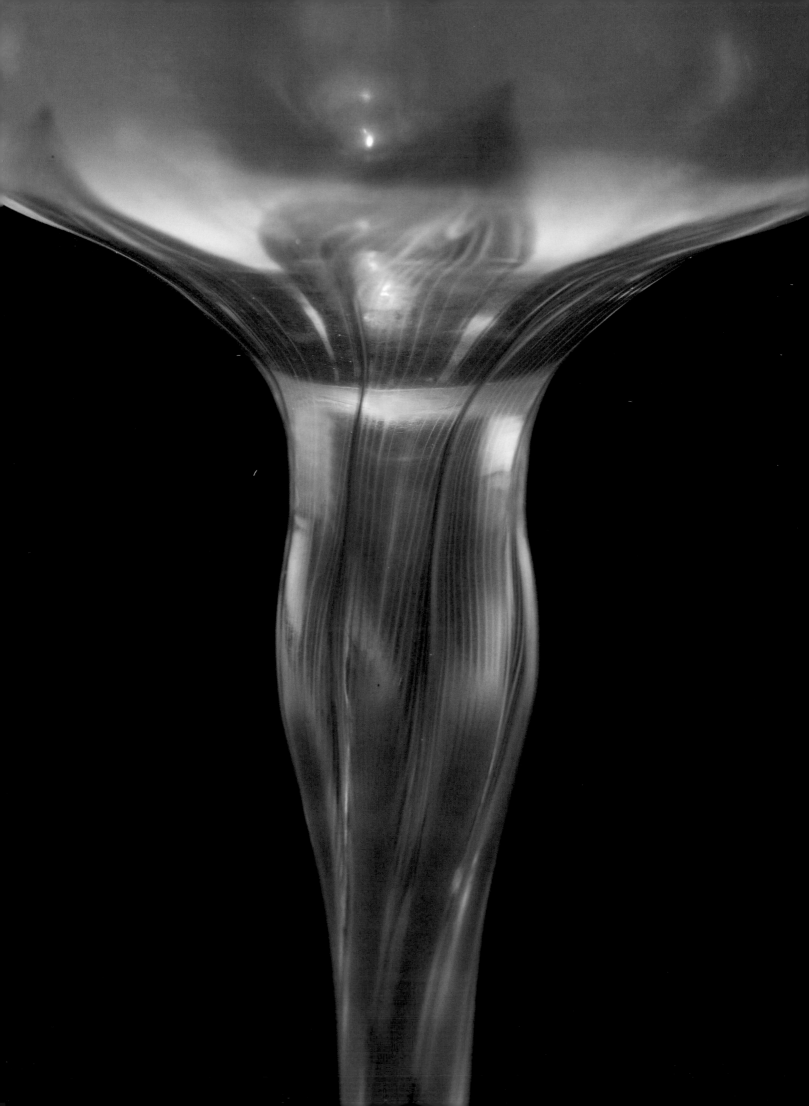

13 FLOWERFORM VASE
c. 1904–6
Blown glass
Height: 12 ¹/₄ in. (31.1 cm)
Engraved on underside: 2403C
[and] LC TIFFANY—FAVRILE
Acc. no. 89999

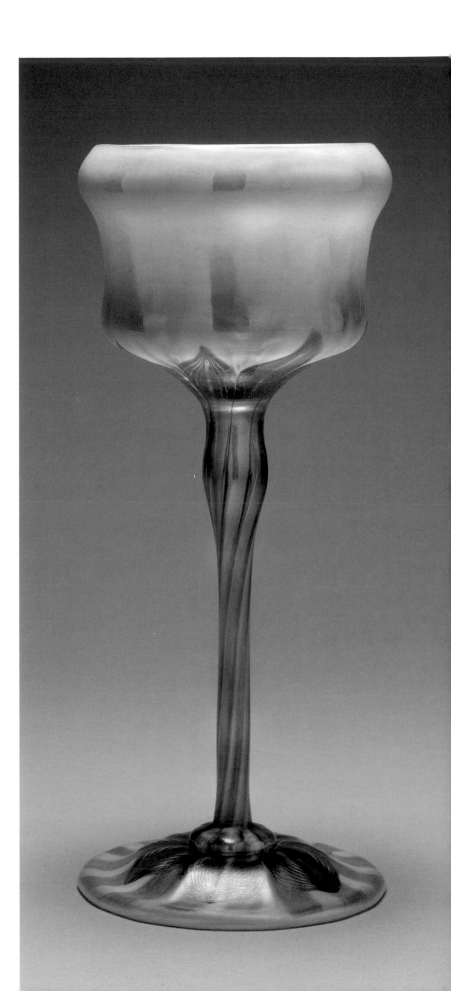

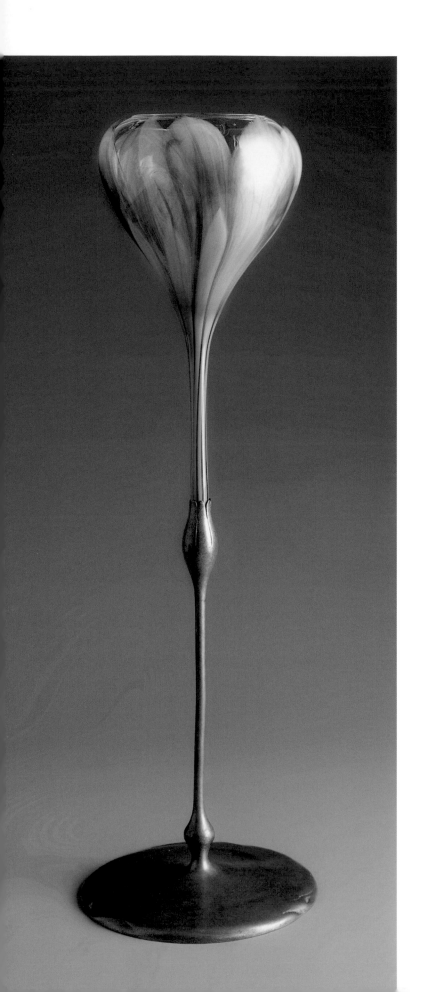

14 FLOWERFORM VASE
1895–1902
Blown glass, gilt bronze
Height: 18 ¹/₈ in. (46 cm)
Stamped on underside of bronze base:
TIFFANY STUDIOS / NEW YORK /
[conjoined monogram of TGDCO] /
25695 53-35 ~~35~~
Engraved on side of stem: 5335
Acc. no. 80109

15 | FLOWERFORM VASE
c. 1900–1903
Blown glass
Height: 11 in. (27.9 cm)
Engraved on underside: L.C.T. W4603
Acc. no. 80112

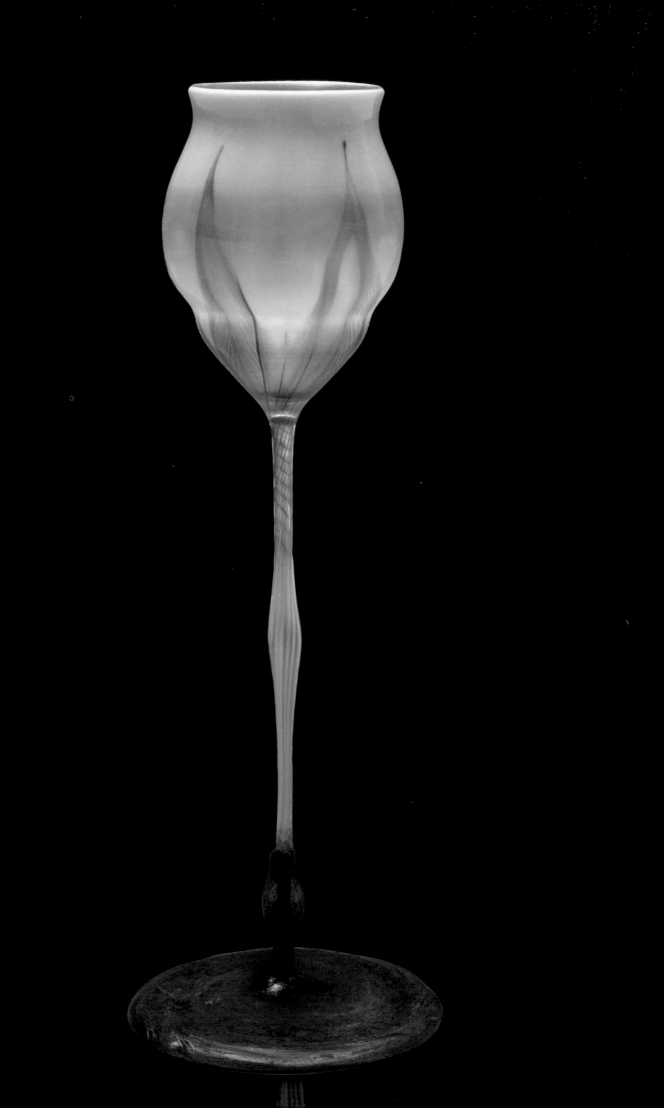

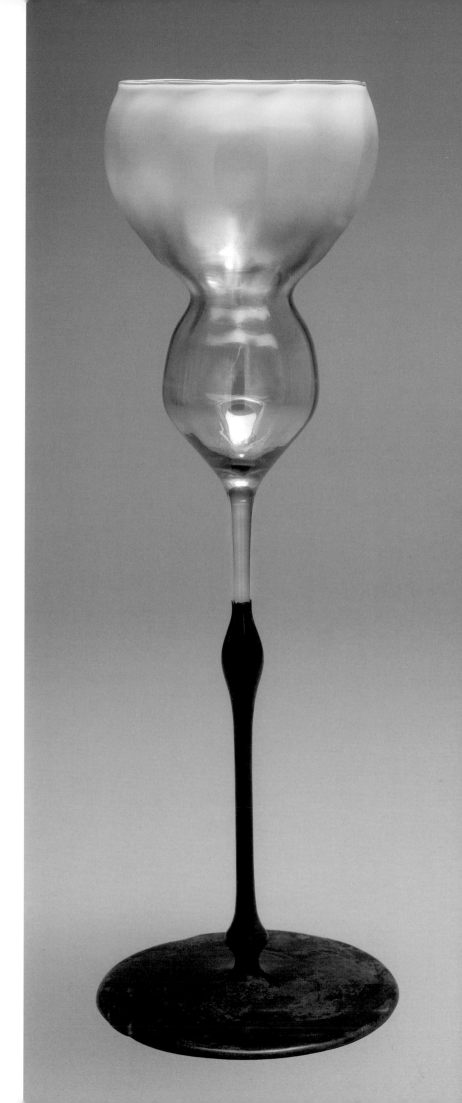

16
FLOWERFORM VASE
1898–1902
Blown glass, silver–plated bronze
Height: 17 1/4 in. (43.8 cm)
Stamped on underside of bronze base:
TIFFANY STUDIOS / NEW YORK /
[conjoined monogram TGDCO]
/ 23819 / 1753
Engraved on side of stem near
base: 1753
Acc. no. 80120

17
FLOWERFORM VASE
1895–1900
Blown glass, bronze
Height: 16 3/4 in. (42.5 cm)
Stamped on underside of bronze
base: TIFFANY STUDIOS /
NEW YORK
Acc. no. 80838

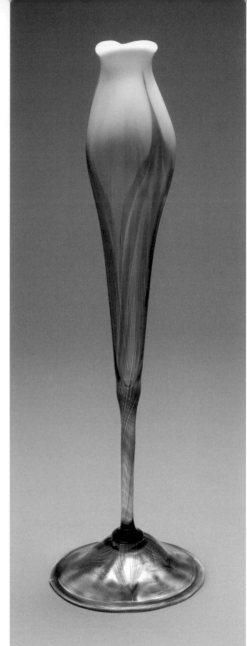

18 | FLOWERFORM VASE
c. 1900–1903
Blown glass
Height: 19 ½ in. (49.5 cm)
Engraved on underside:
L.C.T. W2878
Acc. no. 80794

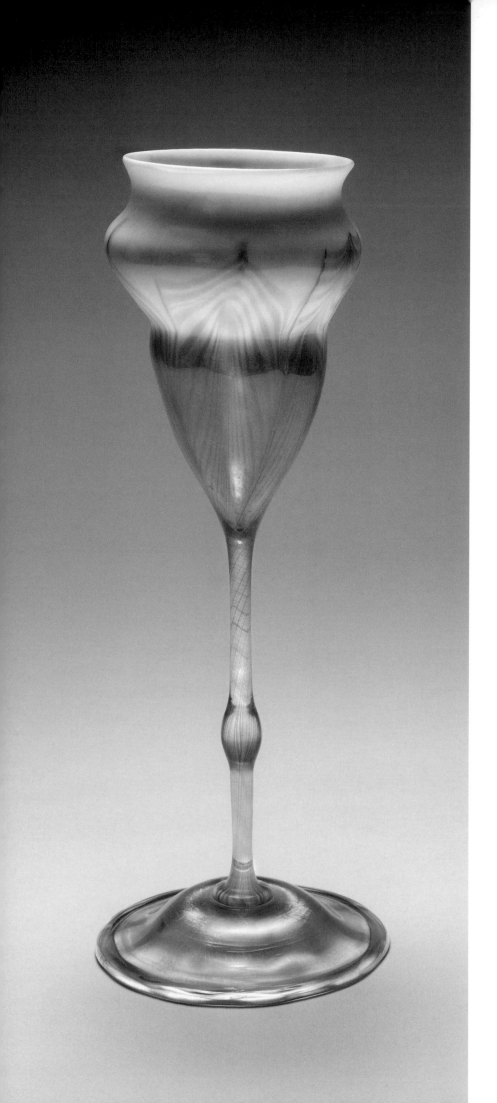

19 | FLOWERFORM VASE
c. 1900–1903
Blown glass
Height: 13 in. (33 cm)
Engraved on underside:
LCT Y7837
Acc. no. 80121

20 | FLOWERFORM VASE
c. 1900–1903
Blown glass
Height: 13 1/8 in. (33.3 cm)
Engraved around pontil:
LCT Y8324
Acc. no. 80284

In this unusual cup-like chalice
is a rare combination of milky
white and semi-opaque glass with
a slightly flared iridized rim.

21 | FLOWERFORM VASE
c. 1905
Blown glass
Height: 14 1/2 in. (36.8 cm)
Engraved on underside:
L.C.T. / Y8273
Acc. no. 80281

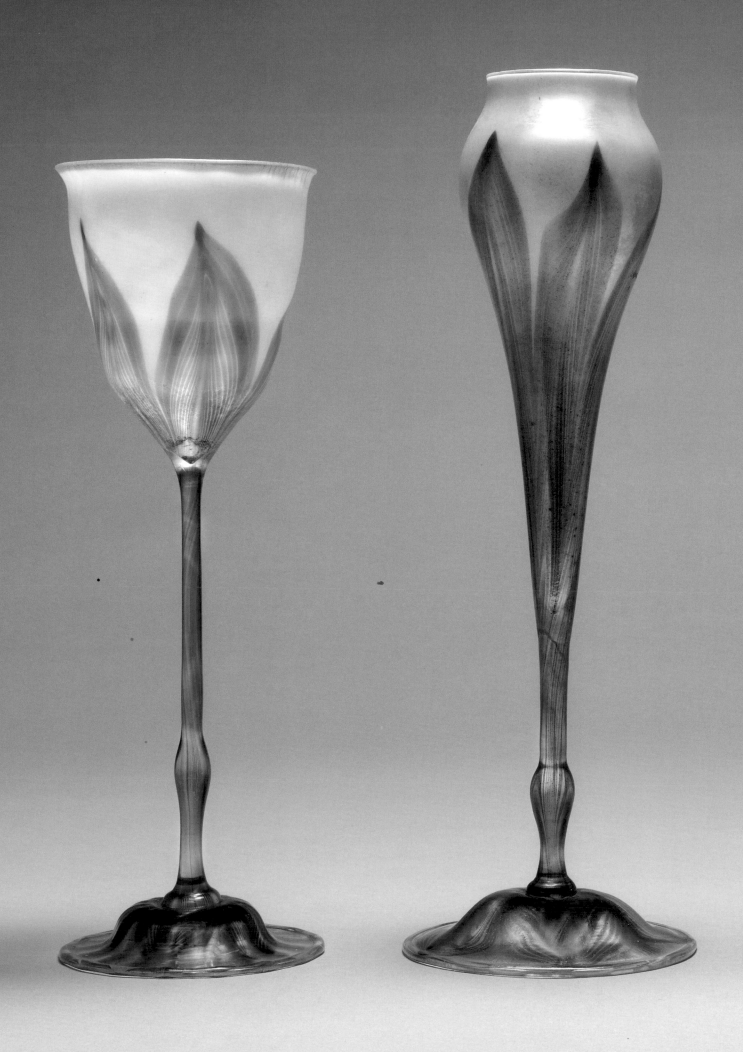

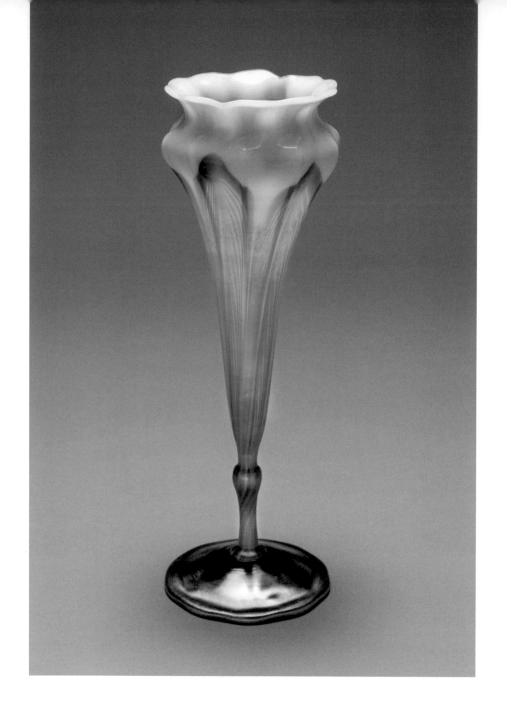

22 FLOWERFORM VASE
c. 1903–4
Blown glass
Height: 12 1/8 in. (30.8 cm)
Stamped on underside of base:
LCT 2366A
Acc. no. 80123

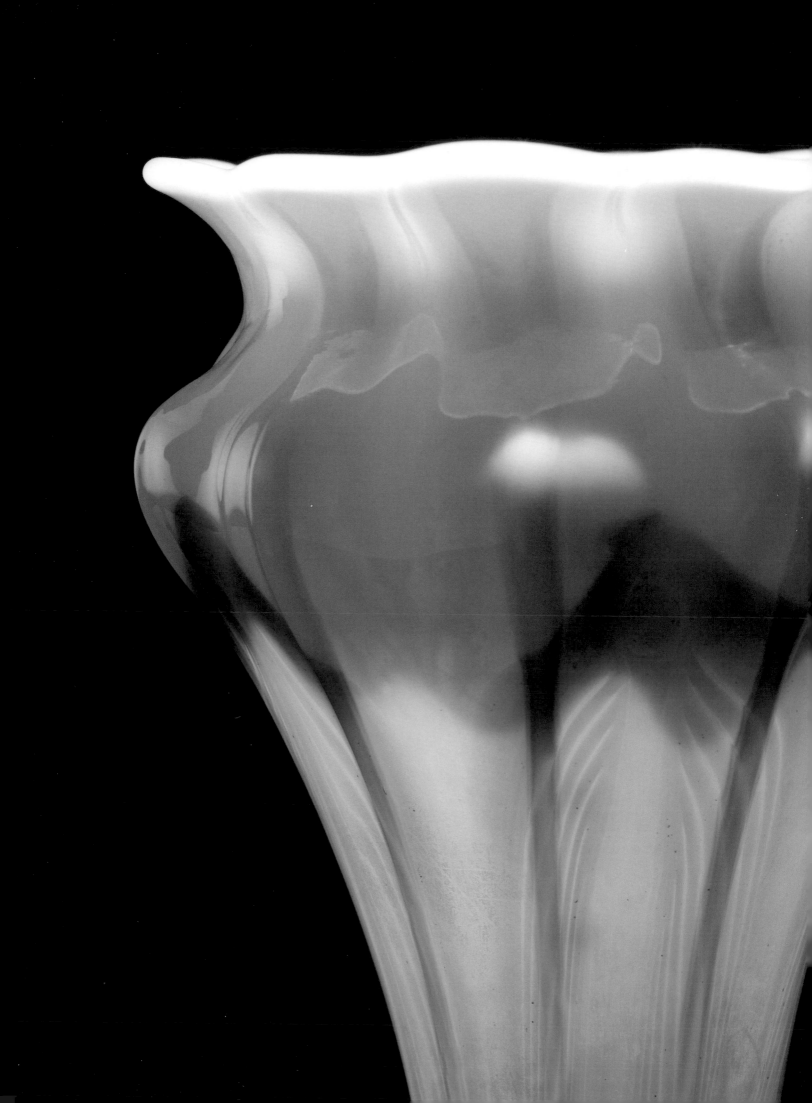

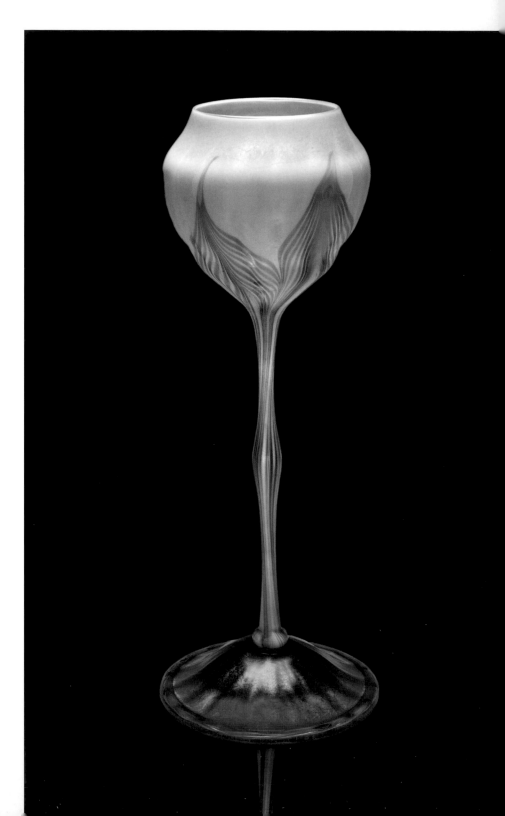

23 | FLOWERFORM VASE
c. 1898–1900
Blown glass
Height: 14 3/4 in. (37.5 cm)
Engraved on underside:
L.C.T. R9711
Acc. no. 80390

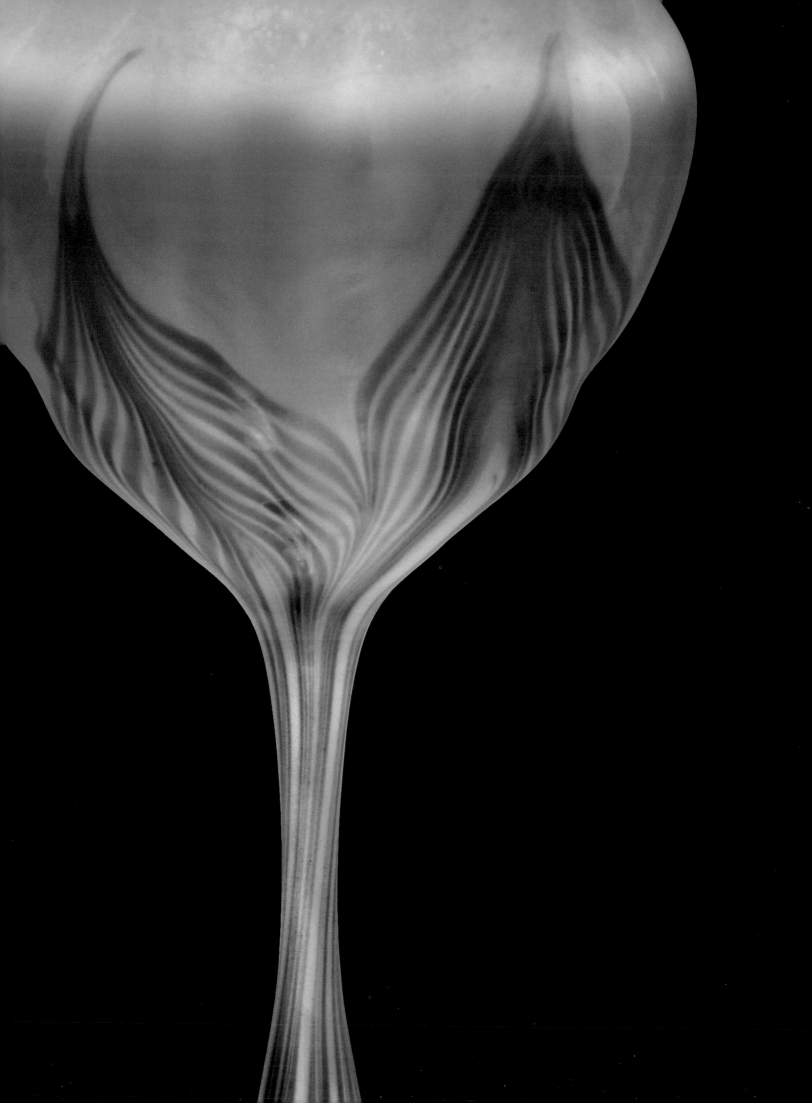

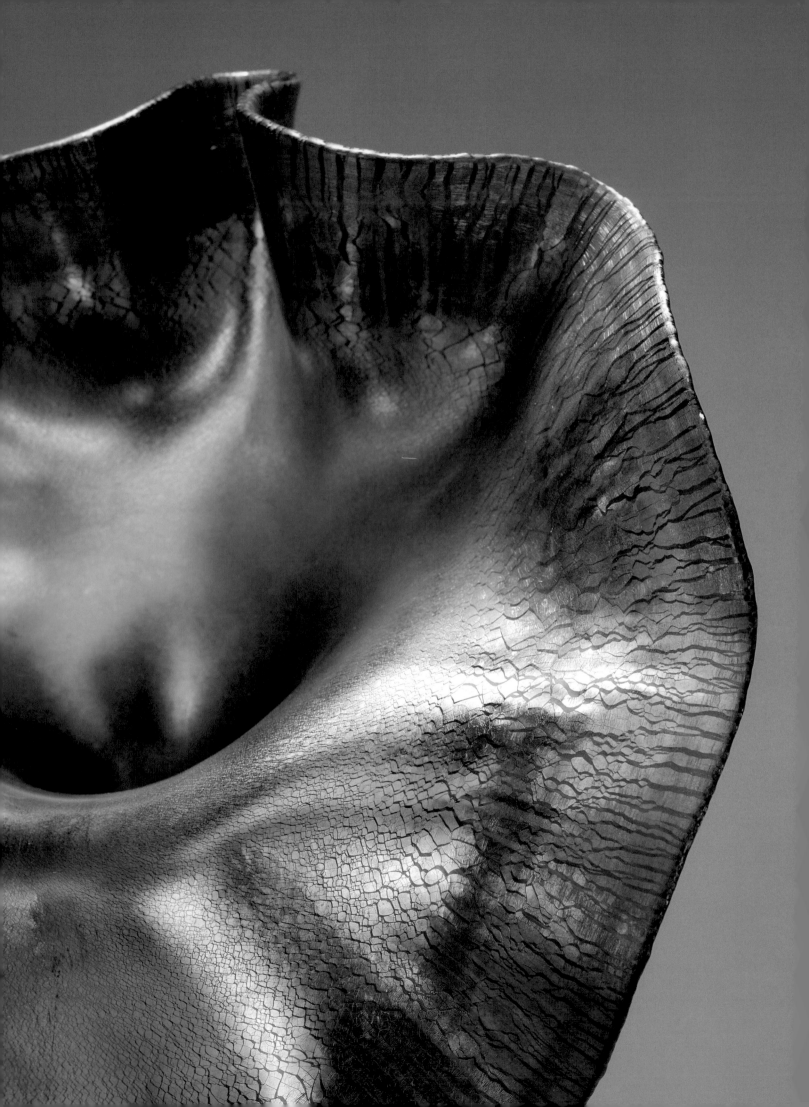

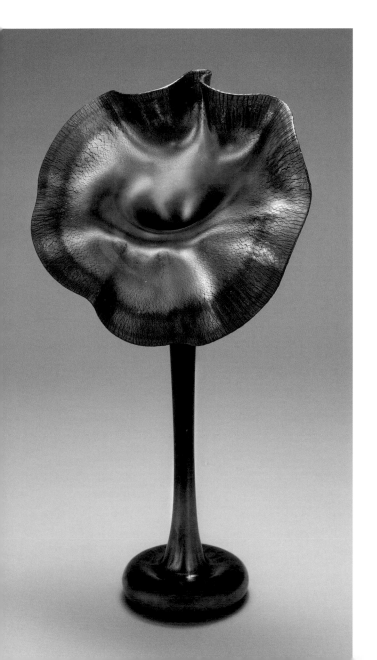

24 | JACK-IN-THE-PULPIT VASE
1907–10
Blown glass
Height: 20 3/4 in. (52.7 cm)
Engraved on underside of base:
3016E L.C. Tiffany–Favrile
Acc. no. 80308

The form of this vase was inspired by the jack-in-the-pulpit flower, a native perennial herb found in the eastern part of the United States. The tiny flowers of this plant are not visible; they are hidden away deep inside the leaf structure that we normally think of as the plant's bloom. What we do see is a cylindrical structure, called the "jack," inside a leaf-like cup with an overhanging "pulpit," resembling a minister in vestment robes. The vase appeared in a range of sizes and iridescent colors. This example's rich coloration ranges from blues and greens to gold and silver.

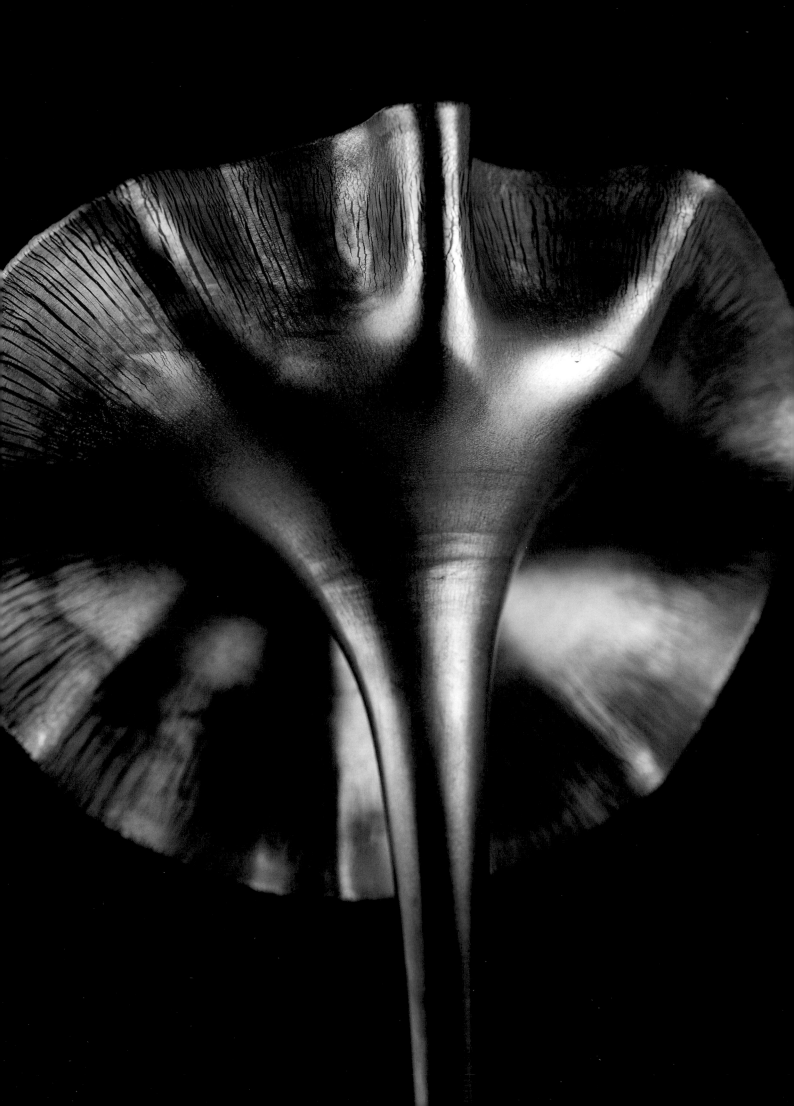

VASE
FORMS

Tiffany's early vases were described in an 1896 booklet, *Tiffany Favrile Glass*, as "wonderful in color and novel in form" and enriched with iridescence.[1] The vase forms shown in the booklet's four photographs were organic and asymmetrical, with both complementary and opposing colors. Imperfections, irregularities, and such defects as bubbles were celebrated rather than rejected as they would be in most glasshouses. Many skilled craftsmen and designers worked in the Corona factory with Tiffany overseeing the design process and production. Robert Koch related that a former employee told him that Tiffany often made informal sketches in pencil on any available piece of paper. These then were traced and rendered by one of his draftsmen. Tiffany gave his approval of many of the final drawings by signing, in pencil, in a space provided by a rubber stamp. According to Koch, none of Tiffany's original drawings for glass vases have survived.[2]

The production of Tiffany glass vases was an arduous process. Siegfried Bing described it in poetic terms: "Look at the incandescent ball of glass as it comes out of the furnace; it is slightly dilated by an initial inspiration of air. The workman charges it at certain pre–arranged points with small quantities of glass, of different textures and different colors, and in the operation is hidden the germ of the intended ornamentation. The little ball is then returned to the fire to be heated. Again it is subjected to similar treatment (the process being repeated sometimes as many as twenty times), and, when all the different glasses have been combined and manipulated in different ways, and the article has been brought to its definite state as to form and dimensions, it presents the following appearance: The motifs introduced into the ball when it was small have grown with the vase itself, but in differing proportions; they have lengthened or broadened out, while each tiny ornament fills the place assigned it in advance in the mind of the artist."[3] After the vases were formed in this unique process, they were annealed in an oven, then removed and placed on a shelf to cool and wait for finishing. In the finishing department, the mark left in the glass from the metal rod, or pontil, upon which it was made was polished down; the vase was signed, numbered, registered, and, finally, shipped out to one of Tiffany's many retail outlets, such as Marshall Field & Co.

Bing was important in promoting Tiffany's Favrile glass internationally. Both men shared an artistic vision of design based on nature, which their family fortunes enabled them to realize through ambitious enterprises. In 1894 Bing became Tiffany's

1. Tiffany Glass & Decorating Company, *Tiffany Favrile Glass* (New York: Tiffany Glass & Decorating Company, 1896), n.p.

2. Robert Koch, *Louis C. Tiffany: The Collected Works of Robert Koch*, 176.

3. Siegfried Bing in *Exhibition of L'Art Nouveau, S. Bing, Paris*, exh. cat. (London: Grafton Galleries, 1899), 17–18, quoted in Rosalind M. Pepall, ed., *Tiffany Glass: A Passion for Colour* (Paris: Skira Flammarion, 2009), 119.

4. Martin Eidelberg, "Bing and L.C. Tiffany: Entrepreneurs of Style" *Nineteenth-Century Art Worldwide* 4, no. 2 (Summer 2005). <http://www.19thc-artworldwide.org/index.php/summer05/215-excavating-greece-classicism-between-empire-and-nation-in-nineteenth-century-europe>

5. Quoted in Eidelberg, "Bing and L.C. Tiffany: Entrepreneurs of Style."

6. See Robert Koch, *Louis C. Tiffany: The Collected Works of Robert Koch*, 176–77, for reproduction of this publication.

Tiffany glassworkers forming a blown-glass vase, c. 1910.

European representative, and he sold examples to museum collections in France, Belgium, and especially Germany, where modern design was embraced.[4] The artistic invention of Tiffany's new glass designs, according to Bing, was its simulation of nature, "fine veins, filaments, and trails of color similar to the delicate nuances in the skin of fruit, the petal of a flower, the veins of an autumn leaf."[5]

Tiffany glass quickly earned international recognition. In 1895 Siegfried Bing included twenty pieces of Favrile glass in the inaugural exhibition at his Paris gallery, L'Art Nouveau. Favrile glass was introduced to the New York market in 1897 at Tiffany's Fourth Avenue studio. Tiffany Glass & Decorating Company's promotional pamphlet of 1896, the first publication about his blown iridescent glass, included eight photographs of Favrile glass and recommended the vases to collectors.[6] The Smithsonian Institution, the Metropolitan Museum of Art, and the Cincinnati Museum of Art were among the American museums that collected Tiffany's work as contemporary American industrial design in the late 1890s. Leading European museums also collected Tiffany's works, thanks in part to Bing's efforts. These early collections, which remain largely intact, help to document Tiffany's work.

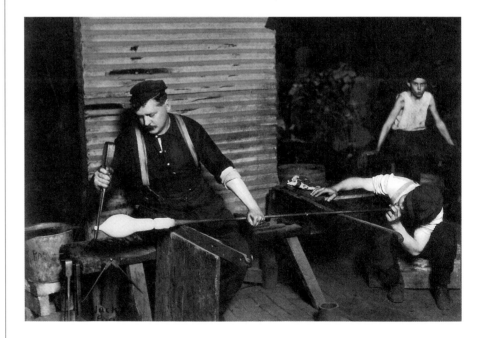

25 VASE
c. 1899–1900
Blown and applied glass
Height: 13 5/8 in. (34.6 cm)
Engraved on underside: 09186
Acc. no. 80291

The design of this vase combines
iridescent glass with opaque appliqué,
based on German prunts (small
blobs of glass fused to the body). Feather
motifs adorn the rim. The unusual
coloration of purple against a lemon
ground provides a rich contrast.
Similar pieces were shown in the Tiffany
display at the Exposition Universelle
in Paris in 1900. The *o* prefix letter mark
indicated that the vase would not
be sold but would be kept for Tiffany's
own collection or sent to Europe
for exhibition.

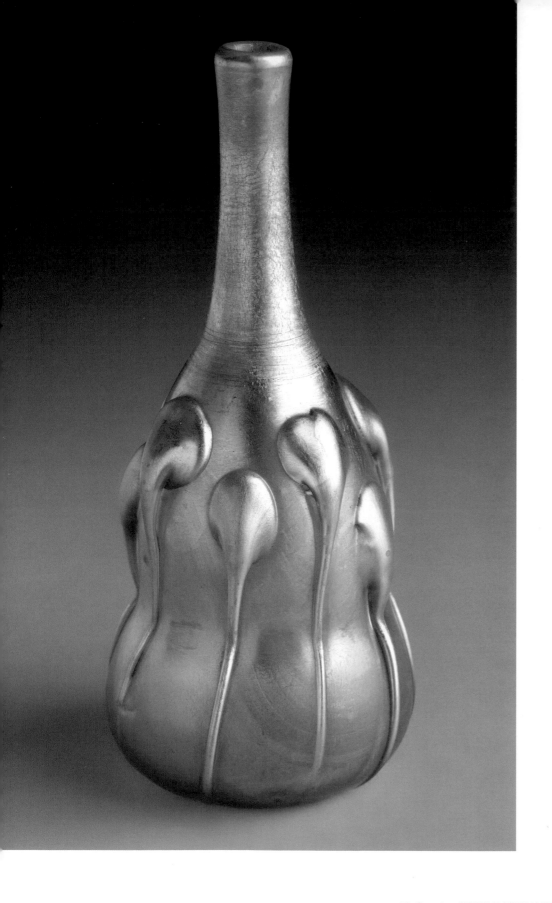

26 BOTTLE-FORM VASE
c. 1897–98
Blown glass
Height: 5 ½ in. (14 cm)
Engraved on underside: L.C.T. / 03217
Acc. no. 89984

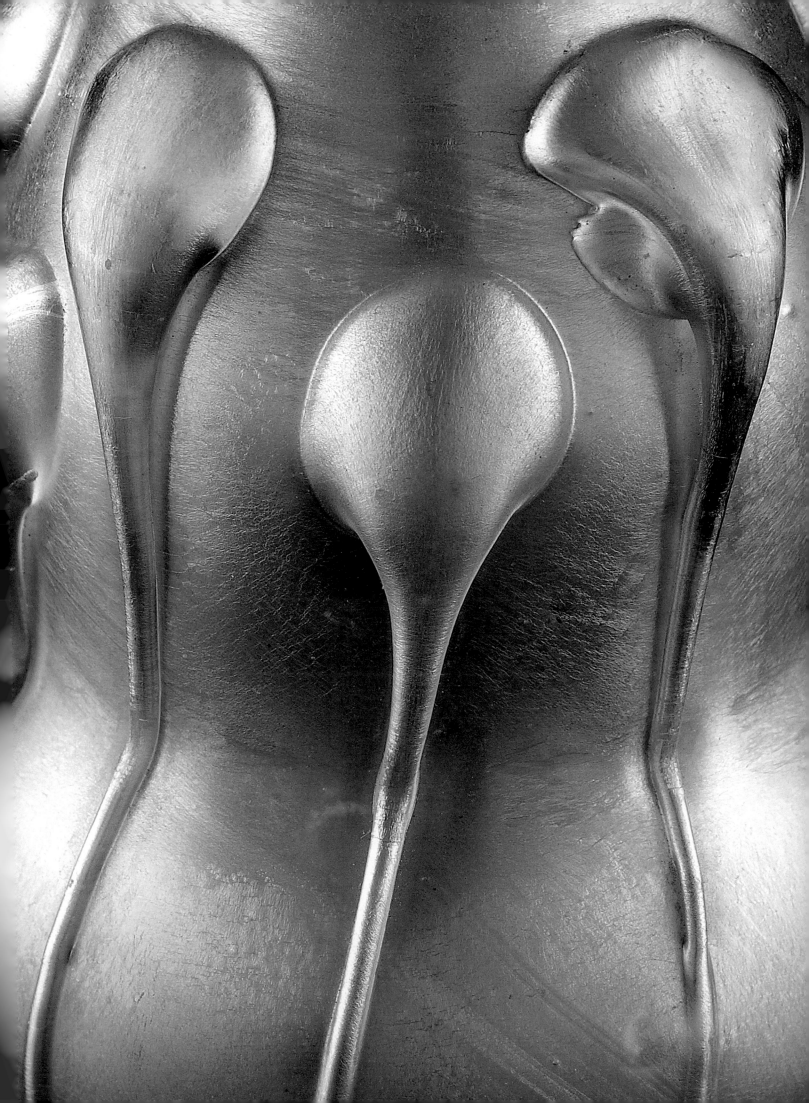

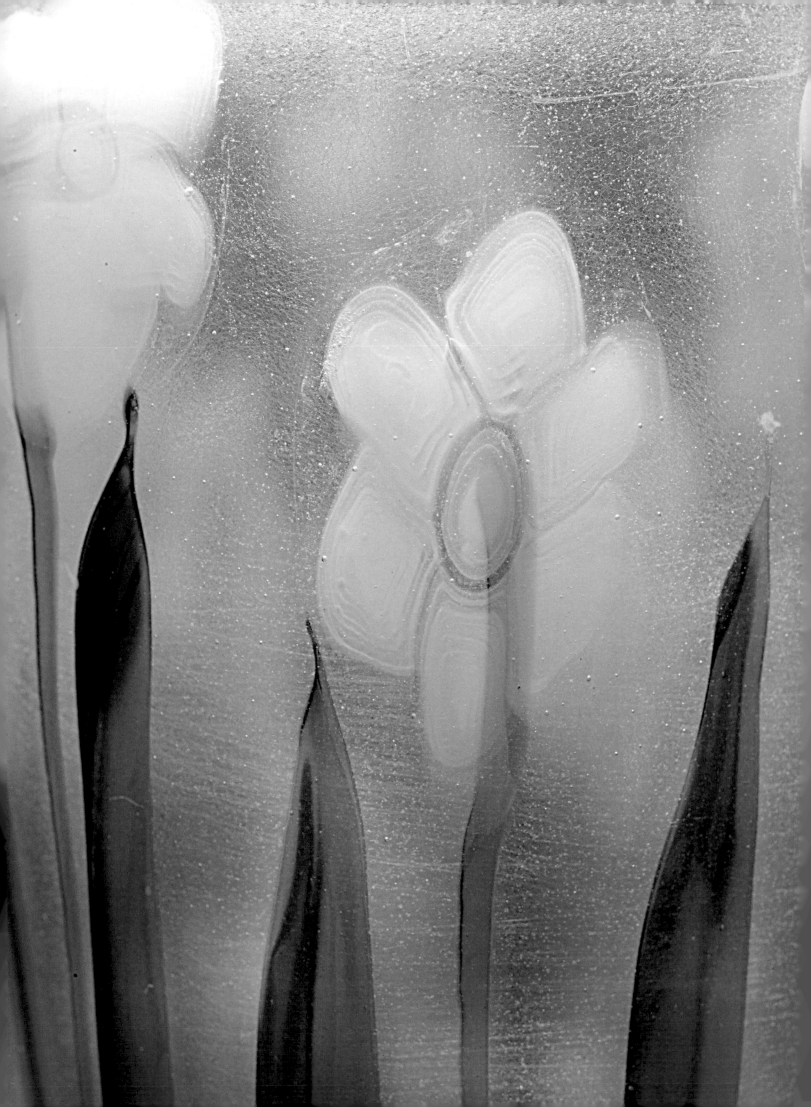

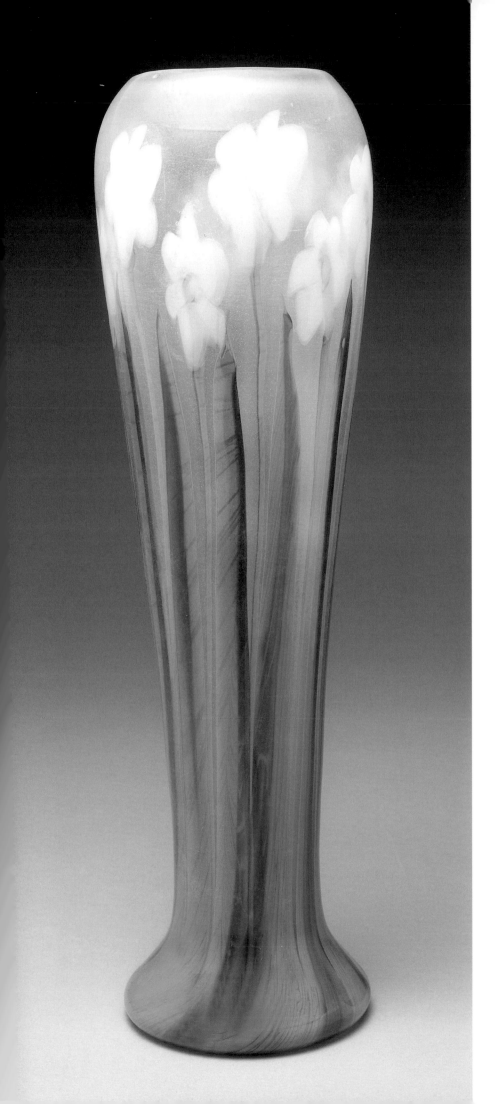

27 | NARCISSUS PAPERWEIGHT VASE
c. 1914–15
Blown glass
Height: 15 in. (38.1 cm)
Engraved on underside: 8043M
L.C. Tiffany Inc. Favrile
Acc. no. 80234

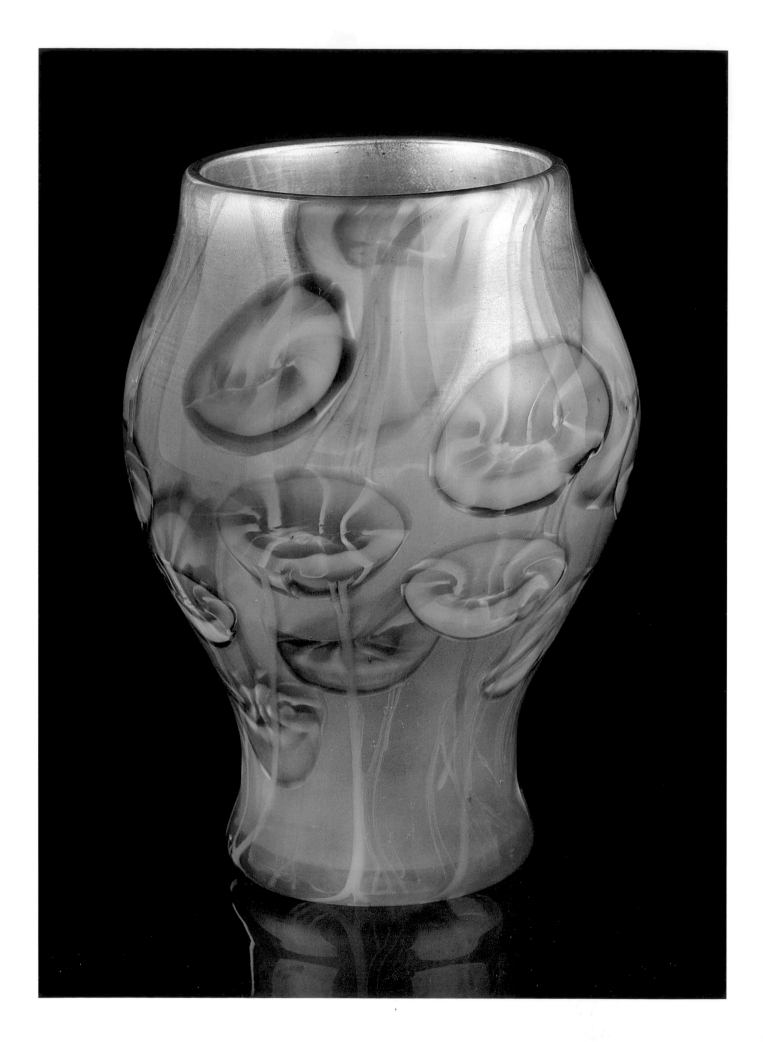

28 PAPERWEIGHT VASE
c. 1898–1900
Blown glass
Height: 7 ¾ in. (19.7 cm)
Engraved on underside:
Louis C. Tiffany / U4113
Acc. no. 80259

Some of Tiffany's vases were created
with a technique similar to that used
for glass paperweights: a smooth outer
layer of glass encased a decorated layer,
giving a liquid shine and magnifying
the decoration, reminiscent of ancient
Venetian glass techniques. The outer
layer of glass protected the morning glory
decoration and the magnification
creates a striking aesthetic. The delicate
flowers float with long, wavy stems as
though underwater. The subtle
coloration of shades of blue, gold,
green, and white creates a cool, ethereal
sensibility. This model marks Tiffany's
turn toward floral imagery.

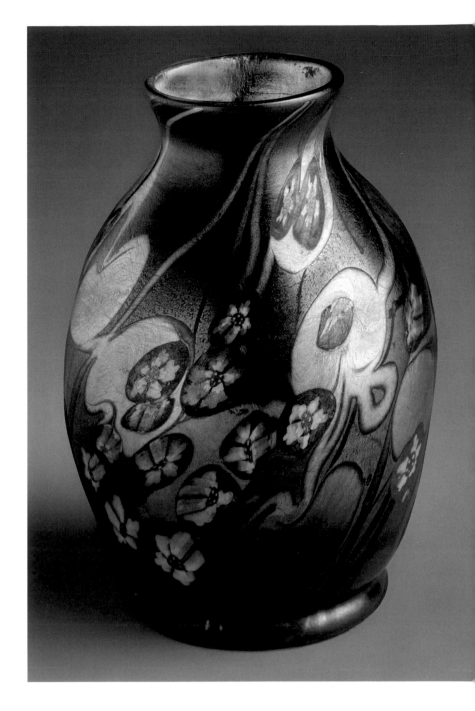

29 MINIATURE VASE
c. 1898–1900
Blown glass
Height: 3 in. (7.6 cm)
Engraved on underside: LCT / R1039
Acc. no. 80840

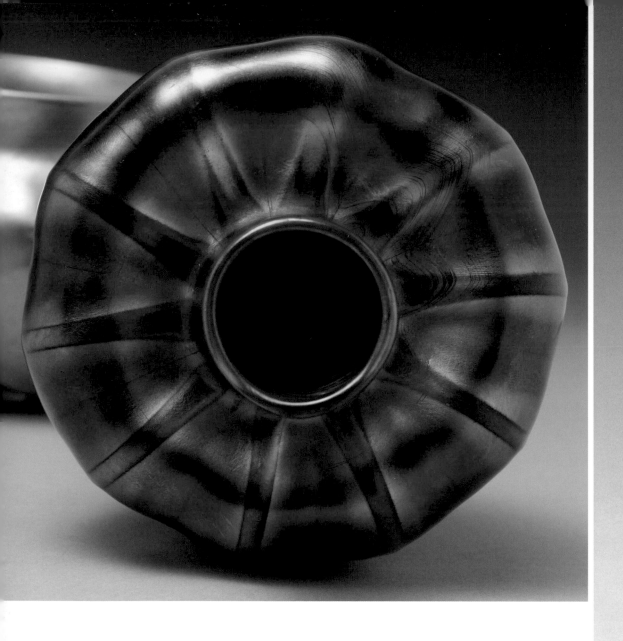

30

VASE
c. 1898–1900
Blown glass
Height: 4 ½ in. (11.4 cm)
Engraved on underside: LCT N1353
Acc. no. 80230b

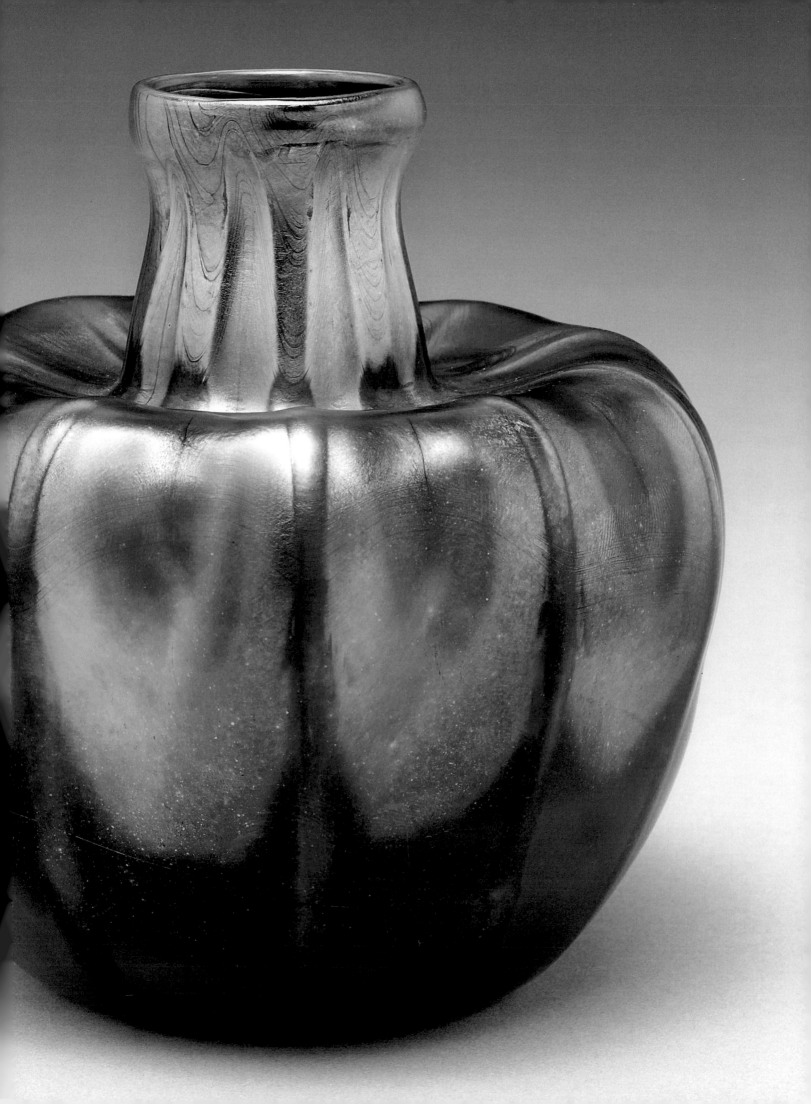

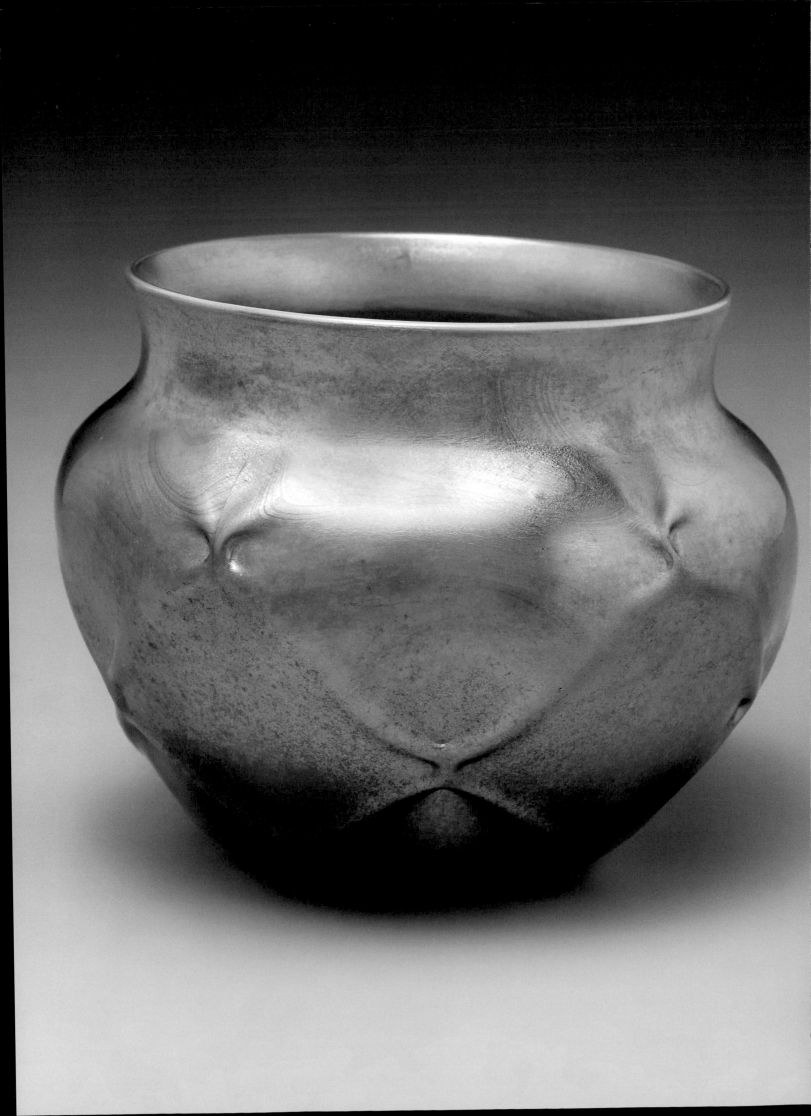

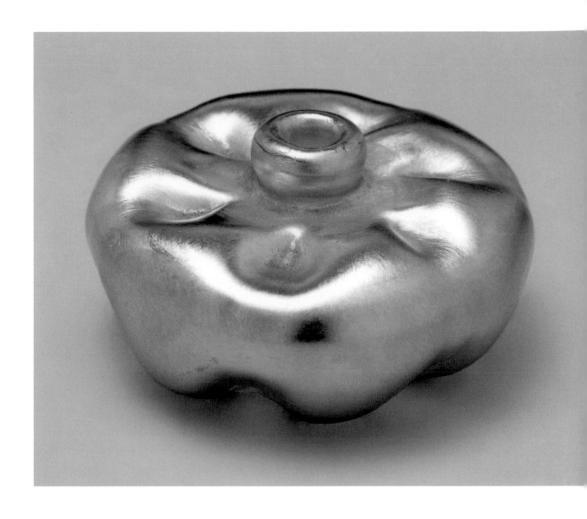

 VASE
c. 1896
Blown glass
Height: 3 1/2 in. (8.9 cm)
Engraved on underside: LCT /D859 [?]
Acc. no. 80230a

32 MINIATURE VASE
After 1900
Blown glass
Height: 1 in. (2.5 cm)
Engraved on underside: 7029 [?]
Acc. no. 80652

Miniatures were common in Tiffany glass and had no function other than providing the pleasure of small, collectible treasures to be grouped and enjoyed. These miniatures mimic or adapt the designs of the larger vases, and demonstrate the range of Tiffany's innovative forms.

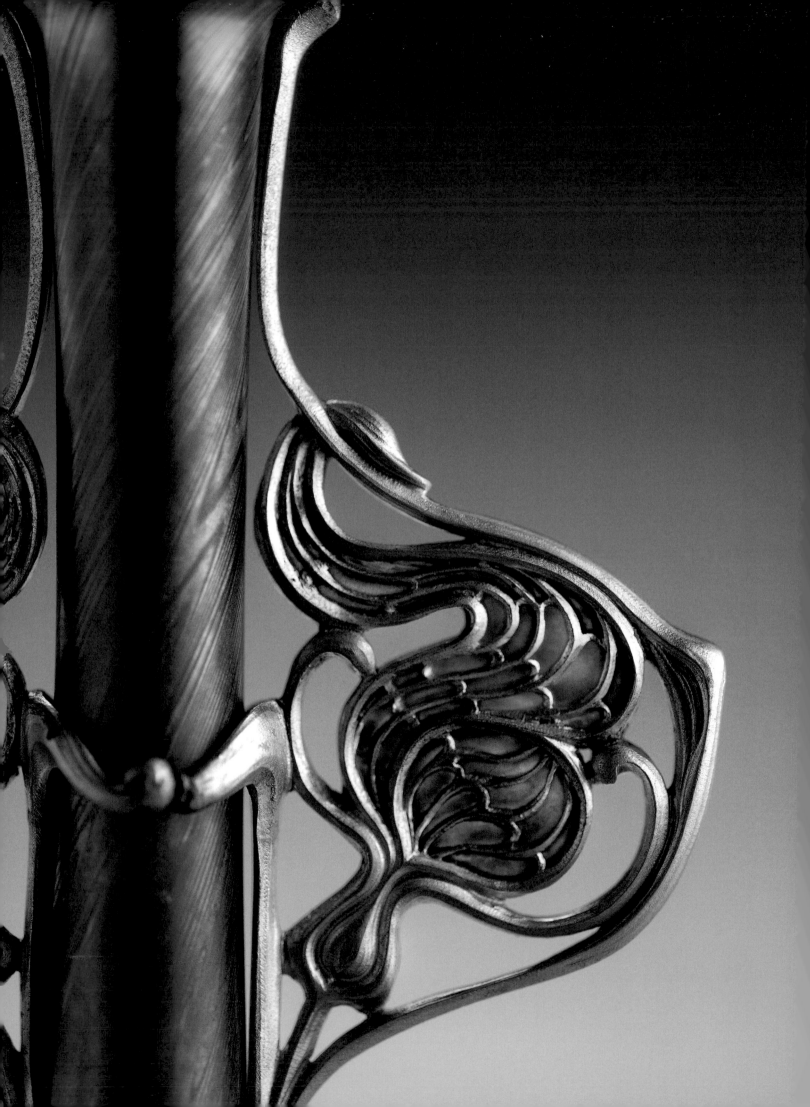

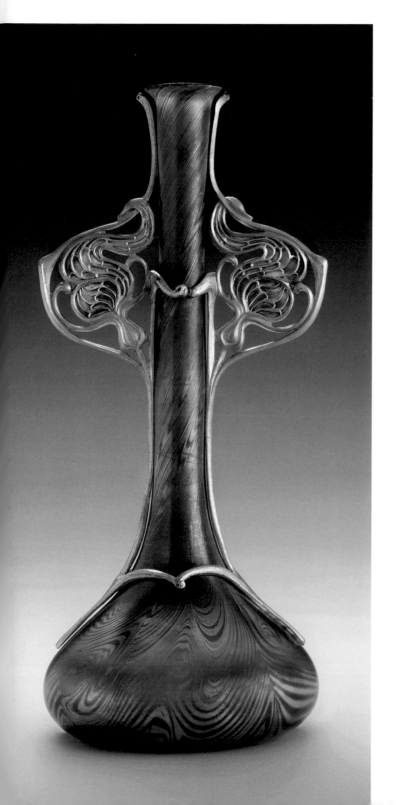

VASE

c. 1897–98; mounts c. 1898
Blown glass, mounts of gilt silver and
plique-à-jour enamel
Height: 9 5/8 in. (24.4 cm)
Engraved on underside: L.C.T. / G88
Mounts designed by Edward Colonna
Acc. no. 80275

This vase combines the artistry of Louis
Comfort Tiffany and Edward Colonna.
Born in Germany, Colonna immigrated
to New York in 1882 and worked for
Tiffany from 1883 to 1884. Colonna would
later work for Siegfried Bing, who in
1894 had become Tiffany's sole represen-
tative in Europe, selling Tiffany Favrile
glass in his store L'Art Nouveau in Paris.
About 1897–98 Bing changed his
approach to business from representing
various designers to presenting "a
unified look by creating a house style, one
which would be more acceptable to
the French."[1] Bing hired his own staff,
including Colonna, to achieve this goal.
Among the first of Colonna's assignments
was to create mounts for objects Bing
had in stock, including Favrile vases by the
Tiffany Glass & Decorating Co. The
enameled mountings transformed "these
diverse objects into ones with a common,
modern style."[2] Colonna's Art Nouveau
mounts, with stylized flowers within the
brackets, were executed by Eugène
Feuillâtre, a French sculptor and enameller
who had worked with René Lalique.
Although small in scale, this vase has
dramatic presence because of Colonna's
mounts and would appeal more to Bing's
European clientele.

1. Martin Eidelberg, "Bing and L.C. Tiffany:
Entrepreneurs of Style," *Nineteenth-Century
Art Worldwide* 4, no. 2 (Summer 2005). <http://
www.19thc-artworldwide.org/index.php/
summer05/215-excavating-greece-classicism-
between-empire-and-nation-in-nineteenth-
century-europe>.

2. Eidelberg, "Bing and L. C. Tiffany: Entrepreneurs
of Style."

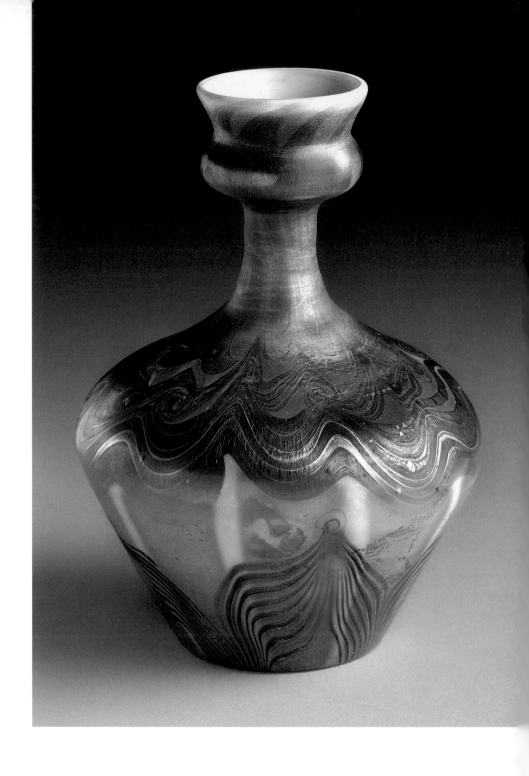

34

VASE
c. 1894
Blown glass
Height: 5 ½ in. (14 cm)
Engraved on underside:
L.C.T. [not original] / B292
Acc. no. 80817

VASE
c. 1904–6
Blown glass
Height: 6 in. (15.2 cm)
Engraved on underside:
LCT – Favrile 8989C
Acc. no. 80806

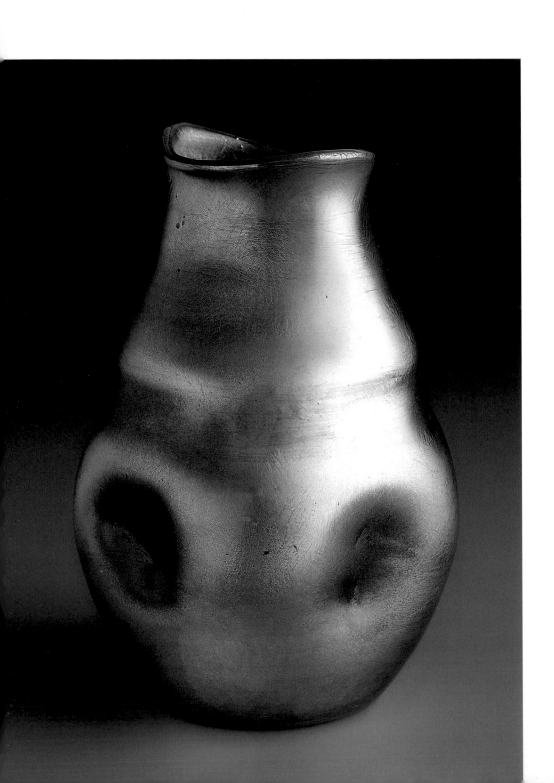

36 | MINIATURE VASE
c. 1914–15
Blown glass
Height: 2 ½ in. (6.4 cm)
Engraved on underside: L.C.T. *Tiffany Favrile*/5729J
Acc. no. 80657

37 | MINIATURE VASE
After 1900
Blown glass
Height: 2 in. (5.1 cm)
Engraved on underside: LCT
Acc. no. 80653

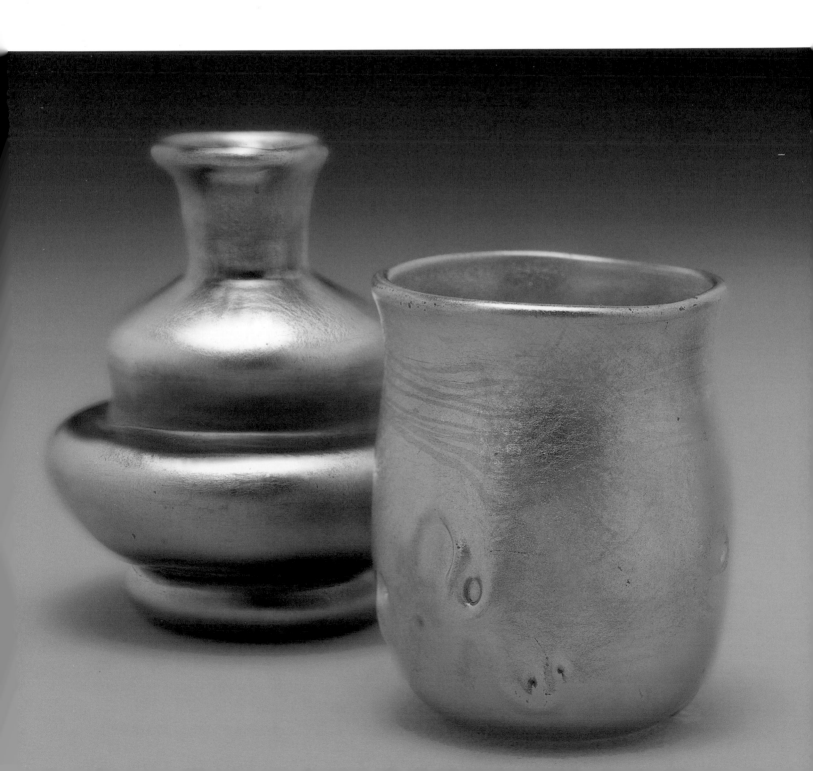

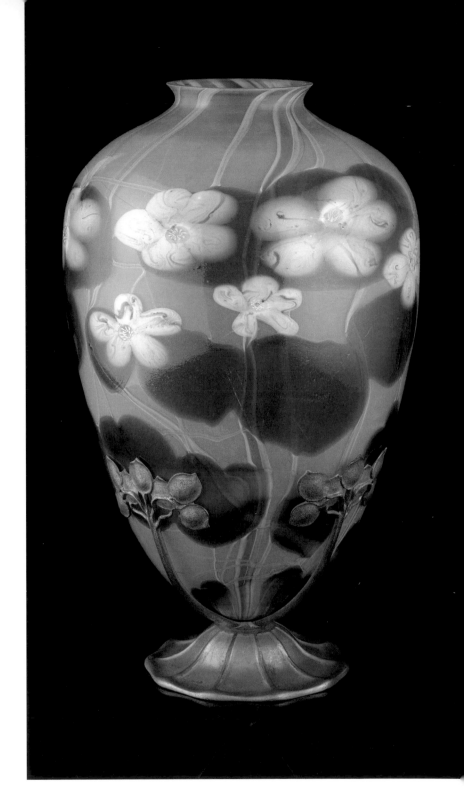

WATER LILY PAPERWEIGHT VASE WITH STAND

c. 1910
Blown glass, gilt bronze stand
Height: 16 ½ in. (42 cm)
Stamped on underside of stand:
TIFFANY STUDIOS / NEW YORK / 25
Acc. no. 80798

This spectacular paperweight vase is
supported by a decorative gilt–bronze
stand, with stems that terminate in the
shimmering seed pods of the Chinese
money plant, *Lunaria annua*. The vase
itself is large in scale, and the vibrantly
colored glass depicts lily pads floating
on a pond with white blossoms. The
vase cannot stand on its own because
of its rounded base, and so must be
placed in a stand or could alternatively
be used as a hanging lamp shade.[1]

1. See Robert Koch, *Louis C. Tiffany: The Collected
Works of Robert Koch*, 113, below left.

FURNITURE
AND
INTERIORS

In the late 1870s, Louis Comfort Tiffany began working on interiors, following the basic tenets of the Aesthetic Movement, which had begun in England in the 1860s. In America, the movement was prevalent from the mid-1870s through the 1880s and later. In adhering to the principles of this design paradigm, Tiffany's interiors demonstrated an "aversion to blank surfaces, and a rigid compartmentalization of decorated areas, usually into horizontal bands or square or rectangular panels with rich ornamentation."[1] Decorative elements from various historic sources were used to create a unified and harmonious whole. Tiffany's first interior was completed in 1878 for the top floor of his own home and studio in the Bella Apartments at 48 East 26th Street in New York City, published in *Artistic Houses*, 1883–84. The drawing room combines American furniture, "with its fine blotches of grain, and Japanese mushroom wall-paper … tiling with blue plaques," among other materials and objects, modern and antique, as well as oriental porcelain displayed throughout.[2]

Among Tiffany's earliest and most ambitious interiors was the 1879 commission for the pharmaceutical magnate George Kemp, which included the entrance hall, dining room, library, and salon of his house at 720 Fifth Avenue, New York. He created an eclectic mixture of Near Eastern and North African influences that also incorporated his stained-glass windows. Its color, luxuriousness, and sense of harmony cannot be conveyed in the flatness of black-and-white photographs since depth, contrast, and texture are invisible. However, *Artistic Houses* provides us with a vivid description of the salon, which allowed one to "refresh one's self with the delicious melody of color," described as Arabic with an inclination to the Persian in its forms.[3]

Around 1880, Tiffany went into partnership with Candace Wheeler, forming Tiffany & Wheeler at 335 Fourth Avenue in New York, which specialized in embroideries. By the end of that year, he had also established two other businesses: Tiffany & de Forest specialized in decorating services, and L. C. Tiffany & Co. specialized in furniture.[4] In 1881, Louis C. Tiffany & Co., Associated Artists, was formed as a partnership of Tiffany, Candace Wheeler, Lockwood de Forest, and William Pringle Mitchell, but "Associated Artists" became an umbrella term that was used loosely in reference to the many different associations that were founded and closed between 1877 and 1883.[5] One of the few surviving interiors by this firm was the richly decorated Veterans Room of the Seventh Regiment Armory, New York, of 1881. Other significant interior commissions included the Mark Twain House in Hartford, Connecticut (1881), and the Red Room of the White House (1882–83). Although the firm was dissolved in 1883, Candace Wheeler

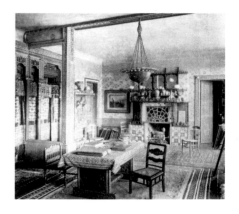

Drawing Room, Bella Apartments, 48 East 26th Street, New York, 1878. From *Artistic Houses, Interior Views of a Number of the Most Beautiful and Celebrated Homes in the United States*, New York, D. Appleton & Co., 1883.

1. Marilynn Johnson, "The Artful Interior," *In Pursuit of Beauty: Americans and the Aesthetic Movement* (New York: The Metropolitan Museum of Art and Rizzoli, 1986), 128.

2. *Artistic Houses: Interior Views of a Number of the Most Beautiful and Celebrated Homes in the United States* (New York: D. Appleton & Co., 1883, repr. New York: Benjamin Bloom, 1971), 4.

3. *Artistic Houses,* 53.

4. Roberta A. Mayer and Carolyn K. Lane, "Disassociating the 'Associated Artists': The Early Business Ventures of Louis C. Tiffany, Candace T. Wheeler, and Lockwood de Forest," *Decorative Arts* 8, no. 2 (Spring–Summer 2001): 3.

5. Mayer and Lane, 3, 4.

6. Alice Cooney Frelinghuysen, *Louis Comfort Tiffany at the Metropolitan Museum* (New York: The Metropolitan Museum of Art, 2006), 14.

7. *A Synopsis of the Exhibit of the Tiffany Glass and Decorating Company in the American Section of the Manufacturers and Liberal Arts Building at the World's Fair, Jackson Park, Chicago, Illinois, 1893, with an appendix on Memorial Windows* (New York: Tiffany Glass & Decorating Company, 1893), 7.

8. A "parlor armchair" from the Kemp House is in the Newark Museum, acc. no. 96.87. An armchair from the Rembrandt room of the Havemeyer House is in the collection of The Metropolitan Museum of Art, acc. no. 1992.125. See Frelinghuysen, *Louis Comfort Tiffany at The Metropolitan Museum of Art*, 14.

9. For the bronze table and armchairs at The Metropolitan Museum of Art, acc. nos. 66.97 and 64.202.1,2, see Marilynn Johnson, *19th Century America, Furniture and Other Decorative Arts* (New York: The Metropolitan Museum of Art, 1970), cat. no. 262.

10. See Alice Cooney Frelinghuysen, "An Expression of Individuality: The Interiors of Laurelton Hall," in *Louis Comfort Tiffany and Laurelton Hall: An Artist's Country Estate* (New York: The Metropolitan Museum of Art; New Haven, CT: Yale University Press, 2006), 81–103.

continued her textile work under Associated Artists while Louis C. Tiffany & Company handled other projects.

In 1891, Tiffany received from Louisine and H. O. Havemeyer one of his most important domestic interior commissions for their house at 1 East 66th Street, New York, which he designed in collaboration with the painter Samuel Colman. The exotic interior for the music room "featured a unique chandelier, with airborne blossoms of Queen Anne's lace, fine wire stems, and countless opalescent glass balls, fitted together with arms that extended over the entire ceiling."[6] Rich surface ornamentation derived from Near and Far Eastern sources and unifying eclectic elements provided a harmonious modern setting for the Havemeyers' distinguished art collection. Tiffany also provided special designs for furniture inspired by the Near East.

The production and sale of furniture became part of Tiffany's undertakings as an interior decorator. The firm's booklet for their display at the World's Columbian Exposition describes the variety of styles and forms exhibited there. This included a center table of dark green oak; a settle utilizing a mosaic composed of tiny squares of natural wood of different colors, each surrounded by a fine line of metal; and a chair and sofa in the Francis I style, carved, gilded, and elaborately upholstered.[7] Examples of Tiffany's furniture for both the Kemp and Havemeyer houses have survived and are documented in photographs or family provenance.[8] While Tiffany furniture is sometimes identified by markings, such as a bronze table in the Metropolitan Museum of Art stamped "Tiffany Studios," other unmarked pieces have been attributed to Tiffany only on stylistic grounds, such as a pair of armchairs in the same museum collection.[9]

The culmination of Tiffany's career as an interior designer was his design for his own house, Laurelton Hall at Oyster Bay, Long Island, which he began building in 1903. Many of his ideas for interiors explored in his earlier career were achieved in his house and garden, where he combined his artistic creations with his prized collections as well as his love of nature. One entered the house through the fountain court, an impressive room three stories high. An octagonal pool lined with iridescent glass was at the center, within which a Favrile glass vase form functioned as a fountain from which water spilled over. Nature, always Tiffany's inspiration, is here extravagantly celebrated through an abundance of flowers and plants.[10]

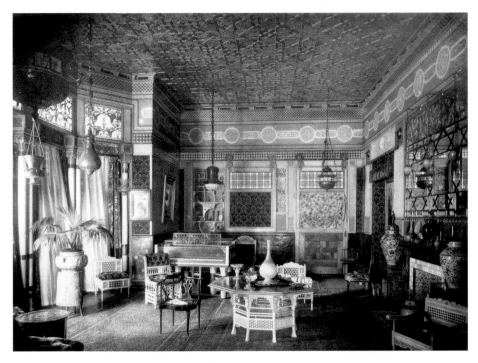

Salon, George Kemp House, 720 Fifth Avenue, New York, 1879, from *Artistic Houses, Interior Views of a Number of the Most Beautiful and Celebrated Homes in the United States*, New York, D. Appleton & Co., 1883.

Music room, H. O. Havemeyer House, 1 East 66th Street, New York, 1891–92, *Architectural Record* 1, Jan–Mar 1892, Avery Architectural and Fine Arts Library, Columbia University.

Veterans Room of Seventh Regiment Armory, Park Avenue and 67th Street, New York, 1881. New-York Historical Society.

Laurelton Hall: Moorish fountain in the entrance hall, after 1906. The Metropolitan Museum of Art.

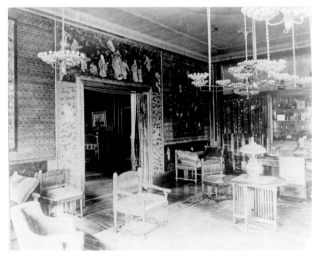

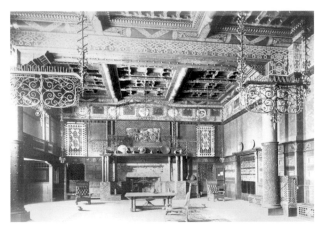

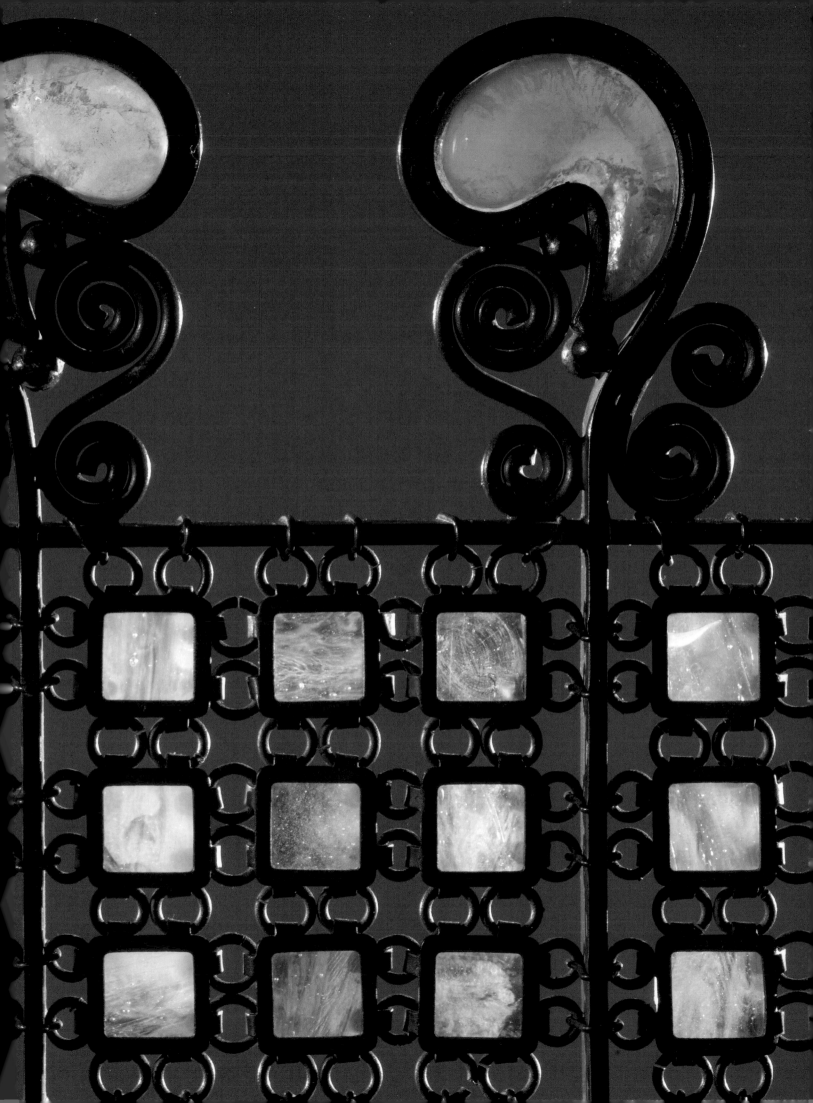

39 | FIRE SCREEN

Early twentieth century
Molded and blown glass, bronze,
wrought iron
36 3/8 x 44 5/8 x 12 1/4 in.
(92.4 x 113.3 x 31.1 cm)
No marks
Acc. no. 60216

A rare survival, this fire screen is a
simpler version of one Tiffany designed
for the entrance hall in the H. O.
Havemeyer House, 1891–92.[1] While
the Havemeyer screen combines gilt
metal and glass in an intricate design and
an imaginative mixture of Near Eastern
motifs, this example is a simpler, bolder
design resembling an embroidery with
seventy-seven squares, each "woven"
with favrile glass squares. Firelight
passes through the spaces between the
glass as well as the glass itself.

1. See "Modern American Residences," *The Architectural Record* 1, no. 3 (January–March 1892).

Louis Comfort Tiffany and Samuel Colman,
Fire screen from the entrance hall of the
H. O. Havemeyer House, 1891–92. University
of Michigan School of Art and College of
Architecture and Urban Planning.

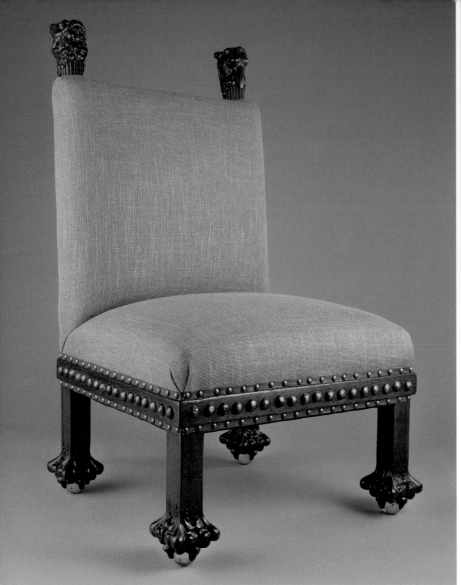

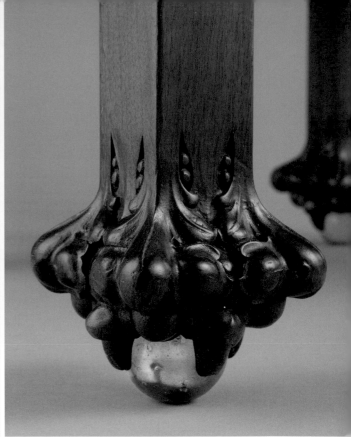

40 | SIDE CHAIR

c. 1881–1883
Walnut, brass, glass, fabric
39 x 21 7/8 x 20 1/2 in. (99.1 x 55.6 x 52.1 cm)
Attributed to Louis Comfort Tiffany
Acc. no. 10700

This side chair, originally part of a larger suite, is related to Tiffany's furniture designs for the Veterans Room of 1879 at the Seventh Regiment Armory and for the William S. Kimball House of 1882. Of particular note are the superbly carved finials—one an egret, the other a toad. Brass studs, individual finials, and glass ball feet were used by Tiffany but also other cabinetmaking shops of the period.

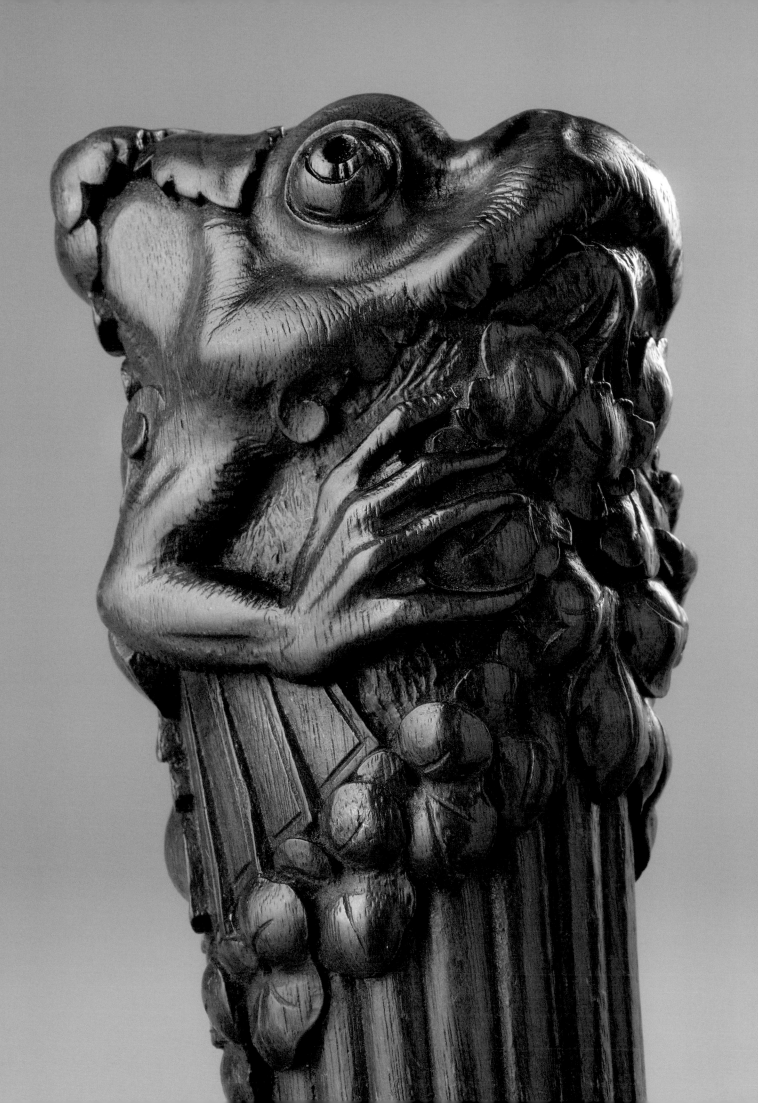

41

LILIES FIRE SCREEN
c. 1900
Blown glass, mahogany
46 ³/₄ x 57 ¹/₂ in. (118.7 x 146.1 cm)
No marks
Acc. no. 60051

This footed screen framed in dark
mahogany resembles the fumed oak of
Arts-and-Crafts furniture. Its large
scale and strong presence suggest it was
placed before a broad hearth, where
its colorful lily design would have been
illuminated by the fire. The lily was
popular during the period of the Aesthetic
Movement. It is often associated with
the Irish writer and poet Oscar Wilde, who
carried the flower. It continued to be
a popular flower for Tiffany, who would
incorporate it into ecclesiastical windows
as well as residential, since it also
symbolized the Resurrection. Here the
white lilies stand out against the lush
green leaves and blue ground of the sky.
A fire behind would have added ever
greater movement to a lively composition.

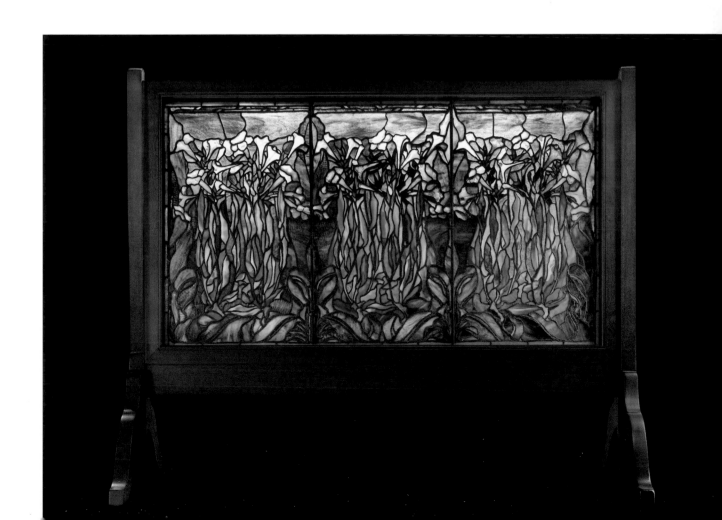

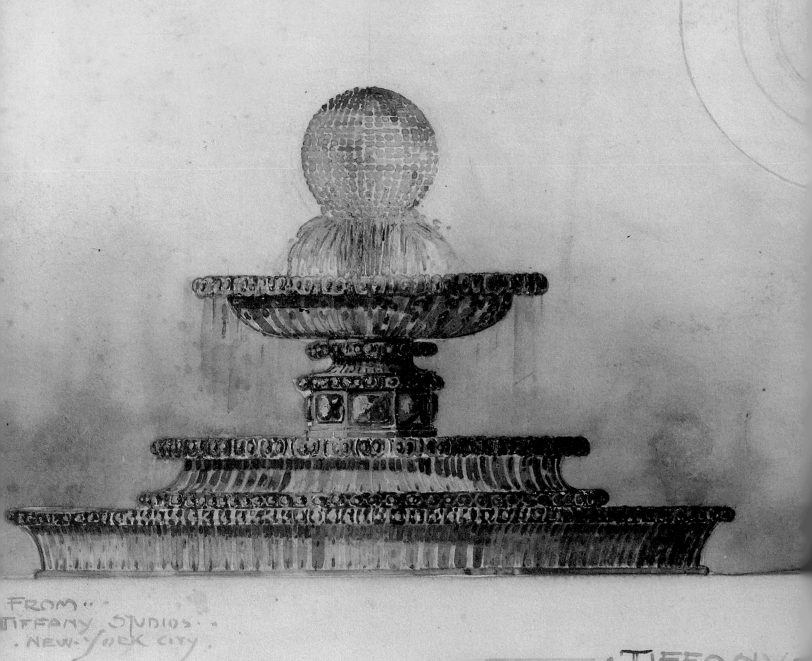

FROM
TIFFANY STUDIOS
NEW YORK CITY

TIFFANY
for MARSA
CHICAGO

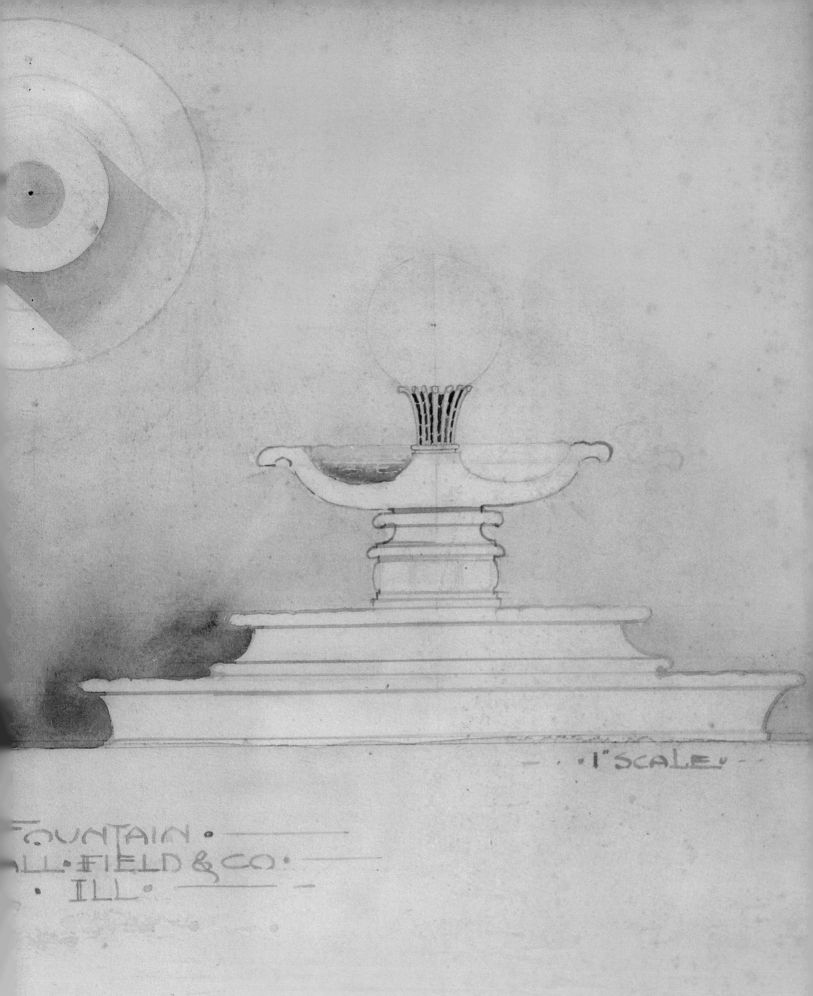

·1"SCALE·

FOUNTAIN·

LL·FIELD & CO·

·ILL·

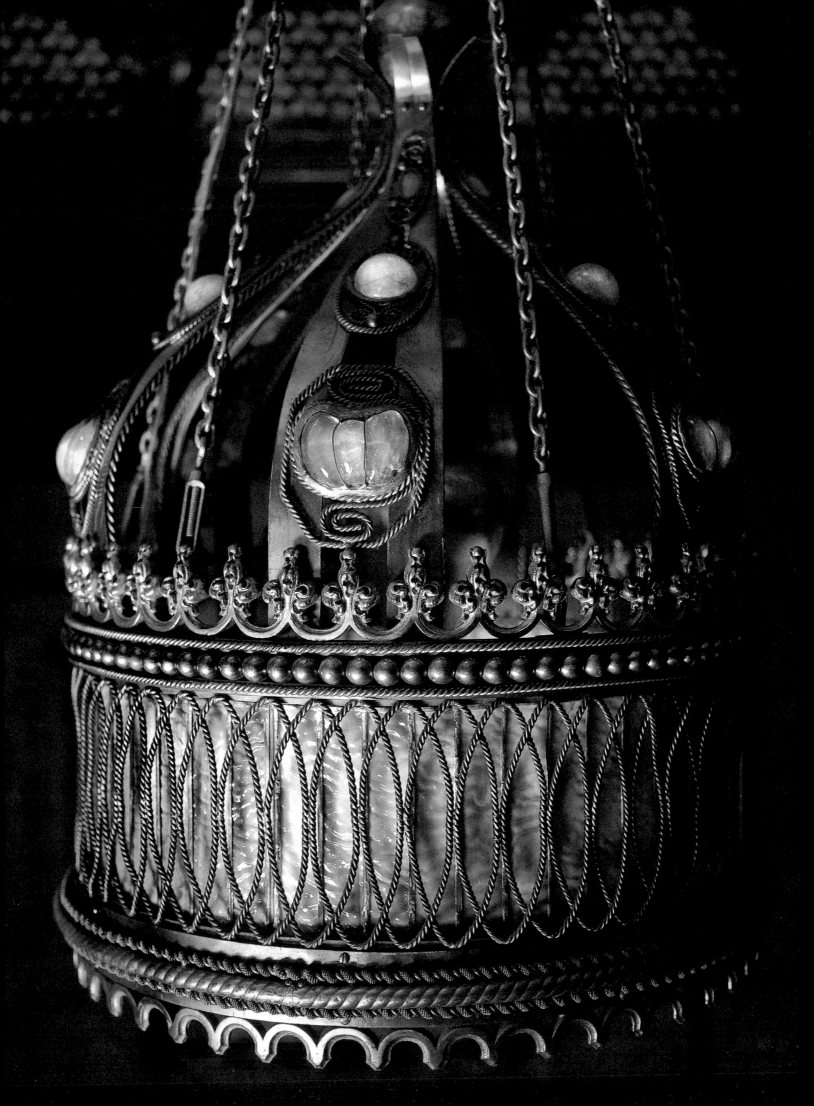

44 MOORISH CHANDELIER
1902–32
Bronze, Favrile glass
30 x 24 ½ in. (76.2 x 62.2 cm)
Acc. no. 30939

DECORATIVE
OBJECTS

In 1897−98, Tiffany established a foundry and metal shop as part of an expansion of his glassworks in Corona, Queens, and Alvin J. Tuck was engaged to manage the metal department. He was the principal designer of the metal objects, working in collaboration with Tiffany.[1]

Many of Tiffany's candlesticks are characterized by long, slender shafts on wide bases with sockets in the form of flowering buds, all in cast bronze. Similar in form to some of the floral vases, their fragile-looking bronze stems were far sturdier than those of the glass forms. The elongated candlesticks are characteristic of English and European Arts-and-Crafts designs of the late nineteenth and early twentieth centuries. For example, the Chicago craftsman Robert Jarvie made similar elongated candlesticks in silver and other materials, but with smooth surfaces and without decoration as seen in the Tiffany examples.

The candlesticks were typically made and sold as singles rather than pairs. These candlesticks were finished in green, brown, silver, or gold, and sometimes with iridescent glass jewels. This latter type was created by blowing molten glass directly into a pierced bronze form. The candlesticks were successful in terms of their production to meet wide demand during the period of expansion by Tiffany Studios, especially for gift items. Candlesticks were sold at retail stores throughout the country, including Marshall Field & Co. in Chicago, and could also be specially ordered.

The candelabra for the World's Columbian Exposition were the first early examples of Tiffany's designs for this form in metal to be exhibited (CAT. 49). Six years later, in 1899, the first major international exhibition of Tiffany's work was held in London at the Grafton Gallery, arranged by Siegfried Bing. Candelabra were among the Tiffany objects exhibited: there were examples of one, two, and four lights in metal with glass blown inside.

Tiffany accessories ranged from commercial desk sets to unique objects in enameled copper, silver, bronze infused with Favrile glass, and gilt. Enamel-on-copper wares were among the most exotic of Tiffany's creations (CAT. 51). According to Janet Zapata, Tiffany undertook his first experiments with enameling on metals in 1898 at the glassworks in Corona, Queens. The enamel department was originally set up in a small laboratory in Tiffany's 72nd Street house in Manhattan, moved to 23rd Street, and, finally, moved to the glass factory at Corona in 1903. Enamel work was done by women: Patricia Gay was in charge of the new department, which included Alice Gouvy and Julia Munson. Enameling was a straightforward technique: a paste composed of flint or silica with other

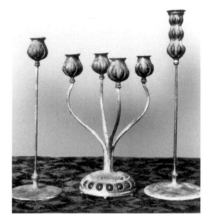

Candlesticks, c. 1899.

1. Robert Koch, *Louis C. Tiffany: The Collected Works of Robert Koch* (Atglen, PA: Schiffer, 2001), 214.

The metal showroom at Tiffany Studios, as shown in a promotional booklet in 1913.

2. Janet Zapata, *The Jewelry and Enamels of Louis Comfort Tiffany* (New York: Harry N. Abrams, 1993), 43–45.

3. See Robert Koch, *Louis C. Tiffany: The Collected Works of Robert Koch*, 215–19.

additives was spread in a thin layer over metal and fused onto it by extremely high heat. Enamel can be produced in a broad variety of colors, it ranges from transparent to opaque, and it can be applied to many different types of metal. Tiffany preferred copper as the base, which could be raised like silver hollowware over an anvil until its shape was formed.[2]

When he became art director for his late father's firm, Tiffany & Co, in 1902, Louis Tiffany set up his own separate jewelry department in the Fifth Avenue store, which also sold such objects as the silver and enameled box seen in this section (CAT. 50). Most of the accessories in gold and silver designed by Louis C. Tiffany were produced by Tiffany & Co. beginning in 1907.

Whereas the enamelware was done by a small department experimenting with new forms and surface treatments in limited production, the bronze desk sets are one of the most common of Tiffany items seen today. According to Robert Koch, Tiffany Studios produced more than fifteen patterns in matched sets in the first quarter of the twentieth century. However, they were not sold as sets: they were illustrated together in a Tiffany Studios 1920 catalogue, but each piece was priced and sold individually. Each illustration was followed by a list of the entire set, with a number, brief description, and price for each piece.[3]

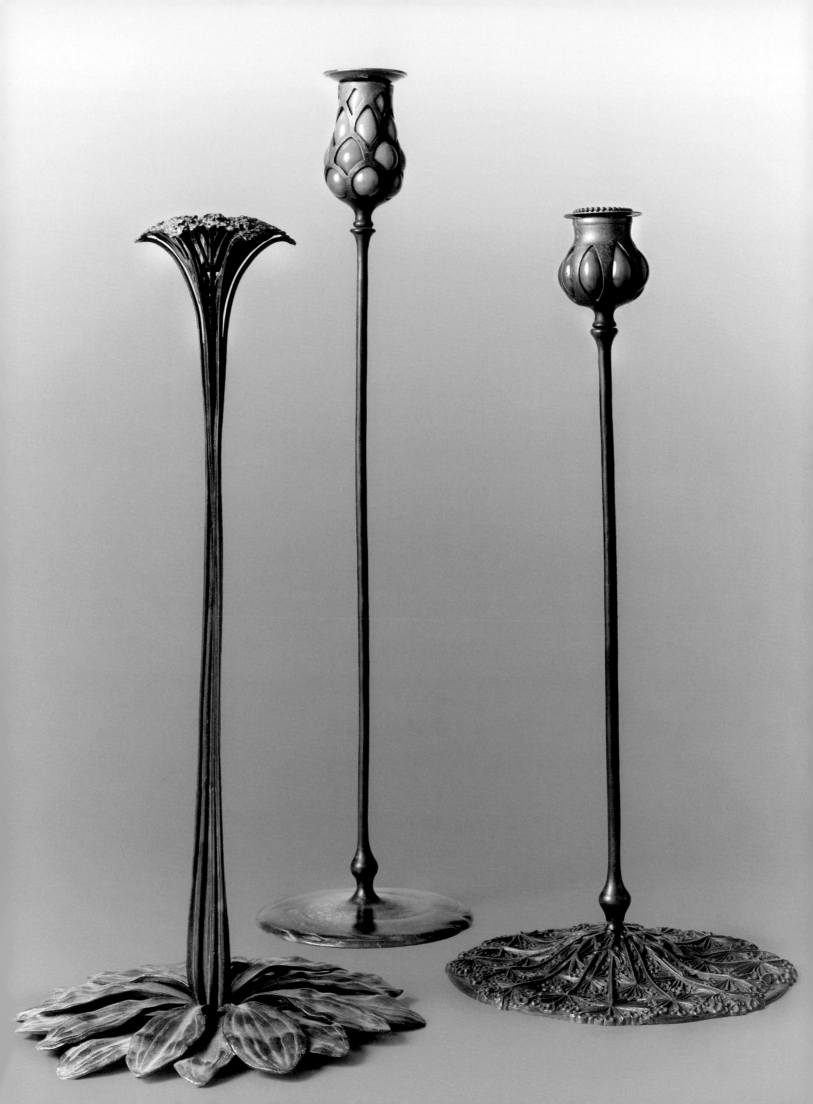

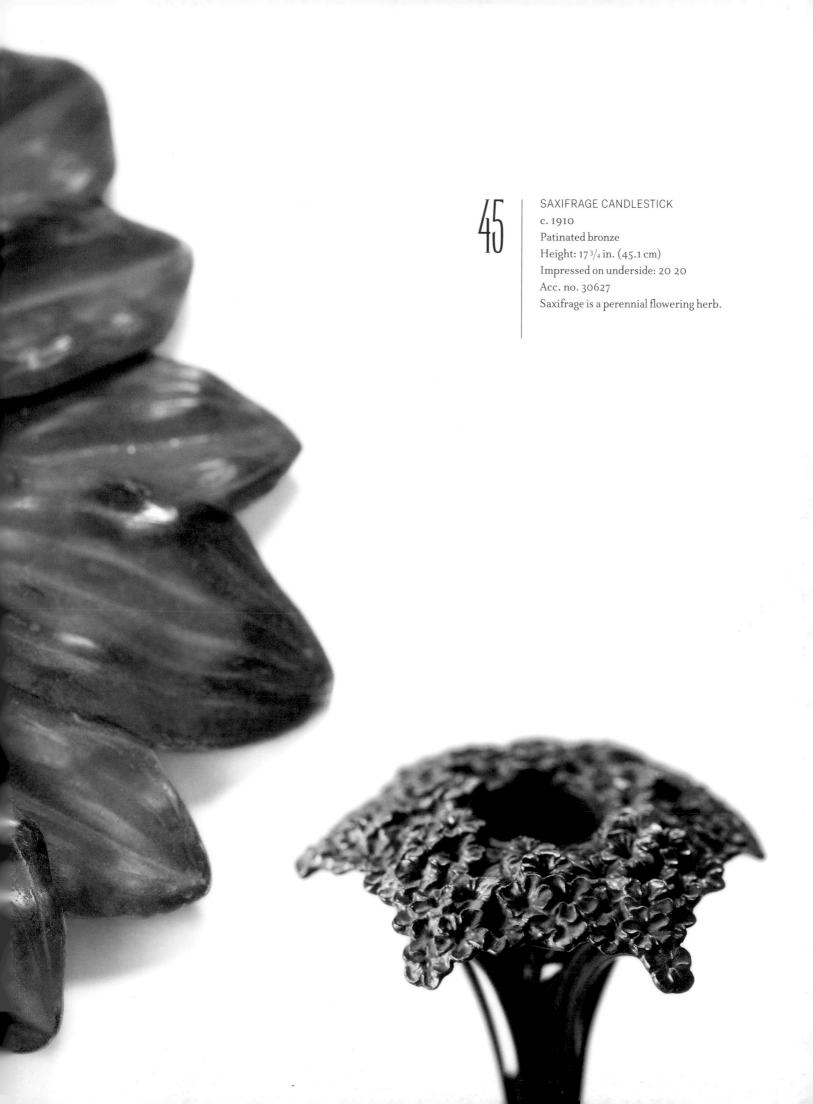

45

SAXIFRAGE CANDLESTICK
c. 1910
Patinated bronze
Height: 17 3/4 in. (45.1 cm)
Impressed on underside: 20 20
Acc. no. 30627
Saxifrage is a perennial flowering herb.

46

Page 149 (center)
PINEAPPLE CANDLESTICK
Before 1902
Bronze, blown glass
Height: 25 ¾ in. (65.4 cm)
Impressed on underside of base
(barely discernible): [conjoined
monogram TGDCO] / S1571
Acc. no. 38047

47

WILD CARROT CANDLESTICK
1898–1902
Patinated bronze, blown glass
Height: 18 in. (45.7 cm)
Impressed on underside:
TIFFANY STUDIOS / NEW YORK /
[conjoined monogram TGDCO] / D881
Acc. no. 30978

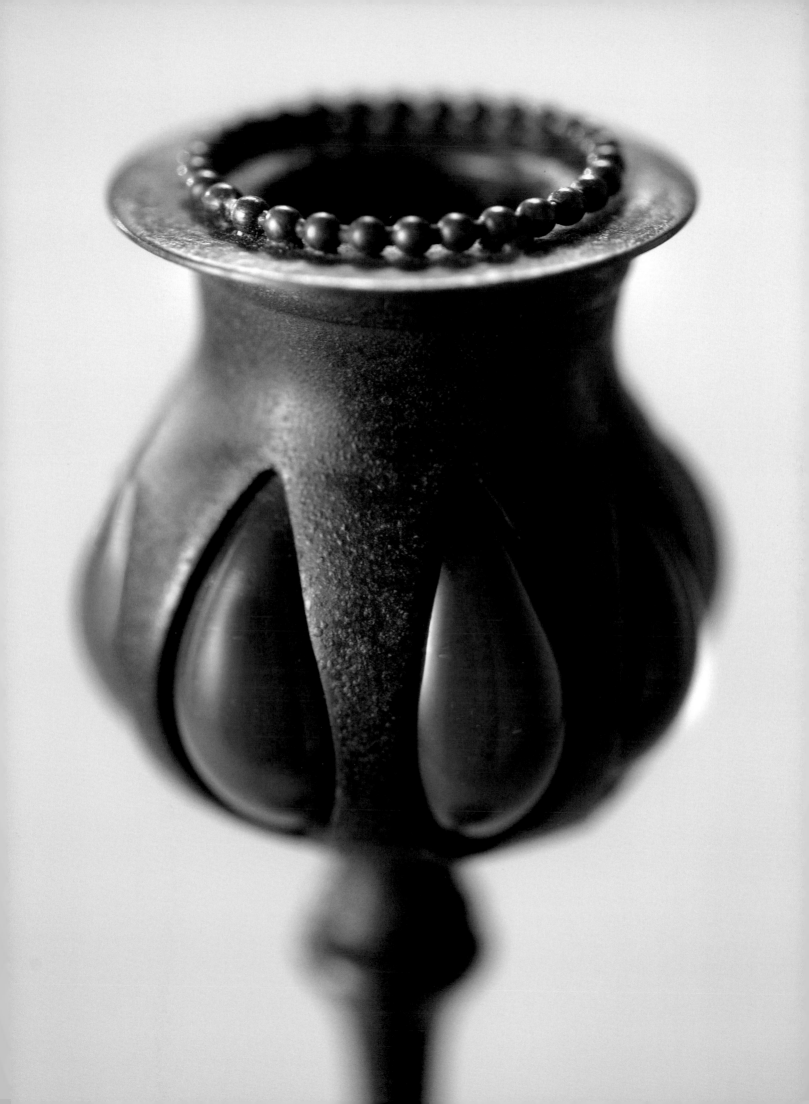

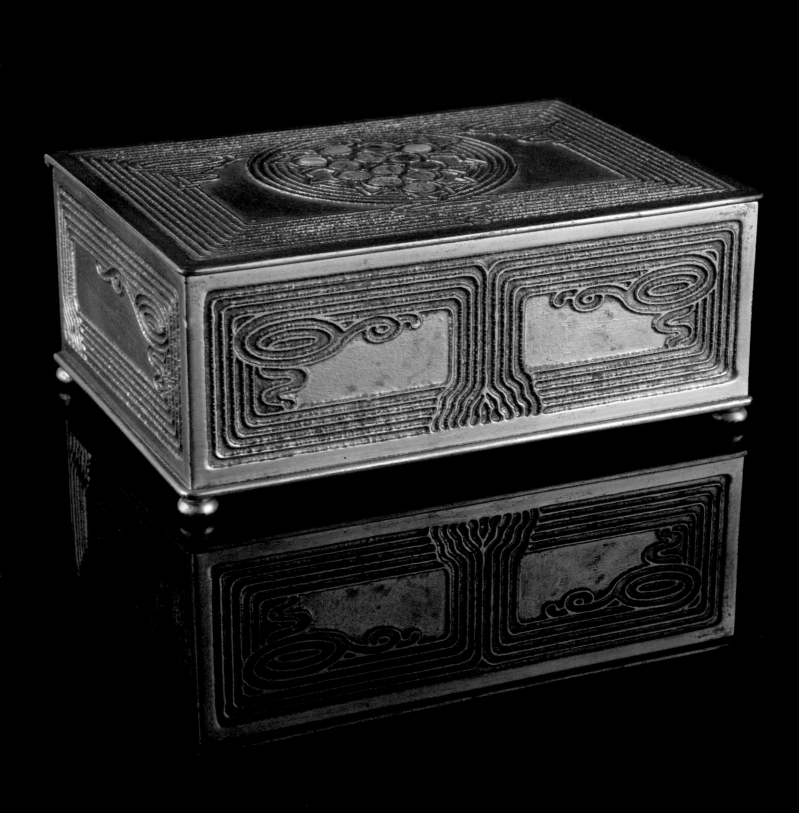

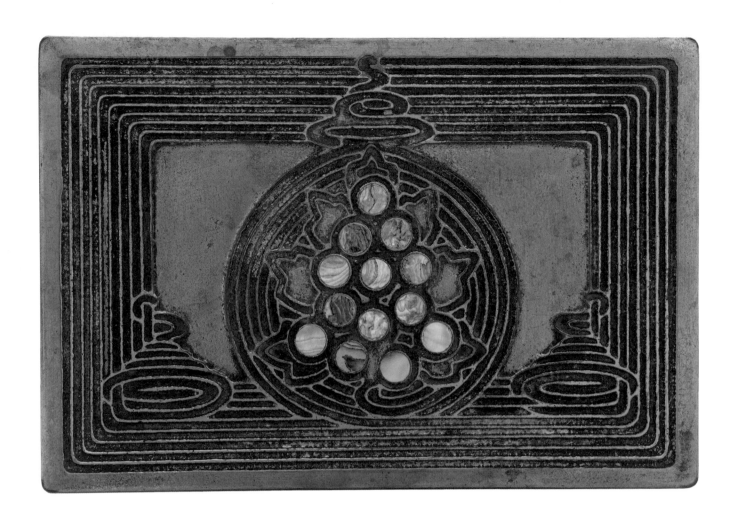

 JEWELRY BOX
1900–1910
Gilt bronze, abalone,
velvet-covered wood
2 1/2 x 4 1/2 x 6 1/2 in. (6.4 x 11.4 x 16.5 cm)
On underside: TIFFANY STUDIOS /
NEW YORK / 1174
Engraved on underside: 1110
[not Tiffany mark]
Acc. no. 80236

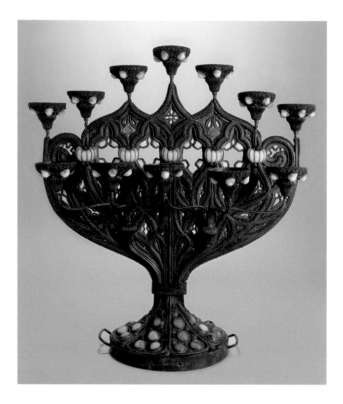

BENEDICTION CANDELABRUM
1893
Bronze, molded glass
47 x 44 in. (119.4 x 111.8 cm)
No marks
Acc. no. 30816

This candelabrum was designed for the Tiffany Glass & Decorating Company exhibit at the World's Columbian Exposition. Its melange of opulent, medievalizing styles related to the Romanesque- and Byzantine-inspired interior of the Tiffany chapel. The intricate workmanship demonstrated the virtuosity of the Tiffany firm in ecclesiastical designs, which were promoted in the Chicago exhibition. Two tiers of candle cups—seven above and five below, raised on slender, curved arms—are each decorated with coiled bronze wire and inset with four opalescent glass cabochons. The Gothic trefoil arched top is also decorated with coiled bronze wire, pierced, and inset with faceted emerald-green glass jewels. The circular base is inset with opalescent glass cabochons. According to a period photograph of the Tiffany chapel, there were six candlesticks on the altar and two alongside the lectern (see p. 23). In addition, there were at least two of these benediction candelabra. Another example was in the Takeo Horiuchi Collection, Japan.[1] Although the location of the benediction candelabra was not recorded in photographs, they were displayed in the adjacent ecclesiastical section, "external to and at one side of the chapel," according to *A Synopsis of the Exhibit of the Tiffany Glass & Decorating Company*, published in 1893 by the company, which also illustrated one of the candelabra.[2]

1. Alastair Duncan, *Louis C. Tiffany, the Garden Museum Collection* (Woodbridge, Suffolk, UK: Antiques Collectors' Club, 2004), 446.

2. Email from Jennifer Thalheimer, curator, Morse Museum of American Art, August 20, 2012.

50

COVERED BOX
c. 1905
Silver, transparent enamel
Width: 4 3/4 in. (12.1 cm)
Stamped on underside: TIFFANY /
FURNACES / STERLING / 245
Acc. no. 80004

51 | INKWELL
1899–1902
Enameled copper, blown glass liner
2 1/4 x 3 in. (5.7 x 7.6 cm)
Stamped on underside: SG835
Acc. no. 80559

52 | INKWELL BOX
1900–1910
Patinated bronze, blown glass
4 1/4 x 8 5/8 x 3 5/8 in.
(10.8 x 21.9 x 9.2 cm)
Engraved on one glass inkwell: LCT
Acc. no. 80393

This square-cornered inkwell box is
straightforward and masculine,
incorporating iridescent Favrile glass
on the sides and top. There are eight
hooks for pens on the inner lid, two
Favrile glass inserts for ink within, and
a small drawer at the center front.

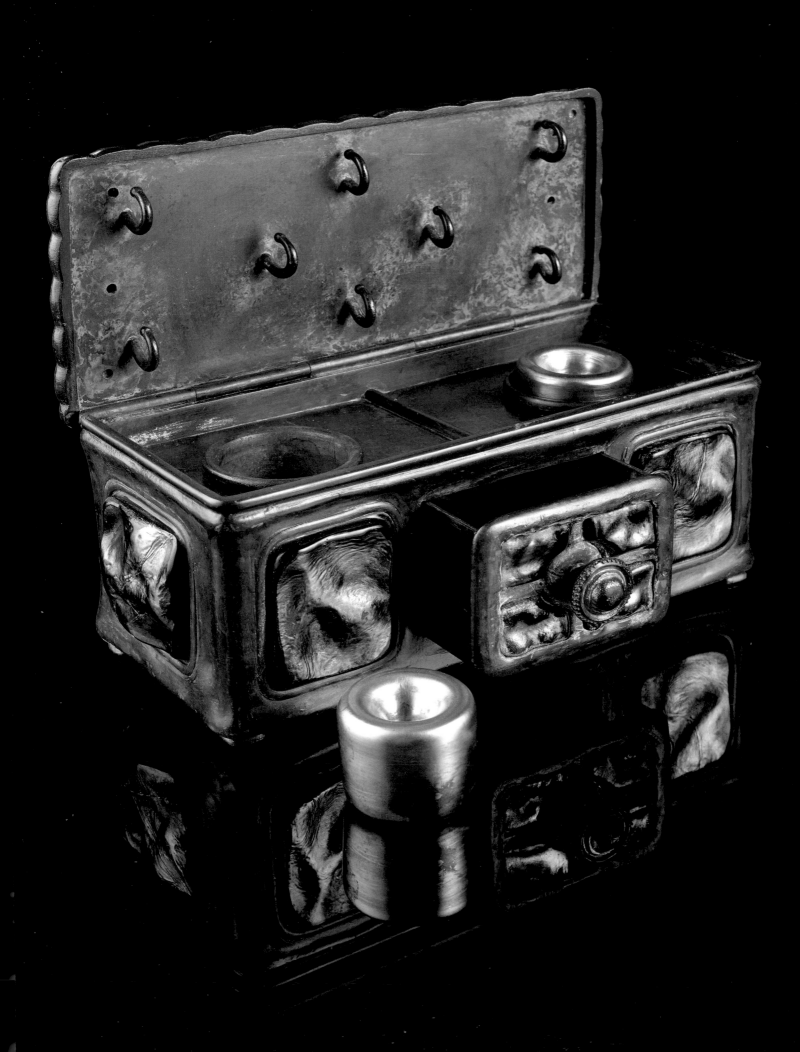

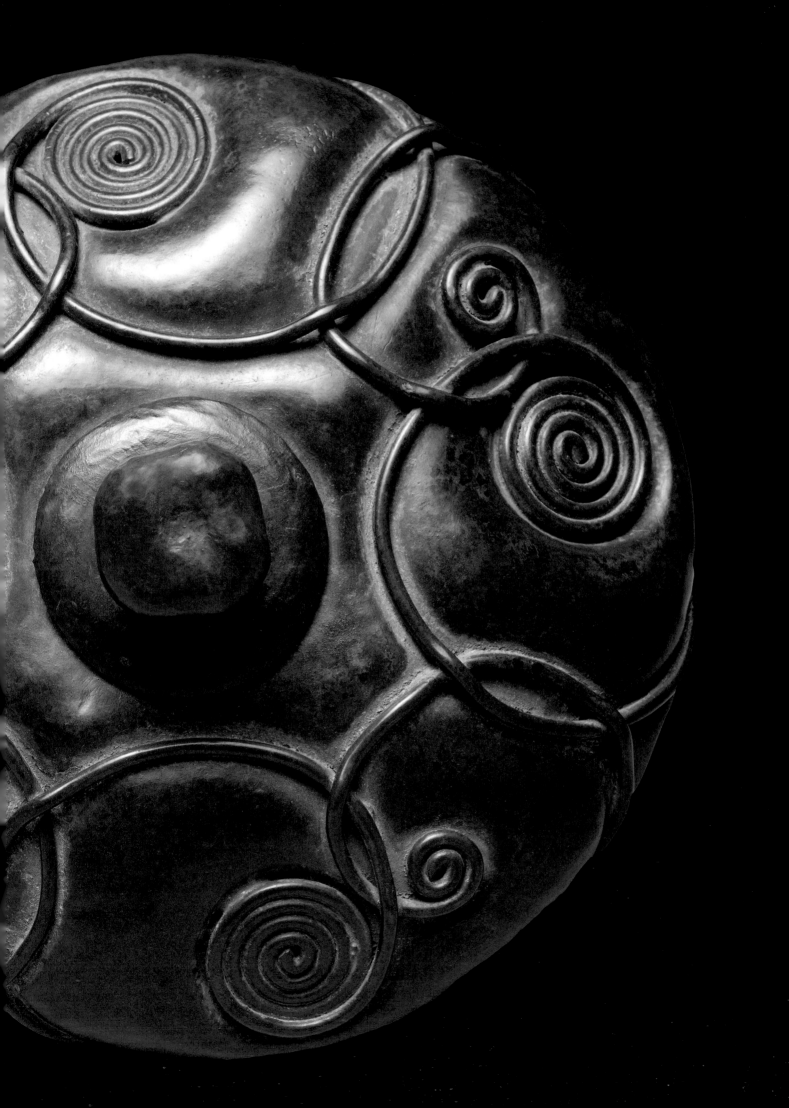

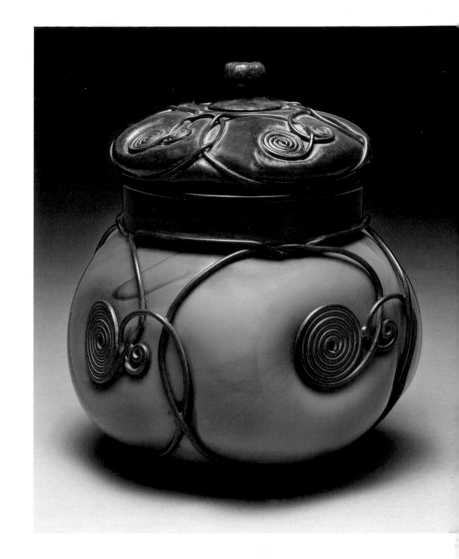

HUMIDOR
1902–10
Bronze, blown glass
8 1/2 x 6 1/2 in. (21.6 x 16.5 cm)
Stamped on base: TIFFANY STUDIOS /
NEW YORK / 1025
Acc. no. 80246

This striking humidor is an imaginative, fanciful design of overlapping spirals of bronze wire terminating in tightly curled wire circles. The green Favrile glass is blown into the bronze framework and provides a striking harmonious ground for the wire design derived from Middle Eastern decorative motifs. The design on the top echoes the configuration on the body. Tiffany used a similar technique on other objects, including lamp bases from the same period.

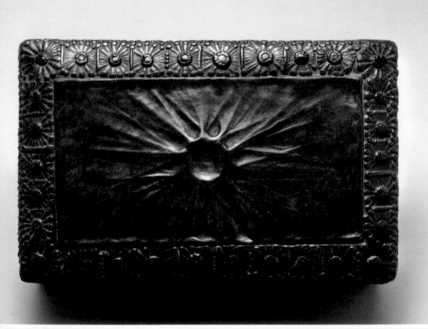

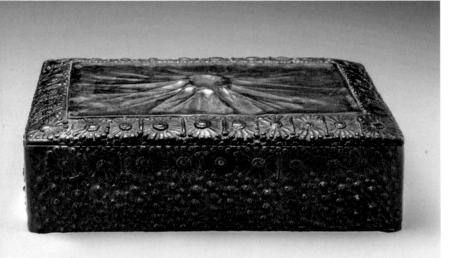

54

CANDLESTICK
1899–1920
Blown glass and bronze
Height: 13 ½ in. (34.3 cm)
Scratched on underside of base: RIW
[not Tiffany mark]
Shade signed: F7051 [?]
Acc. no. 30276

55

HUMIDOR
c. 1902–10
Patinated bronze, cedar lining
3 x 9 x 6 in. (7.6 x 22.9 x 15.2 cm)
Stamped: TIFFANY STUDIOS /
NEW YORK / 252
Acc. no. 89987

Although it appears handcrafted, this humidor is cast in bronze with repoussé work of stylized flowers and circles in relief in a medievalized design. An identical box was in the collection of Edgar Kaufmann Jr., an early collector of Tiffany, who saw this design as an Arts-and-Crafts object representing the origins of modernism.[1] The design reflects Tiffany's fascination with Japanese metalwork as interpreted by his creative imagination.

1. Illustrated in Robert Judson Clark, ed., *The Arts and Crafts Movement in America 1876–1916* (Princeton, NJ: Princeton University Press, 1972), 23.

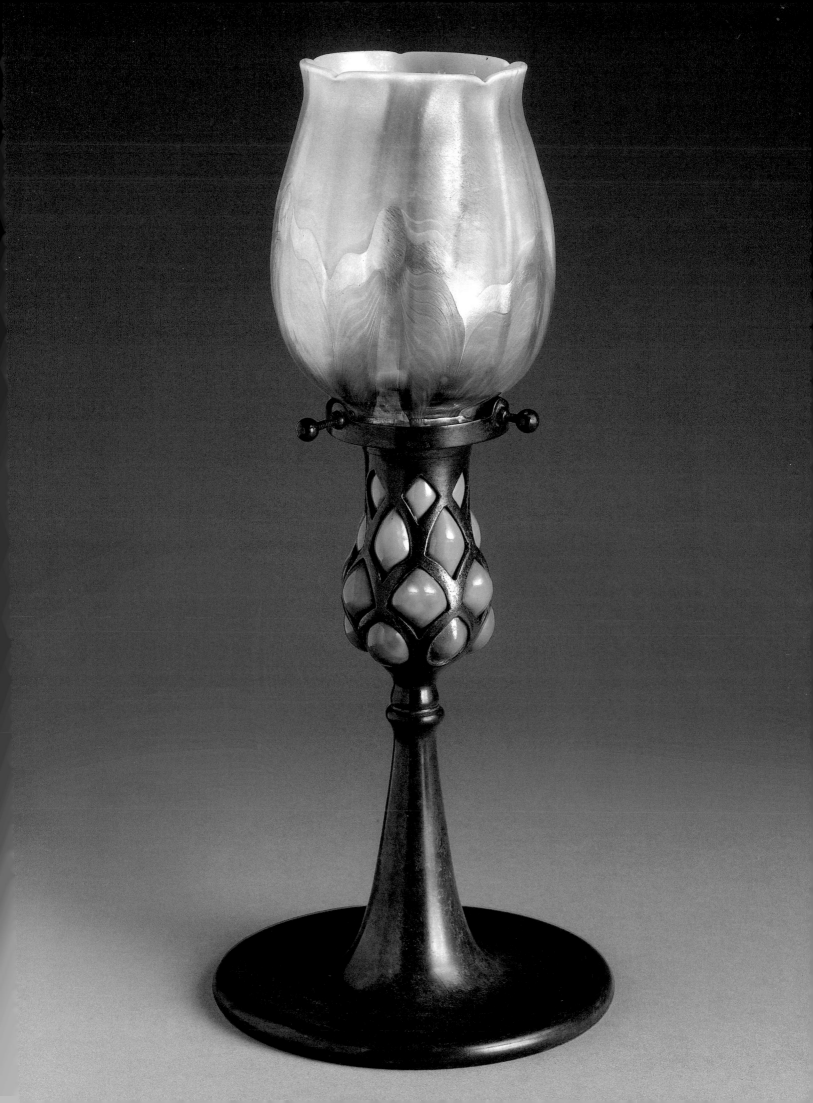

WINDOWS

L ouis Comfort Tiffany began designing stained-glass windows in the 1870s. In 1885, he started a company to produce them using glass purchased from other factories. After he founded the glassworks in 1892–93, he was able to supply his own glass for his windows. Tiffany explored new ways of creating windows that were very different from the academic, painted windows seen in Europe in the nineteenth century. Tiffany and his competitor John La Farge were simultaneously but separately experimenting with a variety of innovative techniques to achieve more vibrant colors, texture, and depth.

Each of these two artists patented the opalescent glass seen in their designs. Both also used plating, in which two or more layers of glass were added to the back of the window to create vibrant color and light effects.[1] According to a contemporary account published by Tiffany Glass & Decorating Company, the two windows Tiffany exhibited at the World's Columbian Exposition illustrate the new technical possibilities of this glass, described as a very realistic effect "obtained without the assistance of paints or enamels, solely by using opalescent glass in accordance with the principles that govern mosaic work."[2] As a contemporary Tiffany promotional booklet stated: "As all our windows are built in accordance with the mosaic theory, without the intervention of paint, stains or enamels, they are practically indestructible, and will not corrode, peel or fade."[3]

Other techniques Tiffany employed in his windows included mottling, whereby a chemical was added to the glass during precisely controlled temperature changes to create color patterns; fractured or confetti glass, which embedded small pieces of colored glass into sheets of clear glass; and drapery glass, which, through a process of stretching and twisting the glass like dough, simulated folds in fabric and was also used for flower petals. In addition, Tiffany used leading to delineate design as well as for support and often employed jewels of molten glass set into the windows, sometimes even using stone pebbles (CAT. 59).[4]

Tiffany windows were made through the collaborative efforts of many people, beginning with a presentation drawing for commission approval. Next, a more detailed, full-size cartoon was drawn. From this cartoon, through several steps of numbering, cutting, spacing, and transferring the sections, a template was created for the glasscutters. After the glass was cut, each piece was encased with a strip of copper around its

1. United States Patent Office, utility patent no. 237,418, "Colored-Glass Window," invented by Louis C. Tiffany, New York, N.Y, specifications page, lines 11–20 and 26–30. Application filed October 25, 1880; patent granted February 8, 1881.

2. Tiffany Glass & Decorating Company, *World's Columbian Exposition*, 1893.

3. Tiffany Glass & Decorating Company, *Memorial Windows*, n.d., n.p.

4. For a more detailed discussion of these glassmaking methods, see Alastair Duncan, *Tiffany Windows* (New York: Simon & Schuster, 1980), 80, 97–102. See also descriptions in Rosalind Pepall, ed., *Tiffany Glass: A Passion for Colour* (Paris: Skira-Flammarion; Montreal: Montreal Museum of Fine Art, 2009), 110–11.

Tiffany Studios, glass shop, from *Character and Individuality in Decorations and Furnishings*, New York: Tiffany Studios, 1913.

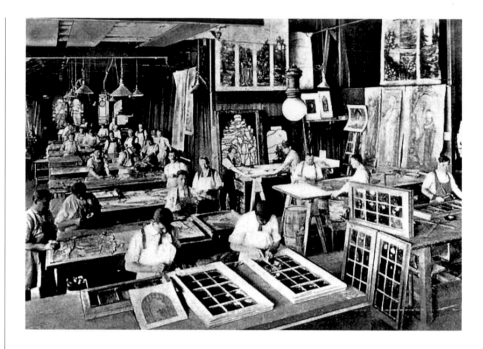

5. For a more detailed discussion of this process, see Martin Eidelberg, Nina Gray, Margaret K. Hofer, *A New Light on Tiffany: Clara Driscoll and the Tiffany Girls* (New York: New-York Historical Society, 2007), 28–30.

6. For a discussion of the different types of windows, see the chapter "Window Themes" in Alastair Duncan, *Tiffany Windows* (New York: Simon & Schuster, 1980), 135–90. For a listing of Tiffany windows in the United States, see Duncan, *Tiffany Windows*, 200–224.

edges for welding and set into position, following the cartoon. The glass was then welded together, enameled, and leaded.[5]

Most of Tiffany's windows were ecclesiastical, commissioned as memorials for churches or mausoleums. Many retain inscriptions that help document the design, even when removed from their original setting. These windows often illustrate stories in the Bible, as seen in the *Guiding Angel* and *King Solomon* windows. Landscape windows were also sometimes used for churches, as were flowers. For example, lilies symbolized the Resurrection, while the River of Life represented the path to eternal life. Landscapes, seascapes, and gardens were often used in residences, libraries, schools, and other buildings. Geometric or medallion windows were more abstract and adapted thirteenth-century stained-glass prototypes. Tiffany continued to produce windows through the 1920s. Many survive today in churches throughout the country.[6]

56

Page 169
GUIDING ANGEL WINDOW
1917
Leaded and enameled glass
62 x 38 3/4 in. (157.5 x 98.4 cm)
Signed in enameled cameo: TIFFANY
STUDIOS / NEW YORK / 1917
Acc. no. 40105

The Guiding Angel was a favored
subject for memorial windows.
The woman is led to eternal life by a
robed angel and embraced by its
extraordinary wings, which allowed
for a fantasy of color and movement
in greens, blues, purples, and yellows.

57

FLORAL WINDOW
Late 1890s
Leaded glass
58 x 22 in. (147.3 x 55.9 cm)
No marks
Acc. no. 40152

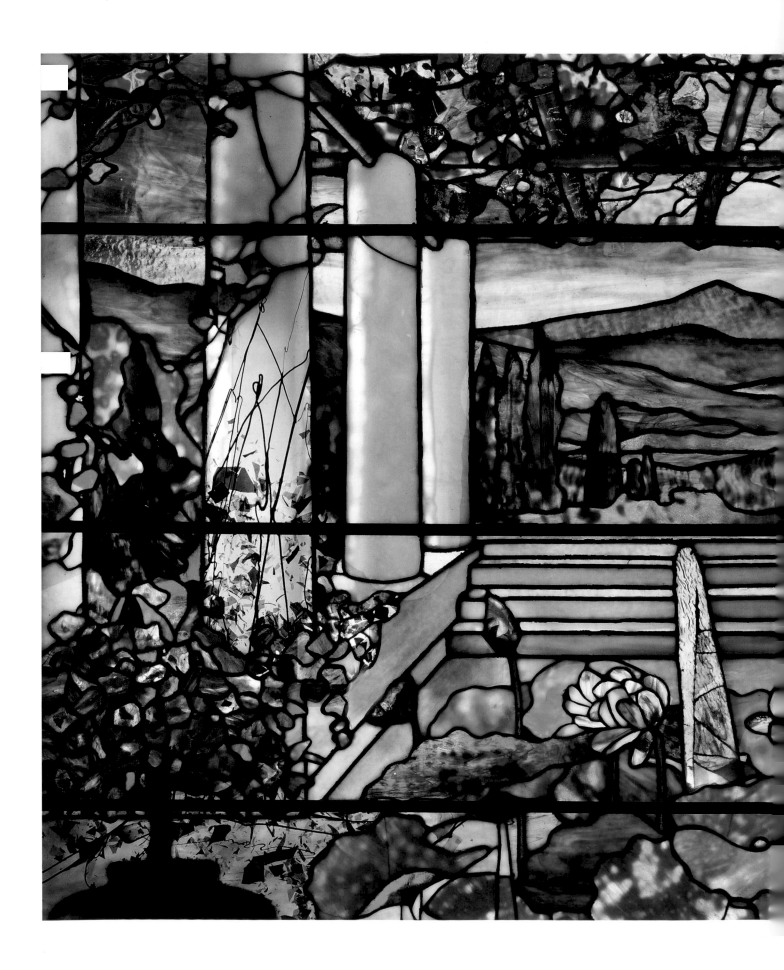

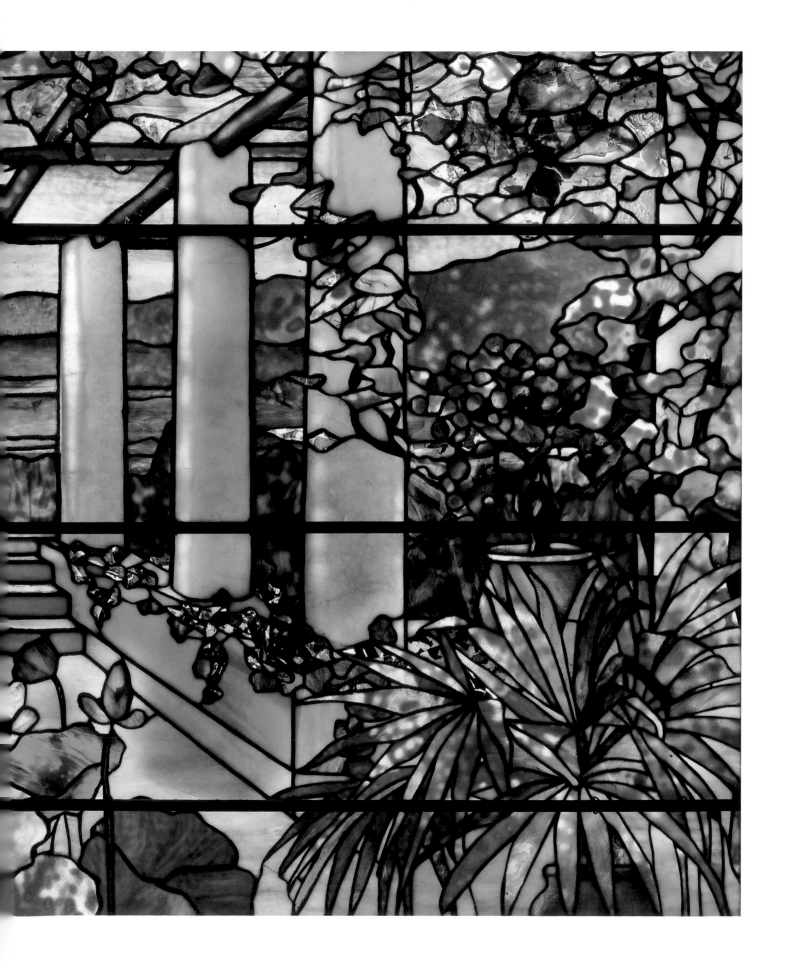

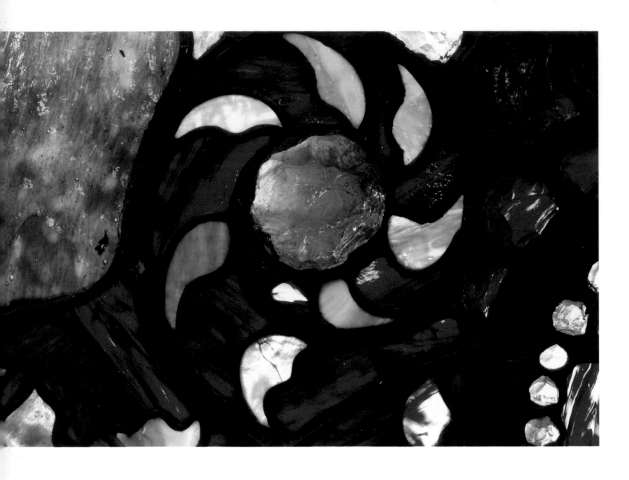

58

Page 172–73
GARDEN LANDSCAPE WINDOW
1900–1910
Leaded glass
37 x 65 ½ in.
(94 x 166.4 cm)
No marks
Acc. no. 40153

This sumptuous window captures
an imaginary ideal landscape with a
terrace and loggia in the foreground
and, in the distance, a view of
hills with a setting sun. The garden
in the foreground includes azaleas,
palms, and lotus near a pool with a
fountain. A detail of the back of
the window shows how the brilliant
coloration was achieved through
glass plating, an effect reminiscent
of an impressionist painting.
A nearly identical window was in
the Tiffany Garden Museum,
Matsue, Japan.[1]

1. Alastair Duncan, *Louis C. Tiffany, the
Garden Museum Collection* (Woodbridge,
Suffolk, UK: The Antique Collectors' Club,
2004).

59

GEOMETRIC WINDOW
c. 1890
Leaded glass
58 x 43 in. (147.3 x 109.2 cm)
No marks
Acc. no. 40106

60

LANDSCAPE WINDOW
1893–1920
Leaded glass, pebbles
80 x 44 1/2 in. (203.2 x 113 cm)
Stamped in lead: TIFFANY STUDIOS
Acc. no. 40163

Tiffany's landscape windows provided him with the greatest opportunity to explore his inventive artistic techniques in stained glass. This extraordinary window depends on light striking the front as well as coming through the back and utilizes confetti glass for the trees and iridescent glass in all borders. Although the original setting for this window is not known, it was most likely for a private house. The composition is a window within a window with an original landscape of a tree in the foreground with additional trees in the distance, balanced by the lake on the left. Subtle color changes occur with the angle and quality of the light. Tiffany Studios was not officially incorporated until 1902, but it began using the mark in the 1890s.

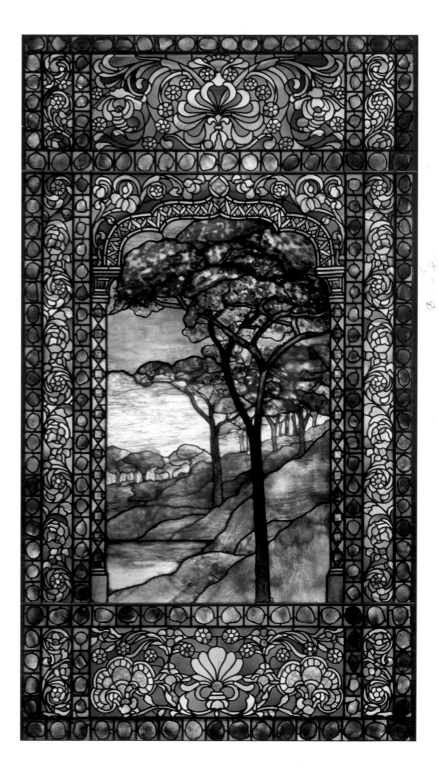

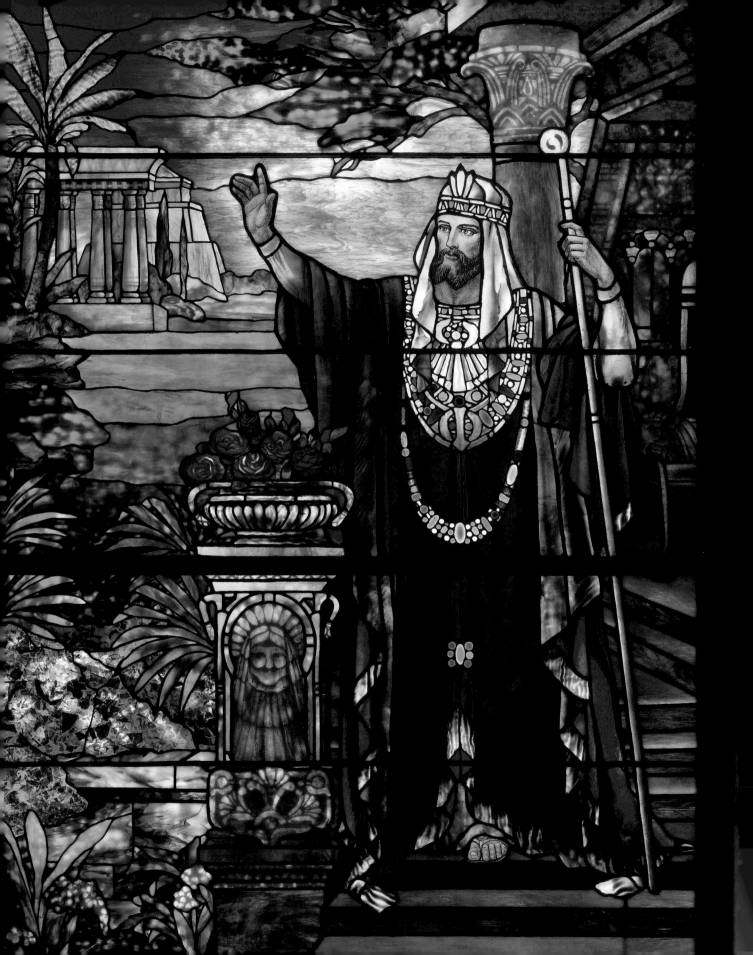

61

KING SOLOMON WINDOW
c. 1900
Leaded, enameled, and jeweled glass
65 x 47 1/4 in. (166.1 x 120 cm)
Signed in cameo at lower right:
Louis C. Tiffany, New York
Acc. no. 40116

King Solomon was known for the magnificence of his kingdom and the visual splendor of his temple, conveyed in the building in the far left distance and the steps to the throne on the right, from which he descends, pausing with a gesture of blessing. According to 2 Chronicles 1:11, Solomon asked God for wisdom and knowledge rather than riches and wealth, so God replied: "I will give thee riches, and wealth, and honor, such as none of the kings have had that have been before thee, neither shall there any after thee have the like." Probably designed for a church or synagogue, this window is characteristic of Tiffany's later designs with its saturated bright colors. Some painting is utilized for detail work, and large pieces of glass form the drapery in Solomon's robes. The subject allowed for an exuberant exploration of color in the robes, the flowers in the foreground, and the bowl of red roses on the pedestal. The scene is fanciful, incorporating a stage-like backdrop, like an opera set.

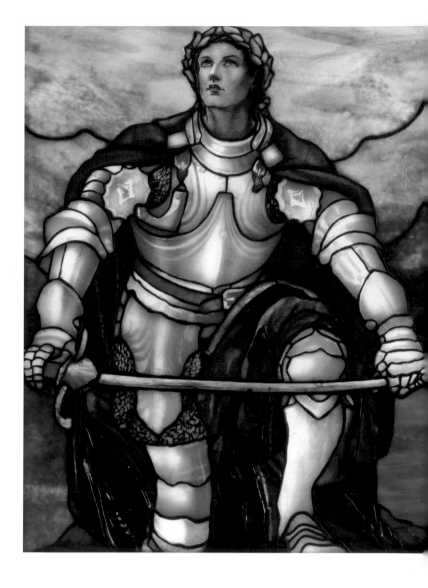

62

SOLDIER OF THE LORD WINDOW
c. 1910
Leaded and enameled glass
29 7/16 x 22 5/8 in. (74.8 x 57.5 cm)
No marks
Acc. no. 40161

63

WINDOW
1895–1902
Leaded glass
46 1/4 x 13 1/4 in. (117.5 x 33.7 cm)
Original paper label for Tiffany Glass
& Decorating Company
Painted on back of frame: 859
On back of frame in chalk:
Loft over GARAGE
Acc. no. 40165

This is a specimen window that was
in the Tiffany showroom at 333 Fourth
Avenue. The scene is a storm-tossed
sailboat, depicted in somber shades of
green and blue with white, achieved
through plating.

64

RIVER OF LIFE WINDOW
1900–1910
Leaded glass
82 x 43 1/2 in. (208.3 x 110.5 cm)
Signed in enameled cameo in lower
right: Louis C. Tiffany NY
Acc. no. 40004

The River of Life theme was favored for
memorial windows in churches and
mausoleums, allowing Tiffany to explore
nature in lieu of the human figures so
often required for the biblically themed
windows. The rich color palette consists
of shades of blue, green, and amber,
with enameled layers of mottled, striated,
and opalescent glass. The blooms on the
magnolia tree were among Tiffany's
favorite flowers, as were the irises seen
along the bottom. A similar themed
window of about 1908 is in the
Metropolitan Museum of Art. It was
designed as a memorial to the Frank
family of New York and was originally
installed in a Brooklyn mausoleum.

65

Pages 184–85
LANDSCAPE WINDOW
1905–20
Leaded glass
40 3/4 x 58 3/4 in. (103.5 x 149.2 cm)
Signed in enameled cameo in lower
right: Louis C. Tiffany NY
Acc. no. 40173

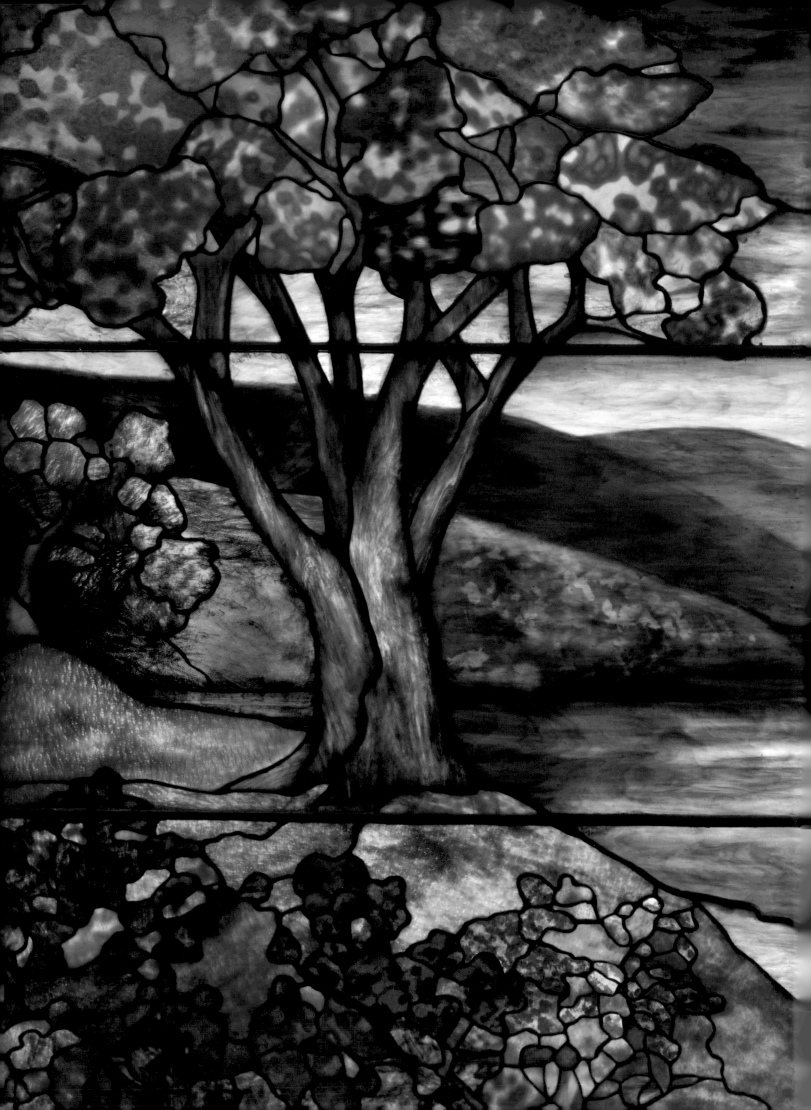

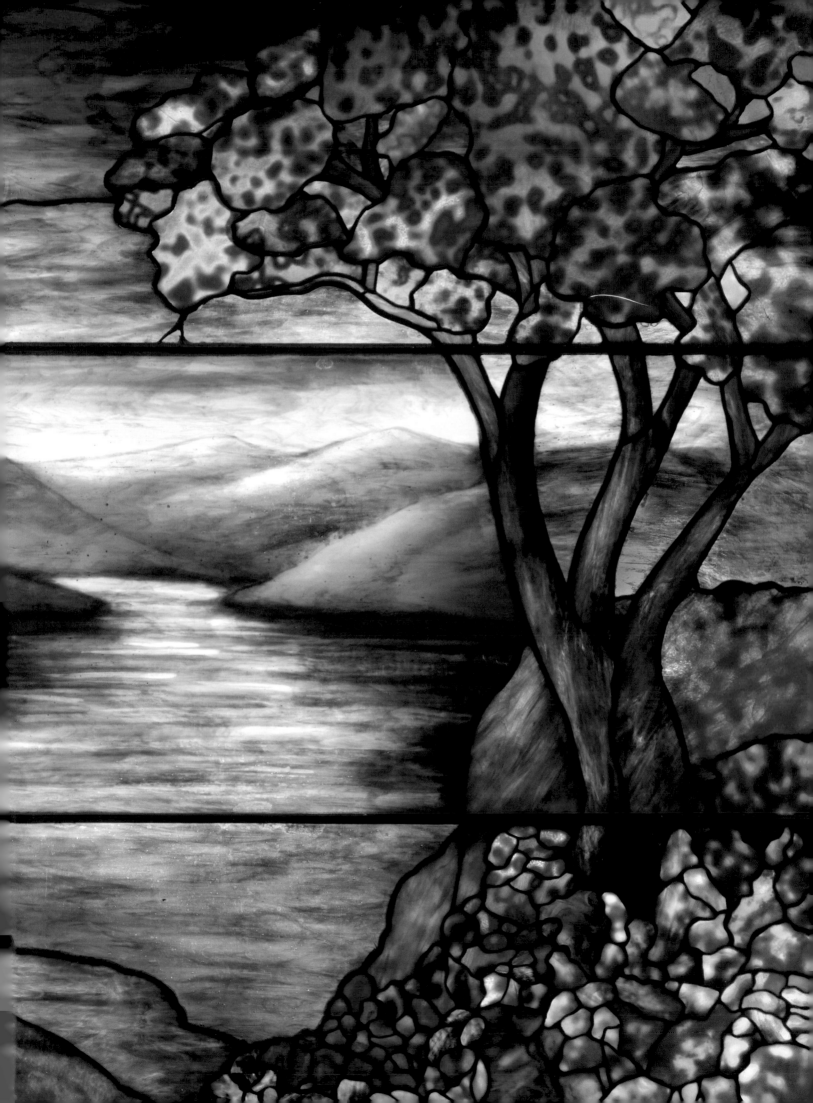

LOUIS COMFORT TIFFANY CHRONOLOGY

1848 Louis Comfort Tiffany is born in New York to Harriet Olivia Avery Young and Charles Lewis Tiffany, founder of Tiffany & Co.

1866–67 Attends formal art classes at the National Academy of Design, where he meets Samuel Colman, a landscape painter.

1868–69 Studies with Léon-Charles Adrien Bailly in Paris. When he returns to New York, he sets up a studio at the YMCA on West 23rd Street.

1870–71 Travels with Robert Swain Gifford to London, Paris, Madrid, Málaga, Gibraltar, Tangier, Malta, Sicily, Naples, Amalfi, Sorrento, Cairo, Alexandria, Algeria, Tunisia, Rome, and Florence.

Becomes a member of the American Water Color Society and the Century Association and is elected an Associate of the National Academy of Design.

1872 Marries Mary (May) Woodbridge Goddard. They have three children: Mary Woodbridge Tiffany (1873), Charles Lewis Tiffany II (1878), Hilda Goddard Tiffany (1879).

1875–77 Works at Thill's Empire State Flint Glass Works in Brooklyn where he develops drapery glass.

1876 Exhibits three oil paintings and six watercolors at the Centennial Exposition in Philadelphia.

1877 Participates in the Society of Decorative Arts, along with Candace Wheeler, Lockwood de Forest, and Samuel Colman.

Elected to the Society of American Artists.

1878 Exhibits paintings and watercolors at the Exposition Universelle in Paris. Establishes Louis C. Tiffany and Company and embarks on glassmaking.

1880 Head of Louis C. Tiffany and Company, Furniture; Tiffany and Wheeler, Embroideries (in partnership with Candace Wheeler); and Tiffany and de Forest, Decorators (in partnership with Lockwood de Forest).

1881 Elected a director of Tiffany & Co. Tiffany and Wheeler and Louis C. Tiffany and Company merge to form Louis C. Tiffany and Company,

Associated Artists. The company decorates the Veterans Room of the Seventh Regiment Armory in New York and the Red Room at the White House the following year.

1882 Granted a patent for "useful improvements in colored-glass windows."

Ends partnership with Lockwood de Forest.

1883 Establishes Louis C. Tiffany and Company following dissolution of Louis C. Tiffany and Company, Associated Artists.

1884 Death of Mary (May) Woodbridge Goddard Tiffany.

Louis C. Tiffany and Company is listed under decorators in the Lakeside City Directory of Chicago. The firm and successor firms will continue to be listed until about 1890.

1885 Establishes Tiffany Glass Company following dissolution of Louis C. Tiffany and Company.

Moves his family to his father's house on 72nd and Madison Avenue. Designed by McKim, Mead, & White, the house has three apartments. Charles Tiffany occupies the first two floors; his daughter the third; and the uppermost floor will be LCT's studio and living areas. LCT designs the interiors for the three apartments. The house will be cited as "the most artistic house in New York City."

Collaborates with Thomas A. Edison to create electric footlights for the Lyceum Theater in New York.

1886 Marries Louise Wakeman Knox, a painter. They have four children: Louise Comfort Tiffany and Julia de Forest Tiffany (1887), Annie Olivia Tiffany (1888), and Dorothy Trimble Tiffany (1891).

1887 Tiffany Glass Company is producing interior decorative works including wallpaper, fabrics, relief ornamentation, leather, metal, woodwork, stained and leaded glass windows, glass tiles, mosaics, and floorings.

1890 Jacob A. Holzer, who had worked for sculptor Augustus Saint-Gaudens and the painter and stained-glass artist John La Farge, becomes chief designer at the Tiffany Glass Company, heading the mosaic workshop.

1891–92 Collaborates with Samuel Colman on the interior decoration of the Louisine and Henry Osborne Havemeyer house in New York.

1892 Reopens Tiffany Glass Company as Tiffany Glass & Decorating Company.

1893 Tiffany Glass & Decorating Company exhibits at the World's Columbian Exposition in Chicago, where Tiffany shares space with his father's firm, Tiffany & Co. The focus is Romanesque revival chapel with Byzantine-style mosaics and devotional objects including benediction candelabra. Other exhibits include secular stained-glass windows, notably *Parakeets and Gold Fish Bowl*.

The Art Institute of Chicago commissions Tiffany Glass & Decorating Company to create a gallery, funded by Mrs. Thomas Nelson Page as a memorial to her first husband, Henry Field.

Tiffany Glass & Decorating Company designs the windows for the Second Presbyterian Church in Chicago. *Christ Blessing the Little Children* is the earliest of ten windows by Tiffany in this building.

Forms Stourbridge Glass Company in Corona, Queens, as a separate glass production business from Tiffany Glass & Decorating Company. Arthur J. Nash oversees the workers making blown Favrile glass vases.

1894 Registers "Favrile" as a trademark with the U. S. Patent Office. Tiffany Favrile glass is displayed at the Art Institute of Chicago and offered for sale at Tiffany Glass & Decorating Company. The Musée des Arts Décoratifs and the Musée de Luxembourg acquire Favrile glassware.

Jacob A. Holzer designs a mosaic frieze for the lobby of the atrium of the Marquette Building in Chicago.

Siegfried Bing, proprietor of the gallery L'Art Nouveau in Paris, visits Tiffany Glass & Decorating Company. Bing will become Tiffany's distributor in Europe, with exhibitions in 1895 and 1897.

1895 Exhibits windows with designs by artists including Henri de Toulouse-Lautrec, Édouard Vuillard, Pierre Bonnard, Henri-Gabriel Ibels, Paul-Élie Ranson, Kerr-Xavier Roussel, Paul Sérusier, and Félix Vallotton and examples of Favrile glassware at the Salon of the Société Nationale des Beaux-Arts, Paris.

1896 Tiffany glass enters museum collections, including the United States National Museum (now the Smithsonian Institution); Louisine and Henry Osborne and Havemeyer present forty pieces to the Metropolitan Museum of Art, New York.

Publication of *Tiffany Favrile Glass*.

1897

Favrile glass for sale at O'Brien's Art Galleries, Chicago.

Opens foundry and metal shops in Corona.

Jacob A. Holzer collaborates with architect Charles Coolidge to design the interior of the Chicago Public Library (the Chicago Cultural Center today). Holzer designed the elaborate mosaic decoration.

1898

Tiffany Glass & Decorating Company acquires Schmitt Brothers Furniture Company.

The Art Institute of Chicago commissions Tiffany Glass & Decorating Company to construct a dome with a gold opalescent glass skylight and a brass and crystal electrified chandelier for Fullerton Hall, a gift from Charles W. Fullerton in memory of his father.

Tiffany Glass & Decorating Company decorates the Grand Army of the Republic Memorial Hall in the Chicago Public Library in neo-Renaissance style.

1899

Exhibition, organized by Siegfried Bing, at Grafton Galleries in London, including Favrile glass, lamps, mosaics, metalwork, and sketches.

Blown glass included in the Mir Iskusstva International Art Exhibition, St. Petersburg.

1900

Exhibits windows, Favrile glass, lamps, mosaics, and enamels at the Exposition Universelle in Paris. LCT and Arthur J. Nash are awarded grand prizes, and LCT is appointed a Chevalier of the Legion of Honor.

Allied Arts Company, formerly Tiffany Glass & Decorating Company, is incorporated. Products are sold under the name Tiffany Studios.

1901

Designs the court at the Pan-American Exposition in Buffalo featuring a magnificent fountain of crystal, onyx, and pearl glass made by the Allied Arts Company. Awarded a grand prize for exhibit of windows and Favrile glass.

Prize-winning exhibits at expositions in St. Petersburg and Dresden.

Allied Arts Company builds a new plant in Corona for the manufacture of decorative art metal.

Eastern Arts Company is incorporated to buy, sell, import, export, and manufacture objects of art.

Marshall Field & Co. becomes the authorized agent for Tiffany in Chicago.

1902

Death of Charles Lewis Tiffany. LCT inherits $3 million from his father's estate.

Elected second vice president of Tiffany & Co and continues as a director until his death in 1933; becomes art director of Tiffany & Co.

Purchases land on Long Island that will become Laurelton Hall, his country estate.

Exhibits at the *First Annual Exhibition of Original Designs for Decorations and Examples of Art Crafts having Distinct Artistic Merit* at the Art Institute of Chicago.

Fountain from the Pan-American Exposition is installed in the Pompeiian Room of the Congress Hotel in Chicago. Tiffany Studios also provides windows and an art-glass skylight for the room.

Stourbridge Glass Company renamed Tiffany Furnaces; Allied Arts Company is integrated with Tiffany Studios.

1903

Awarded an honorary Master of Arts degree from Yale University.

Tiffany Studios introduces Favrile pottery.

1904

Death of Louise Wakeman Knox Tiffany.

Awarded gold medal at the Louisiana Purchase International Exposition in St. Louis.

1906

Collaboration with Edward Bennett of D. H. Burnham & Company on the Men's Grille at Marshall Field & Co., Chicago.

1907

Becomes first vice president and assistant treasurer of Tiffany & Co. following the death of Charles C. Cook, who had succeeded C. L. Tiffany as president.

Tiffany & Co. buys the enameling and jewelry division of Tiffany Studios.

Tiffany Studios designs the arched and domed mosaic ceiling of the five-story atrium at Marshall Field & Co. in Chicago.

Awarded a gold medal at the Jamestown Exposition in Virginia.

1909

Awarded grand prize at the Alaska-Yukon-Pacific Exposition in Seattle.

Eastern Arts Company merges with Tiffany Studios.

1911

Tiffany Studios creates a mosaic curtain for the National Theater in Mexico City.

1913

Hosts an Egyptian extravaganza at Tiffany Studios that the *New York Times* called "the most lavish costume fete ever seen in New York."

1914

Hosts "Men of Genius" ball at Laurelton Hall. Among the guests were Childe Hassam, Nikola Tesla, William Sloane Coffin, Charles Scribner, and Frederick Bok.

The Art Work of Louis Comfort Tiffany by *New York Times* critic Charles De Kay is published by Doubleday Page & Co.

Angel of Truth triptych designed by Tiffany Studios for John G. Shedd, president of Marshall Field & Co., is installed in the Shedd Mausoleum in Rosehill Cemetery.

1915

Awarded gold medal at the Panama-Pacific Exposition in San Francisco.

1916

Hosts "The Quest of Beauty" luncheon at Tiffany Studios in celebration of his sixty-eighth birthday, accompanied by a retrospective of his work including paintings, decorative art objects, ironwork, and textiles.

Collaborates with Maxfield Parrish on the *Dream Garden* mosaic, commissioned by Frederick Bok and installed in the lobby of the Curtis Publishing building in Philadelphia.

1918

Establishes the Louis Comfort Tiffany Foundation, which will become an art school based at Laurelton Hall.

1920

Tiffany Furnaces is restructured and renamed Louis C. Tiffany Furnaces. A. Douglas Nash is in charge of the operation.

1924

Louis C. Tiffany Furnaces goes out of business. A. Douglas Nash Company is formed with Tiffany continuing to have an interest, but this firm closes in 1930.

1926

Awarded a gold medal at the Sesquicentennial International Exposition in Philadelphia.

Tiffany Studios designs the peacock entry doors for the C. D. Peacock jewelry store in the Palmer House in Chicago.

1932

Tiffany Studios files for bankruptcy. Louis C. Tiffany Studios Corporation is formed to support the bankrupt Tiffany Studios.

1933

Louis Comfort Tiffany dies of pneumonia at his New York house. His estate is valued at $880,701. Contents of Louis C. Tiffany Studios Corporation and Laurelton Hall are sold in a series of auctions in 1936, 1938, and 1946.

JANET ZAPATA

SELECTED BIBLIOGRAPHY

Artistic Houses: Interior Views of a Number of Beautiful and Celebrated Homes in the United States. New York: D. Appleton & Co., 1883. Reissued, New York: Benjamin Bloom, 1971.

Bing, Samuel. *Artistic America, Tiffany Glass, and Art Nouveau*. Cambridge, MA: The MIT Press, 1970.

Bruhn, Jutta-Annette. *Designs in Miniature: The Story of Mosaic Glass*. Corning, NY: Corning Museum of Glass, 1995.

Bullen, J. B. *Byzantium Rediscovered*. New York: Phaidon, 2003.

Duncan, Alastair. *Tiffany Windows*. New York: Simon & Schuster, 1980.

Duncan, Alastair, Martin Eidelberg, and Neil Harris. *Masterworks of Louis Comfort Tiffany*. Exh. cat. London: Thames & Hudson; New York: Harry N. Abrams, 1989.

Eidelberg, Martin, Alice Cooney Frelinghuysen, Nancy A. McClelland, Lars Rachen. *The Lamps of Louis Comfort Tiffany*. New York: The Vendome Press, 2005.

Eidelberg, Martin, Nina Gray, and Margaret K. Hofer. *A New Light on Tiffany: Clara Driscoll and the Tiffany Girls*. New York: New-York Historical Society, 2007.

Eidelberg, Martin, and Nancy A. McClelland, eds. *Behind the Scenes of Tiffany Glassmaking: The Nash Notebook*s, including "Tiffany Favrile Glass" by Leslie Hayden Nash. New York: St. Martin's Press in association with Christie's Fine Arts Auctioneers, 2001.

Frelinghuysen, Alice Cooney. *Louis Comfort Tiffany and Laurelton Hall: An Artist's Country Estate*. New York: Metropolitan Museum of Art; New Haven, CT, and London: Yale University Press, 2006.

Frelinghuysen, Alice Cooney. *Louis Comfort Tiffany at The Metropolitan Museum of Art*. Exh. cat. New York: Metropolitan Museum of Art, 1998.

Johnson, Marilynn A., *Louis Comfort Tiffany: Artist for the Ages*. London: Scala, 2005.

Joppien, Rüdiger and Susanne Langle. *Louis C. Tiffany: Meisterwerke des amerikanischen Jugendstils*. Exh. cat. Hamburg: Museum Für Kunst und Gewerbe, 1999.

Koch, Robert. *Louis C. Tiffany: The Collected Works of Robert Koch*. Atglen, PA: Schiffer Publishing, 2001.

Long, Nancy, ed. *The Tiffany Chapel at the Morse Museum*. Exh. cat. With contributions by Alice Cooney Frelinghuysen, Wendy Kaplan, Laurence J. Ruggerio, et. al. Winter Park, FL: Charles Hosmer Morse Foundation, 2002.

McKean, Hugh. *The "Lost" Treasures of Louis Comfort Tiffany*. Garden City, NY: Doubleday & Company, 1980.

Neustadt, Egon. *The Lamps of Tiffany*. New York: Neustadt Museum of Tiffany Art, 1970.

Pongracz, Patricia C., ed. *Louis C. Tiffany and the Art of Devotion*. New York: Museum of Biblical Art; London: D Giles Limited, 2012.

Zapata, Janet. *The Jewelry and Enamels of Louis Comfort Tiffany*. New York: Harry N. Abrams, 1993.

INDEX

ACKNOWLEDGMENTS

This book and the exhibition it accompanies are the result of the dedicated work and achievement of many talented people at the Richard H. Driehaus Museum, as well as institutions and individuals who have participated as part of an enthusiastic team.

We are indebted to Gianfranco Monacelli and Elizabeth White at the Monacelli Press, whose expertise and enthusiasm have led to this superb publication. The beautiful design is the work of Abbott Miller and Kim Walker at Pentagram. We gratefully acknowledge the editorial contributions of Kate Clark of David A. Hanks & Associates, Anne Hoy, and Lindsey Howald Patton of the Driehaus Museum.

The Museum was fortunate to commission John Faier to photograph all of the Tiffany works in the exhibition for the catalogue. His stunning images reflect his skill in capturing the essential beauty of each object, bringing great sensitivity to the interpretation of glass objects that are often difficult to photograph.

Research for this book was conducted over a two-year period, and we received invaluable assistance from a number of institutions in Chicago and elsewhere. At the Art Institute of Chicago, we thank Mark K. Woolever, archivist for the Ryerson & Burnham Libraries, and Bart H. Ryckbosch, Glasser and Rosenthal archivist for the Archive Department. Tim Samuelson, cultural historian for the City of Chicago, provided many insights and information in our search for Tiffany commissions in Chicago. Lesley Martin, researcher at the Chicago History Museum, and Jennifer Thalheimer of the Charles Hosmer Morse Museum of American Art also assisted with important research. I also acknowledge the valuable assistance of the following individuals and institutions in obtaining photographs for this publication: Stephanie Coleman and Jackie Maman, Art Institute of Chicago; Jennifer Belt and Michael Slade, Art Resource; Christina Amato, Charles Hosmer Morse Museum of American Art; Lucas Simpson, Hedrich Blessing Photographers; Daniel Silva, Hispanic Society of America; Andy Solomon and Beverly Hayes, MacArthur Foundation; Lindsy Parrott, The Neustadt Collection of Tiffany Glass; Melanie Emerson, Ryerson and Burnham Libraries; Katy Gallagher, Second Presbyterian Church of Chicago; Ginevra Reed, Shedd Family; Tony Jahn, Target Corporation; Beth Bahls, University of Michigan Museum of Art.

To the dedicated staff of the Driehaus Museum, I owe my gratitude. Director Lise Dubé-Scherr has patiently guided our process and overseen arrangements for the publication and exhibition from concept to execution, assuring that the project was aligned with the vision of the collector, of high quality, and on schedule. Special thanks go to Joyce Lee, curator of the Driehaus Collection, and her staff for their meticulous work on this complex project, and to the Museum's staff, particularly Mary Dwyer, curatorial assistant, who played an important part in supporting the development of the exhibition. In New York, I was assisted by my colleagues and staff, Jan Spak and Kate Clark. Dr. Martin Eidelberg, professor emeritus, Rutgers University, and I made the initial selection of works for the exhibition, in collaboration with Joyce Lee. Special thanks to Tiffany expert Janet Zapata for preparing the chronology and reading through the manuscript.

The handsome design of the installation was created under the direction of Jeff Daly Design. Jeff Daly's patience and understanding of the unique setting for this exhibition as well as his aesthetic appreciation of Tiffany's work has been invaluable.

Finally, and most importantly, I wish to thank the collector, Richard H. Driehaus, and the Museum's Board of Directors, without whom this extraordinary exhibition and publication would not have been possible.

DAVID A. HANKS

This publication accompanies the exhibition
Louis Comfort Tiffany: Treasures from the Driehaus Collection
held at the Richard H. Driehaus Museum

September 28, 2013–June 29, 2014

The exhibition and publication were made possible,
in part, by presenting sponsor BMO Harris Bank.

BMO ⬢ **Harris Bank**

Photographs by John Faier except as noted below:
The Art Institute of Chicago 27 bottom right, 29 top and
bottom left, 30 top, 51, 129, 131
Art Resource 9 below (digital image © The Museum of
Modern Art), 27 top right, 42 top left, 131 left center and right
Hedrich Blessing 14, 37 top
Dave Burk © Hedrich Blessing 33, 34
Martin Cheung, Friends of Historic Second Church 40, 41
Chicago History Museum 39 bottom
Steve Hall © Hedrich Blessing 29 bottom right
The Hispanic Society of America 23 top
Library of Congress, Prints and Photographs Division, HABS
IL, 16–CHIG, 14-3 32 right
Marco Lorenzetti © Hedrich Blessing 9 top left
John D. and Catherine T. MacArthur Foundation 30
Charles Hosmer Morse Museum of American Art 23 bottom
left, 24 top left, 24 bottom left and right, 48, 148, 168
Museum of Fine Arts, Boston 27 left
Neustadt Collection of Tiffany Glass, New York 47
New-York Historical Society, negative #48407 131 top
Target Corporation 37 bottom right
Michael Tropea 181
University of Michigan School of Art and College of
Architecture and Urban Planning. University purchase 1930,
tranferred to the Museum of Modern Art 1986. 146.10 134
Alexander Vertikoff 18

Copyright © 2013 The Richard H. Driehaus Museum

All rights reserved.

Published in the United States by The Monacelli Press

Library of Congress Control Number: 2013939869

ISBN 9781580933537 (hardcover edition)
ISBN 9780615374895 (paperback edition)

Designed by Abbott Miller and
Kim Walker, Pentagram

Printed in Italy

www.monacellipress.com